African Wildlife Sketches

Jeff Huntly's

African Wildlife Sketches

ASHANTI
PUBLISHING LIMITED
GIBRALTAR
A DIVISION OF ASHANTI INTERNATIONAL FILMS

Design: Dieter Mandlmeier
Typesetting and Reproduction: Pointset
Cover Design: Axel Adelbert, Gütersloh, West Germany
Printing: Interpak

First edition © Jeff Huntly 1990
ISBN
1 874800 05 7 (Standard Edition)
1 874800 06 5 (Collector's Edition)
1 874800 07 3 (Leatherbound Limited Edition)

Published by Ashanti Publishing Limited, Gibraltar,
a division of Ashanti International Films Limited,
Suite C, Regal House, Queensway, Gibraltar.

Distributed in the United Kingdom by
Eddington Hook Limited, 406 Vale Road, Tonbridge,
Kent TN9 1XR

For our daughter Philippa

Contents

Jeff Huntly, born Rhodesia 1931.

Came under influence of his father, Norman Huntly, at an early age, sometimes travelling with him on prospecting and butterfly-collecting trips in the bush. Spent three years as a prospector in the chrome areas of the Great Dyke in Rhodesia (now Zimbabwe). Spent a year in Hwange National Park painting wild-life. Full-time artist and author of Veld Sketchbook. Designed and painted definitive set of fifteen postage stamps for Rhodesia in 1974. Later designed the coins used in Zimbabwe after independence (1980). Paints in water colour, gouache and acrylics. Sketches from life. Designed postage stamps for Ciskei 1989. (Two sets: wagons and ploughs.)

Continues to write and illustrate Veld Sketchbook which is still being published weekly since it began fifteen years ago. Paints landscapes from life. Jeff and his wife, Margaret (who works for Natal Parks Board), live in Pietermaritzburg. Their daughter Philippa lives in Cape Town.

PRINTS AND BOOKS BY JEFF HUNTLY
Veld Sketchbook: Books of Rhodesia, 1974.
Veld Sketchbook Two: Pioneer Head, 1976.
World of the Wagon: A portfolio of prints of paintings.
African Bush Scenes: Portfolio of prints, 1982.
Set of Six Bird Prints: Pioneer Head, 1976.

REGULAR WEEKLY ARTICLES IN
The Star
The Pretoria News
The Natal Witness
The Herald (Zimbabwe – up to 1983)

IRREGULAR OR PREVIOUSLY PUBLISHED
The Argus (Cape Town)
African Wildlife
Toktokkie
Eastern Cape Naturalist 1975

Concerning a "Veld Sketchbook"

I was asked by my publisher to write down in essence what I saw as being a "Veld Sketchbook". Well, I see it as being a collection of writings and drawings of my contact with the veld. Very much a personal response to Nature. An outlook influenced by one man. A text seeking to avoid what can be found in other books. The careful avoidance of exaggeration and careful explanation of what may sometimes appear to be exaggeration – such as the time I saw at least one hundred Bronze Mannikins at my feeding bay and normally these little birds go about in much smaller groups.

I said someone influenced my outlook. It was Hudson. The first time I read a book by William Henry Hudson was when I worked alone in the bush as a prospector. The book affected me deeply, as though I was drinking the crystal water of some lifegiving fountain. Over the years I have read most of his books and go back to them, to drink anew. There is a stone monument to Hudson in Hyde Park, London, a sculptured tribute by Jacob Epstein. I see a "Veld Sketchbook" as a natural outcome of Hudson's influence on my view of nature.

My thanks are due to the editors and editorial staff of the newspapers who first published Veld Sketchbook. Without them the book would not exist.

Many people have helped me in this work, none more so than my wife Margaret and our life-long friend "Bo" Deas. These two will know just how much. To the people in the Natural History Museums (from the early days when Dr Reay Smithers encouraged me in practical ways) to the present when Museum staff go out of their way to help. And I find this same attitude among staff members of National Parks from the Rhodesian era to Zimbabwe and on to Natal Parks Board.

When you go for a long walk in the veld you come across an interesting tree, then a common butterfly and later some old friend of the tree-tops; a familiar bird that you have known since childhood. I think you will find some of them in these pages.

J.H. 1990

The Sunbirds

The nesting period of the sunbirds is a time of excitement and activity. An interesting partnership springs up, actuated by a compelling urge on the part of the birds to rear their brood.

The female gathers the nesting material, and she adopts a favourite route to and from the nest. It is as though she were following an invisible aerial pathway. When she has attached pieces of grass, entwined with spider web, to the support she then begins to fashion the scaffolding of the new nest. This consists of a sling-shaped structure that gradually takes on more and more material to form an untidy "O".

It is not yet a hollow ball, but she continues to thicken the sides and close up the back of the nest. She gets inside now and presses outwards with her wings to shape the hollow within. With wings pressing outwards she pins back material with her bill into a comfortable shape. This is fascinating to watch. The wings only partially open in the confined space – rather like a person pushing outwards with both elbows when making more room in tightly tucked blankets.

It might be inferred from this that all sunbirds use this technique when shaping their spherical nests from within. A veranda roof completes the nest and shields the occupant from raindrops, dew and sunrays. Some dried caterpillar dung is attached to the outside of the nest, no doubt in imitation of certain spider and caterpillar nests from which these accretions dangle.

While all this feminine activity has been going on, the male plays an important role in keeping guard in the vicinity. He calls to the female and keeps her company as she flies to the nearest food supply. At this time his aggressive behaviour and brilliant colour draw attention away from the female, which is precisely what is needed.

A small metallic-green and white cuckoo is now the bane of their lives. Its sad, sweet notes of "mei-het-jie" are the only indication of its presence in the tallest trees. You may see the Klaas's cuckoo being vigorously driven away by the male sunbird, and it would appear that his most important job is to keep the interloper from the nest.

It is obvious that the sunbirds are fully aware of the danger presented by the cuckoo and succeed often enough in getting rid of it. But if the cuckoo achieves its object they have a fatal inability to recognise the cuckoo's egg lying beside their own, and so they provide it with the warmth of life. When the cuckoo chick hatches it promptly ejects the sunbird's eggs or young. It knows!

Why the sunbirds can readily identify the mature cuckoo yet be unable to recognise the alien egg and chick is one of those anomalies that go on repeating themselves endlessly in the cycles of nature.

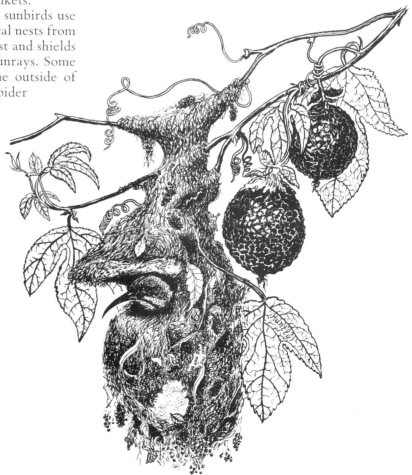

Violence in Nature

My thanks are due to Mrs Joyce Becks for a very rare photograph taken by her son on his farm in Zimbabwe of two Greater Kudu bulls locked in fatal combat. When he discovered them they lay exhausted with their tongues hanging out and with their left horns hopelessly tangled. He and his African workers tried in vain to part the kudu bulls, but in the end were reluctantly forced to put them down to prevent any more suffering.

Mrs Becks told me that her son measured the horns of the larger animal in the manner of Roland Ward (ie "along the seam" a sharp ridge running along the outer edge of the horn). It measured 53 old inches, which still make sense if you are an American or in your fifties. But that's a great Greater Kudu. In my old copy of Roberts's *Mammals of South Africa* he mentions one kudu from near the Kruger Park with horns of 54 inches.

Looking at the mess they had got themselves into one wonders whether they could have been saved, and I asked a friend who is an authority on such matters and whose life is professionally concerned with every aspect of the handling and conserving of big game. What he said was interesting: Unless the farmer could have darted the animals he could not have cut one of the horns to untangle them. Sawing through horn, even near the tip, could cause terrific stress or shock unless the beast were tranquilised by an expert game-capture professional. Cutting the horn approximately in the middle can in any case cause a great loss of blood; although he said he was pretty sure the animal would live and go about from then on with half a horn. However, Mr Becks had none of these sophisticated facilities within reach to save the animals, and so had to shoot them.

Apropos of all this my friend went on to describe how a game-capture team darted a buffalo, which moved its head just as the dart was being fired, so that the dart pierced the widest part of the buffalo horn. They were prepared to try again believing that they had "blown it". But before they could make another attempt the buffalo sank down and fell over. Those horns are full of blood, and the dart had quickly done its work.

He also told me of finding gemsbok bulls in such situations: inextricably locked together after a savage fight. Although their horns are straight they manage to pierce the neck of the antagonist in such a way that the horn gets wedged at its base against the base of the rival's horn. Nothing can part them, and the animals either die of thirst or are dispatched by Bushmen or the first big predator to find them. Although kudu bulls indulge in these savage fights between themselves they put up little defence when cornered by hunting dogs or encircled by tribesmen with spears. They make no "last stand" against their enemies like the sable, roan and gemsbok. No calculated revenge and ambush of his pursuer, as in the case of the wounded buffalo who tries and often succeeds in taking his human tormentor down with him to a bloody end.

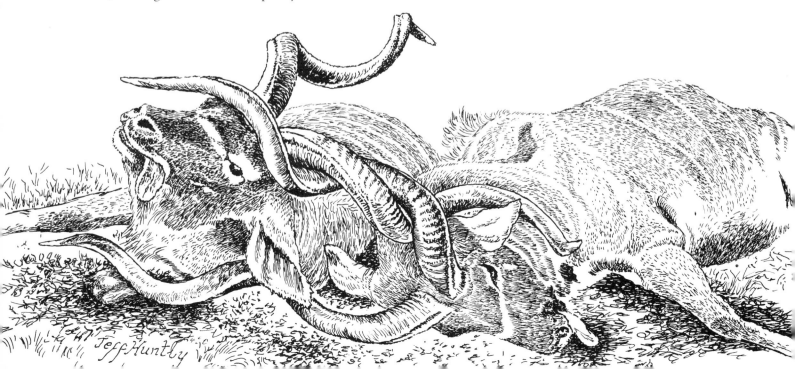

Baboon Spider

Although the baboon spider is of such bulk and armed with fangs not unlike those of an adder, it is – fortunately – unobtrusive, slow of movement and sedentary.

You may find its home near some footpath where the grass has been partly flattened or near a clearing where grass is short or eaten down by cattle.

Here the great female spider occupies a dark burrow sloping into the ground at the end of which there is a chamber.

This spherical room is not much wider than the tunnel, and it is comfortably furnished with silken web: the spider's wallpaper to provide insulation.

One nest examined was extremely damp: in fact the spider had elected to live near a muddy pond, and the nest chamber was always wet. However, the marvellous insulating properties of that gossamer lining enabled the animal to live in comfort. The soil was cleared and the nest exposed with a hoe. The spider remained motionless in the nest chamber while the digging progressed.

A large wide-mouthed jar was then placed over her and pushed steadily into the soft sandy earth, causing both spider and earth to move up into the jar. The lid was carefully slid into place, for now the giant became incensed at this outrageous breach of her privacy. She savagely attacked the fingers on the other side of the glass and woe betide those fingers if a careless move had been made with that lid.

I tried unsuccessfully to convince myself that a clear record of her fighting posture would justify my destruction of her home. She was placed in a white plastic bath for close observation of her movements.

When gently touched with a stick she reared up with forelegs and huge palps held high. The fangs became clearly visible against the white background of the bath, and their effect could be felt as she struck at the stick.

She was taken far away from the homestead and released in a spot where she would be left in peace.

Small children should be warned never to poke their fingers into dark holes for that is probably the one and only occasion on which the baboon spider will be aggressive. After all, when defending her babies it is a not unreasonable attitude!

Years ago my aunt, Mrs Constance Holmes, told me of an experience illustrating both the iron nerve of a pioneering lady and the pacific character of the baboon spider.

Lifting her glass of drinking water to her lips one night she felt the soft touch of hair against her mouth. She calmly returned the glass to its place on the bedside table and found her torch. In the torch-light she saw the spider, whose eye-cluster shone like a diamond as it clung to the tumbler. No doubt its hind legs gripped the rough plaster of the wall beside the glass while the forelegs gripped the rim.

When Mrs Holmes picked up the glass the spider came with it but remained quite still. Her sense of fair play bade her not to kill the spider, since it had not bitten her. She released it outside.

She laughed as she recalled that only after the event did she "allow herself to get a fright!"

Aerial Whirligigs

The eremomelas are members of that great family of *Sylviidae*, the warblers, although they themselves are happily unaware of it. Happiness and a great zest for life are qualities we may see in these little birds whenever they cross our path, so to speak. Three species of this interesting genus are found in northern Natal and the Transvaal, while several more eremomelas swell the number of species farther north in the rest of Africa.

The Green-capped Eremomela performs a curious aerial ritual that I once observed at close quarters. The significance of this "happening" baffles me, for it occurs after the breeding season, which seems to imply that it is not a case of males fighting one another over females or for territorial rights. It seems to be a case of zest for life periodically exploding into a mad game in which both males and females join. It goes like this: a party of eremomelas are busy in a large tree searching for tiny insects. Suddenly a playful mood seizes them and they chase one another through the branches, mounting into the air in a fluttering mass above the tree, snapping bills and keeping up a curious whirring sound peculiar to themselves.

Sometimes a smaller party breaks away from the main group and creates a separate aerial whirligig. Two of them fly at each other, buffeting wings and ascending into the air until exhausted, when they fall back into the tree for a rest – one pair I saw were so engrossed in one another that they fell into the grass under the tree, where they remained for about three minutes, apparently catching their breath and regaining their composure. The group I watched was composed of about sixteen individuals.

Eremomelas behave rather like the common and better known White-Eyes in that they go about in restless bands searching for minute insect life hidden among the leaves of trees. Because fresh young leaves sprout at the ends of branches and in turn attract aphids and other tiny insects, we find the eremomelas gravitating to these topmost places of the tree canopy. The muted colouring of the various eremomela species is perfectly blended with those of fresh young leaves: green, grey, brown and yellow, but all unobtrusive in-between colours, subtle, helping to conceal the birds from their enemies.

One species of eremomela – the Yellow-bellied Eremomela, seems to change habitats come breeding time. Normally its life is spent in the tree-tops, but it builds its beautiful little nest in the twigs of a sapling or young shrub so near to the ground that a small child could peer into the neat cup-shaped nest and see the pure white glossy eggs with their sprinkling of black dots. The nest is in such an exposed, unexpected place that it is invariably overlooked, which is exactly why the clever little birds build it there!

The Green-capped Eremomela, on the other hand, builds its nest quite high above ground hidden in leaf-clusters at the ends of thin branches and impossible to reach for that very reason. Also a very clever survival strategy on the part of these extremely interesting birds.

In the new revised edition of *Roberts' Birds of Southern Africa* by Professor Gordon Maclean we find recorded for the first time the amazing discovery that the Green-capped Eremomelas build the nest and feed the young co-operatively – that is, up to five birds share the job, which in almost all other bird species is done only by the pair concerned.

The Dusky Flycatcher

A pair of these charming little birds made their nest in a creeper against a brick wall just outside our kitchen window. Having the nest so close to our domestic activities allowed me to observe them often and at regular intervals. The creation of the nest – the actual building procedure – is fascinating to watch. Both birds participated and the delicate, rather elastic structure seemed to materialize out of thin air before our eyes as first one bird and then the other would add a strand of cobweb, a piece of fluff, a dry leaf or a thin springy leaf-rib. One particular item which they both favoured was a gossamer-thin skeletonised leaf. These transparent leaves were so fragile and ethereal that they appeared to be grey memories of leaves, ghost leaves being carried in the beaks of fairy birds. In fact the lace-like leaves seemed ideally suited to such frail little birdlings.

The nest snuggled between the wall and a natural hollow made by the curling stems of creeper leaves. It was well concealed by the bright green creeper leaves, robust glossy splashes of colour against the red bricks. The birds had a system of arrival and departure at the building site, each carrying an item to add to the nest and if they arrived at the same time one would politely wait for the other to finish his or her job. This job, by the way, consisted of jumping into the nest hollow – an open cup – and quite vigorously shuffling the body and pressing outwards with the wings thus helping to shape the structure. The piece of fluff or transparent dry leaf would be added to the sides of the nest or woven into the base.

Sometimes when one of the birds was sitting in the nest shuffling the nest-shape in the way I described, the other one would arrive with a new piece of fluff or more often a feather at this stage, for now the final touches were being added. The bird sitting in the nest would remain there and accept the feather from her mate and proceed to line the nest with it by tucking it in between her side and the brick wall.

At this point an amusing incident took place; a leaf on a springy stem kept getting in her way and she sat peering over the side of the nest. She grabbed it with her beak and forced it behind some other leaf-stems. She finished this job and was just settling down when the leaf suddenly swung back to its original position and landed across her face again. She pushed it away, let go and back it came again and again, thwarting her efforts. Eventually she changed her position and got the leaf properly tied into place into the rim of the nest.

Three eggs were laid and their colours seemed to be in keeping with their setting and with the sombre colouring of the birds. The egg-shells were a gentle shade of olive green with a faint suffusing of pale dots – so finely sprinkled as to look like smoke. All this nest building and egg-brooding took place in the middle of December at the height of the rainy season.

Dusky Flycatchers are found along the eastern parts of southern Africa – the high rainfall side of the continent. They are tame, sprightly and occasionally drink at a bird-bath.

Their dull grey colouring does not detract from their charm. Shades of grey!

Veld Fires

Part 1

After a bush fire you may find some curious survivors of the devastation, not all of them ugly or depressing. One of the most beautiful works of art I have ever seen was not painted on canvas but etched in powdery white ash on a pitch-black ground of burnt grass. It was the ash imprint of a burnt-out tree that had been lying on its side in dense dry grass. Evidently it was a species that, when bone dry, burnt entirely, leaving behind this delicate artistry. The entire outline of the tree lay spread out at my feet, transient proof that beauty can be found in unlikely places, free of charge. The imprint would soon be erased by the wind like chalk wiped from a blackboard. But soon other works of art would replace this rare one – common wild flowers. These living splashes of colour spring into being before the grass has time to recover.

Cabbage trees, when caught in a veld fire, behave quite differently from the tree of white ash. They burn brightly, at least their bark does, especially if they are situated in dense weedy growth such as may be found round the stony places that they sometimes prefer. I saw one of these trees overwhelmed by fire. Flames spreading up its stem and along two horizontal branches made it look like a fiery cross. The sap inside the stem, being of a different temperature from the burning exterior, caused expansion and contraction by turns, so that the tree writhed and jerked its arms.

The surrealist Salvador Dali might have translated its tortured motions into a burning octopus, a sequel to his burning giraffe. Many weeks after the fire the charred cabbage tree stood on the hillside, seemingly quite lifeless. But with the onset of the rains its grey-green foliage sprouted again.

In both the Karoo and Patagonia (so similar in many ways) there are small shrubs that burn with intensity when ignited. The Candlebush *Sarcocaulon patersonii* growing on the Plains of Camdeboo has a counterpart on the bleak grey wastes of Patagonia, where it is known to the gauchos as Escandalosa or the scandalous fire-bush. Like the candlebush it has pale yellowish flowers of the everlasting type, or "immortals" as they are sometimes called. Both have spines and prickly leaves.

Bush fires do not always consume everything in their path, for some plants and bushes have evolved ways of eluding the flames. They grow in rock fissures and cracks where the flames cannot reach them and are, incidentally, extremely vulnerable to fire. The two species of Firebush, one of which is found in South Africa, are examples of this type of development. The name Wilderbrandbos alludes to this. But the thick corky bark of the cabbage tree and the dense fibrous covering of the bobbejaansterts are also devices to protect the vulnerable interior from the effects of fire.

A Rewarding Interlude

At the approach of summer people often find young birds in their gardens seemingly abandoned by their parents after having fallen out of their nests. At the present time (early September) we have a pair of Olive Thrushes nesting in our garden. Their nest looks like a round heap of rubbish placed at the end of a branch quite high up. Two half-grown chicks fell from the nest and members of the family rescued them. They sat on their haunches and opened wide their orange-lined mouths whenever they were approached – even trustingly begging for food from the dog who casually sniffed at them but did not molest them.

We could not leave them on the ground, although both parents fed them there. Fortunately I had in my collection an abandoned Fiscal Shrike nest, so this was used as a substitute for their real one, which was inaccessible. The shrike nest was enlarged round its sides with straw mixed with fine fern strands to make a sort of rough basket to hold the youngsters. This was hurriedly placed in a densely matted shrub where twigs in abundance held the basket firmly in place. The youngsters were then placed in this makeshift new home, where they promptly snuggled down inside the bowl. The Fiscal Shrike's nest was excellent for this purpose, being stoutly made and about the same size as a thrush's nest.

We retired; and in due course the parents were on the scene with worms in their beaks looking for their chicks. At this point an interesting thing happened. The chicks began making a "food soliciting" call. This sound is a husky chittering, and obviously it triggered off great excitement in the parent birds. Still carrying their worms they looked, stopped to listen and scurried about agitatedly searching anxiously for the source of the calling. They soon hopped up into the dense twiggy shrub, following the sound of the chicks, and then discovered their precious youngsters in the substitute nest. They fed the chicks happily and dashed off for more food.

We were most interested to observe that these Olive Thrushes fed the chicks in our presence. So many species (the Fiscal Shrike especially) are very shy near the nest and will only approach it when convinced that no person is watching. Our Olive Thrushes had built their nest just above the back door of the house where people are constantly coming and going and where dogs walk about as well. It is possible that they sense the protection that they get from sympathetic birders in the house and also that predators keep away from human habitations? There are no domestic cats to frighten them either. The dogs do not harm them, so altogether they were on to a good thing. They are delightful birds and seem to be far tamer when attending to their chicks than when they are not breeding. At other times of the year they are wild and shy. Very similar to the more well-known Kurrichane Thrush.

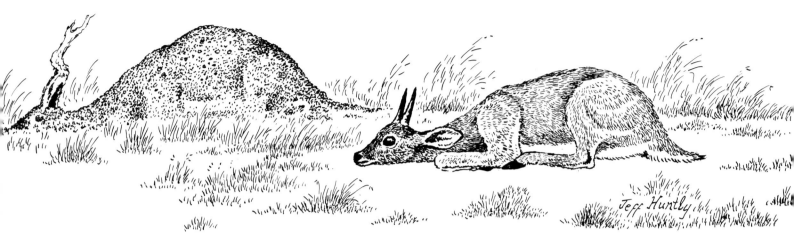

Wild animals are wise in their ways and survive in the proximity of man by employing cunning means of eluding detection.

Imagine yourself afoot in the veld with your dog. He races ahead of you, for he has caught the scent of a buck, and he courses about between bushes and grass clumps in his attempts to find it. Then you spot the buck standing quite motionless, staring at you at a distance of some fifty paces.

You watch him – a male steenbok – and realise that he is slowly crouching down and at the same time folding back his large white-lined ears. By now he is almost flat on the ground, his neck and chin laid flat and extended on the ground, ears held back and in line with the neck, which has the visual effect of breaking up the buck outline.

You are amazed when you see that your dog has meanwhile run past him twice but, because of the immobility of the buck, looking for all the world like a small antheap, the dog has missed him altogether.

In this instance of animal camouflage and skilful self-preservation we see in cameo form how wildlife manages to survive over the centuries, even in close proximity to man with his hunting dogs, his rifles and shotguns, wire snares and love of killing for sport.

In the case of the steenbok I watched the little drama through powerful binoculars and marvelled at how the buck "kept his cool"; for he was hiding between my dog and me. I called loudly to get the dog away from the vicinity, and we proceeded to walk in the opposite direction, now well away from the buck. My loud calling and whistling made no difference to the buck; he remained steadfastly immobile.

When I had got the dog well and truly off in a different direction, I made a stealthy return to the steenbok and discovered that he had risen to his feet and was staring at me with his huge ears extended, now forming the typical buck outline. He turned and bounded away and in a trice had vanished between bushes and grass, but leaving behind him an appreciative human observer, once again delighted to witness another aspect of the canny methods of our wild fellow-creatures.

Warthog

It is said that comparisons are odious; but they can be interesting when two animals are placed side by side, figuratively.

One of the best known animals to the most casual observer in any game park is that comical pig the warthog. Yet one of the least known animals to the most careful observer in any game park is also a pig: the nocturnal bushpig.

Warthogs live out their lives in bright daylight, nearly always in the open bare areas round water-holes, and they have become familiar animals, particularly in the Kruger National Park. Warthogs are clean in their feeding habits, and their diet consists mainly of succulent roots and tubers, green grass, melons and the like. To dig these out of the ground the warthog has developed the habit of kneeling down on its forelegs and rooting with its snout – the upper edge of which acts as a trowel. The drawing shows the typical position at feeding time.

The warthog's nocturnal counterpart, the bushpig, is not a clean feeder; it will devour any abhorrent rubbish, including carrion, along with green food, particularly mealies when these are available. In temperament, too, the warthog differs from his moonlighting congener, being less aggressive than the bushpig. Despite formidable tusks the warthog is a mild creature compared with the savage bushpig, which has also a highly-developed degree of cunning, perhaps as a result of constant warfare with farmers whose mealie-fields are raided by night.

Recently I was astonished to see a large warthog boar running across a cattle paddock near a built-up area near some farms. There he was, far from any game reserve and surrounded in every direction by his enemy and his works, roads, fences, wire snares, strange noises and all manner of things frightening to a wild warthog. He had just crossed a busy road during a lull in the traffic and had not been seen by anyone. There was something sad about his comical yet brave demeanor as he hurried along with tail erect. How far had he travelled, and would he find a safe haven if he kept moving south? I watched him for as long as I could with the glasses and saw him slip under a barbed-wire fence, to be enveloped by the protecting leaves and grass of his beloved bushveld, as if the bush closed her arms round one of her own and led him on to safety.

Perhaps in a far-off millennium mankind will earn the last part of his title by his kindness to those other beings with whom he shares this planet.

Meanwhile his outlook is typified by the humiliating flight of an old warthog in a hostile world.

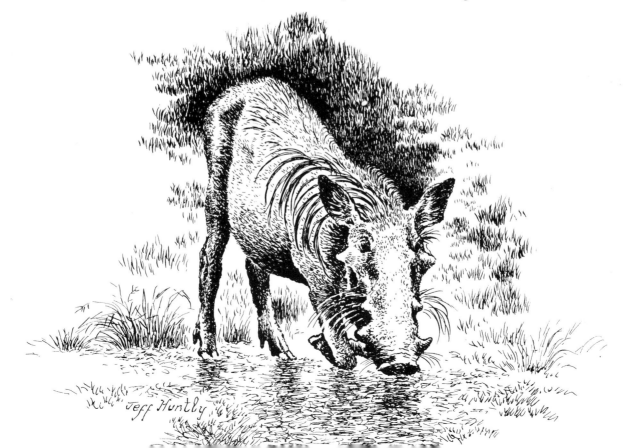

Jeff Huntly

Some Tree Snakes

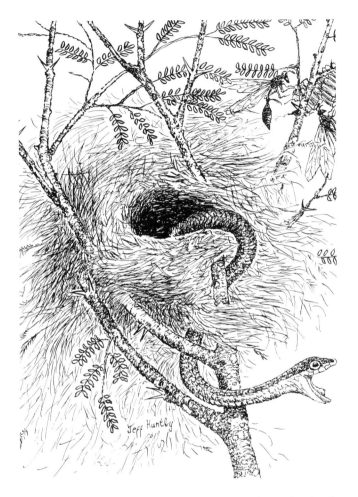

If you have lived on a farm, camped in the bush or spent time in a game reserve you must have heard or seen a mixed flock of birds mobbing some enemy hidden in a tree. If this happens to be an owl or hawk it will soon reveal itself by flying away at your approach. But if upon arrival at the scene of the commotion you can see nothing at all and the birds have become quiet it usually means that they have been mobbing a snake. No matter how carefully you may peer into the tree above your head you will probably look in vain, for the snake remains immobile, relying upon its cryptic markings for complete concealment.

In most cases snakes found up trees turn out to be the *Boomslang*; and this snake probably more than any other arboreal species accounts for so many young birds and eggs. Hence the bitter enmity between birds and tree snakes.

The ornithologist and bird photographer Peter Ginn wrote to me about a fracas between a *Boomslang* and a crowd of mobbing birds that he witnessed from one of his bird hides. The snake had been mobbed for a long time and appeared to be angry, for it lashed out at the birds in futile and frustrated attempts to catch them in its mouth. Half of its body stuck out above the treetop as it lunged at the birds. They merely dodged out of its reach and kept up their molestation. The snake was at the top of a tree and it eventually slithered down a drooping branch and escaped into some bushes.

Birds that typically mob snakes in this fashion are bulbuls, weavers, white-eyes, drongoes, Apalis Warblers, mousebirds and occasionally Bru Bru Shrikes.

The Rubber Hedge Euphorbia (S.A. No.355) seems to exert some potent attraction on snakes. In two separate places in South Africa and Zimbabwe I have often been called to rubber hedges by mobbing birds with their snake victim coiled among the smooth rubbery branches of the bushes. Sometimes the rubber hedges are very old, virtually trees, and then the snakes can be seen easily etched against the sky overhead. Perhaps because the rubber hedge is repellent to man and beast it offers a safe haven to snakes. At all events I have experienced more snake adventures in rubber hedges than in all other places put together. This Euphorbia was named in 1753 by Carl Linnaeus: *Euphorbia tirucalli*.

As a child I went to a boarding school in a rural setting; the veld was near at hand and many of us collected birds' eggs - an activity now rightly strictly prohibited. The hobby introduced us at an early age to several arboreal species of snake whose main interest was also birds, their eggs and particularly their fledgelings. If a record had been kept over the years of schoolboy encounters with snakes it would have been of value to me now. Although we believed that several snake species were involved it was likely that the *Boomslang* was observed in different colour phases – brown and a green variety. The Variegated Bush Snake and the strange and sinister Vine Snake were other snakes found in trees. The latter species, however, was more interested in tree-climbing geckoes and chameleons and favoured dry trees and rough grey branches. This is one of the most amazing of all snakes: it can imitate a dry twig to perfection to escape detection. It even sways in the breeze in time with real twigs. It is found from Natal to the Zambezi. Another technique of the Vine Snake is to remain dead still while twitching its bright red tongue. This action is thought to be a lure to geckoes, tree frogs and other prey, bringing them near enough to be siezed.

The Common Striped Skink

The Striped Skink is the reptilian counterpart of the housefly in many parts of Africa. It is found in farm buildings to which it has gravitated from the surrounding veld, and in the smaller towns it is found in greater numbers on buildings in the outskirts of town near the veld. Old farmhouses often have a skylight in the roof, and insects, being attracted to light, get caught inside these structures. Here one may find the Striped Skink taking up permanent residence near the convenient food supply, for he is dependent upon insects. In such a situation the athletic domestic affairs of lizards can be observed from below. They often fight each other – presumably rival males. These fights are quite fierce, with the contestants circling one another like snarling dogs before coming to grips. Sometimes one may witness a mad chase along guttering, or slithering down corrugated iron roofs, to fall with a thud on the ground below.

In some districts where rainwater is collected in large tanks at the corners of buildings the lizards foul the water, either with their droppings or dead bodies.

I witnessed an interesting episode between some bees and these lizards when the bees got themselves shut up in a farmhouse skylight. Whenever a bee landed on the sloping transparent floor of the skylight a skink pounced on it and devoured it. Grabbing the bee in its jaws, the skink banged it against the floor several times before swallowing it.

I was amazed that these lizards could catch and eat bees with impunity, but even more surprised to find them biting into tubes of artist's oil-paint and eating the stuff! Some tubes of oil colours were found to have the wedge-shaped bite marks of these lizards, and one tube had a quarter of its contents eaten. Pieces of thin metal tube had been spat out. The colour was Burnt Green Earth, and the people at Talens' famous old pigment works in Holland must have mixed some binding agent into their paint that was attractive to lizards.

Foam rubber seems also to attract these lizards, who bite into it, leaving the characteristic imprint of their jaws.

One may occasionally see a Striped Skink out in the veld far from its familiar surroundings of walls and roofs. In the bush it somehow looks different, as when a person one knows well is seen out of context unexpectedly.

It seems that the Striped Skink gains great advantages by living in human habitations. Their natural predators avoid the proximity of people, thus enabling the lizard colony in a farmhouse to multiply. Out in the veld proper their enemies include the Lizard Buzzard and other predatory birds, snakes, mongooses, weasels, civets, servals, foxes and genets.

The scientific name is *Mabuya striata*, first described from Mozambique by Peters in 1844 and later found to have a widespread habitat tolerance in Africa.

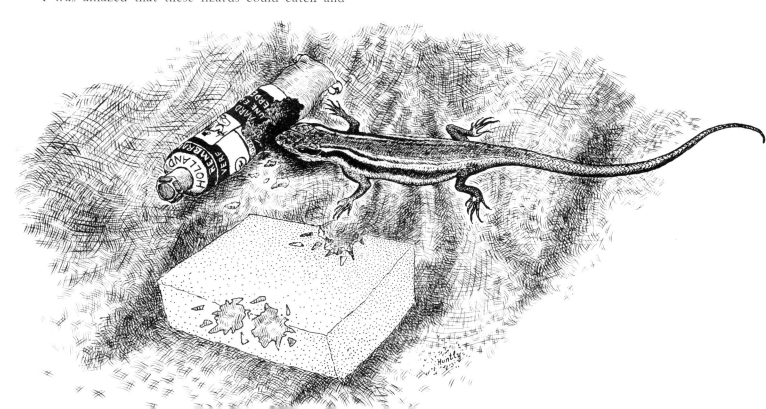

Elephant Shrews

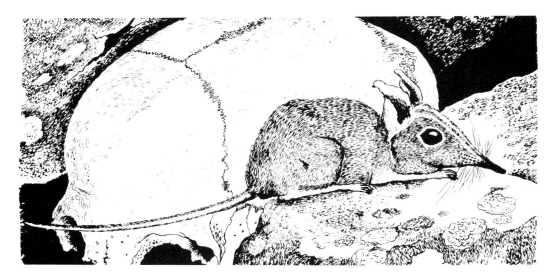

Elephant Shrews in their various forms are found in places suited to them in many parts of Africa. Rock outcrops and dykes with some scrub or tree cover are the ideal habitat, and it is not difficult to find them if their ways are understood. A rocky outcrop in some isolation should be searched for signs. If small dark droppings containing metallic beetle-wing cases and other insect fragments are found at the bases of the rocks, then almost certainly it will mean that Elephant Shrews are in residence. Another sign that will clinch the matter is the presence of runways winding through the grass at the base of the rock-pile. But Elephant Shrew runways are unlike those made by fieldmice. Because they bound along like miniature kangaroos their pathways have regularly spaced patches on their surfaces. A similar effect can be seen on a tarmac road wherever a rise in the surface causes the tyres to press harder on that place, leaving a dark worn patch.

Having established the presence of these animals in your rock pile, sit down among the boulders and remain perfectly still. The photographer may find this method very rewarding. Presently the Elephant Shrews will emerge, for they are not given to hiding for long periods. They will have whisked inside the rock crevices at your approach, but soon their restlessness will drive them out again.

Elephant Shrews bring forth their young at the beginning of the warm season. I saw a tiny babe hopping about in front of the entrance to his cave in the month of September. The little thing was making his first tentative explorations round the rock fortress and displayed all the mannerisms of the very young: unsure and wobbly footsteps, joyful romping and earnest peering about, trying to comprehend the boulders, twisting treetrunks and golden dry leaves, which formed the immediate surroundings of his home.

The life-drawing conveys their most typical attitude when sunbathing. They seek a patch of sunlight shining through the leaves overhanging their rocky domain. As the ray concentrates, so the animal flattens itself with obvious pleasure to soak up the warmth. But the vast orb of the earth keeps rolling, and soon the patch of sun has moved, leaving the little sunbather behind. He snaps to attentiveness and moves to one side to get back into that splash of warmth.

Sometimes the rock fortresses are ancient burial sites long since crumbled into ruin by the elements. Bones and pottery of a bygone era lie scattered about or are caught in clefts between the rocks. Bushman paintings, clay swallows' nests and dassies are other things that I associate with the elephant shrews, for they are often found together.

The movements of these creatures are very abrupt, and their bodies seem to twitch constantly, with birdlike movements. They flip on to their sides and roll rather as a dog might do, then suddenly flip right way up again to bound off like a brown tennis ball from boulder to boulder.

One's first glimpse of the tongue is surprising. It is very large for the size of the animal and makes a brief appearance when it shoots out beyond the snout, like a glittering arrow. The snout may be raised or lowered like an index finger – turned upwards when eating and downwards for smelling and sniffing for insects. They rap the ground with their hind legs as a signal of danger – a habit they share with rabbits and hares.

Deceptive Serpents

The drawing illustrates a principle of the art of deception, the ability of the Southern Vine Snake to look like a twig. The Afrikaans name of *Voëlslang* is more descriptive and accurate, for this clever serpent is the terror of small birds. Birds' eggs and nestlings, chameleons and geckoes all appear on his menu.

This curious snake must be highly intelligent, or else it acts out instincts that have a certain genius about them or so it seems.

For example, when it has to cross open ground to reach a distant group of bushes or copse of trees, it has a cunning trick if it thinks it has been detected. It will freeze into the shape of a broken stick; the mimicry of a stick with a realistic right-angled kink in it is extraordinary. The snake seems to "know" that its normal curved outline like the letter "S" is not suitable. So the broken stick act is used, and if it is done in a place where a few real sticks are lying about then the deception is entirely infallible. But as though this were not enough, it also acts dead if you push its body to one side with a stick. Its body will adopt the shape that it has been pushed into by your stick or the toe of your boot. The snake then looks like the letter "V". And it stays like that until it feels safe again. But it won't budge as long as it knows that you are watching it, and its patience will outlast yours. The drawing shows its keyhole-shaped pupil, which some believe is a device that enables the snake to see its prey better.

If you find a weaver bird's nest hanging from the drooping ends of willow-tree fronds, you may observe how the birds strip away all the leaves near the nest. If there is a colony of weavers they will strip most of the leaves from that half of the tree that bears the nests. This is done to discourage the attentions of the *Voëlslang* and the *Boomslang*. The clever birds strip away cover that might otherwise conceal the snakes. The stratagem doesn't always work, for one may sometimes find snakes inside nests – but it is a deterrent to arboreal snakes generally.

Most tribes and nations have some snake legend in their history, and I should dearly like to know the story behind a certain Bushman painting of a giant snake in the Fort Victoria district of Zimbabwe. It adorns a rock face in Gulubahwe Cave, and it is fifteen metres long. On the snake's back there are a number of human figures, perhaps as many as thirty, for some are faded or flaked away to almost nothing and so cannot be easily counted. Are these ghostly figures going for a joy-ride or being sinuously borne along by the giant serpent to their doom? The Drakensberg rock paintings may outlast those in African countries to the north because the colours are deeply embedded in the more porous rock faces. The Zimbabwean paintings were made on granite, hard as iron and not allowing pigments to sink into the surface. But the secret of the pale serpent and its ghostly riders is locked up for ever with the passing of the Bushmen.

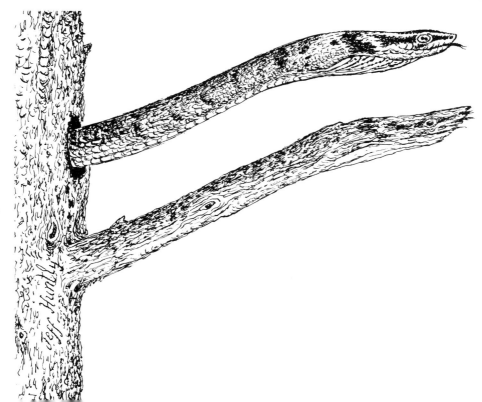

Red-billed Quelea

These avian counterparts of locusts swarm in certain parts of Africa to wipe out crops of rice and millet. Sometimes when aloft they can look like a fast-moving ball of smoke. They mass in that way for mutual protection against hawks. A bird of prey knows better than to dive into a flock of quelea for he would break a wing or his neck hitting such a mass of bodies. Rather he selects stragglers for a meal. A falcon's headlong swoop for his breakfast.

There seem to be two kinds of population in the queleas. One in which small numbers may be seen joining flocks of bishop and widow birds feeding on grass seeds. In this situation they nest in a half-hearted way – by that I mean they build a dozen nests or so and then before making proper use of them they leave that district abandoning the unused nests. They share this habit with Spotted-backed Weavers, which will suddenly abandon a tree full of half-completed nests.

The other type of population is when the queleas feel that everything is just right for them to breed. The right amount of solitude, absence of interference by man, abundance of food and water and so on. Then they festoon the branches of thorny bushes with their small round nests. These breeding colonies can be so extensive as to attract the attention of many predators, which take the chicks. Leguaans, mongooses, jackals, hyenas and even leopards are recorded as visiting these sites to feed on the chicks. Tribesmen finding a colony harvest sackfuls of young birds, which are skewered on wire and roasted over the coals.

Over many centuries these little birds have destroyed entire crops of grain and in some areas are regarded with dread. Ripening crops were guarded by children beating drums to scare the birds away and in rural areas little live scarecrows still guard the crops.

Modern methods of control rely on aerial spraying of the sleeping-quarters of the flocks, usually in reed-beds. In Zimbabwe an efficient method has been worked out to keep the numbers of quelea in check. Without aerial spraying a big flock is quite as devastating as a plague of locusts.

My only experience with a large flock was in a millet field. Knowing of their approach I lay on my back hidden by the dense green stems and leaf blades. After a long time I began to hear the collective sound of thousands of little beaks cracking seeds. A strange sound, unlike anything one might have heard before, recalling a huge orchestra making sighing noises from a distance but breaking up into individual raspings or stridulations as it got nearer. A blend of countless thousands of soft clickings, rustlings and crackles, like piles of dry leaves moving in a wind. The sound came in waves alternately loud and soft.

Some of these birds spied the human form on its back and, with a muffled boom like thunder, the flock rose into the air.

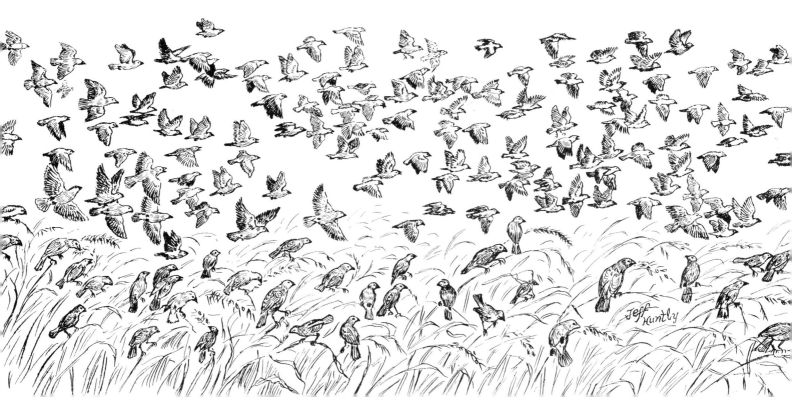

Roan

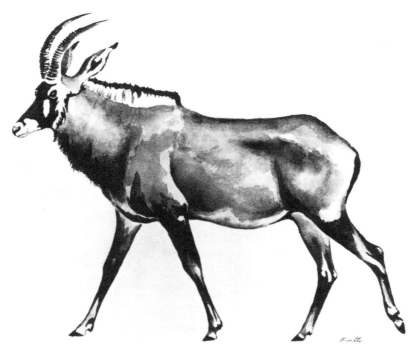

Although such a courageous fighter and able to fend so well for itself against great odds, the roan is sensitive to drought and to advancing "civilisation" and the presence of man. Its need for solitude makes it more vulnerable to final extinction in many of its former haunts than the more adaptable kudu.

Unless expertly handled by experienced game-capture teams it easily suffers from stress and shock. This is true of adult wild animals not accustomed to man, their arch enemy since the dawn of time. (At least since some man-like creature first set eyes on a roan and stalked it.)

Roan, like kudu, have a mirage quality – a wonderful ability to vanish into their background simply by standing still. Now you see it, now you don't.

I recall a certain spot in the Wankie Game Reserve, as it was called in those days, where I could always find roan. It was quite a trek from Main Camp, but I returned to it day after day and was nearly always rewarded by at least a glimpse of them passing like shadows under the trees or disappearing into the universal Jesse bush so prevalent in that part of the park.

On one occasion I was motoring outside the boundary of the park near the station of Dett when a juvenile roan tried to cross the road in front of my car. This youngster had taken fright, running parallel to the road and then veering towards the car in an attempt to cross the road in front of it.

Its mother, which I had not seen until that moment, raced in front of the calf and kicked backwards, hind legs high in the air. This had the immediate effect of turning the calf away from danger, and it cantered off to safety in the opposite direction.

Aesthetically roan, sable, kudu, gemsbok and nyala vie with one another as the most handsome of all hoofed animals. The roan has a subtle quicksilver quality that distinguishes him from his near kinsman the sable. He is longer in the leg, giving more of an impression of a proud stallion sauntering along surrounded by his retinue of females. Even when having to retreat from the presence of man he still manages to do so with a distinct impression of haughty contempt for the ape-like predator with its guns and gadgetry.

Looking back in time we see the grim life of the roan at the hand of man. It can be summed up by a sepia painting by Millais, in *A Breath from the Veldt*. In this picture a small herd of roan antelope are being chased by men on horseback. The antelope gallop exhausted, nostrils flared, mouths agape for breath and eyes filled with fear. Sportsmen's fun.

The future holds even less hope for the roan in his wild state. The ever-increasing human population in need of more and more land and the roan's vulnerability to such competition will ensure grim days ahead for it. Perhaps the survival of the roan will depend upon its very wide distribution in Africa. That may ensure its continuance in one area if and when it becomes extinct in another.

Crowned Plover

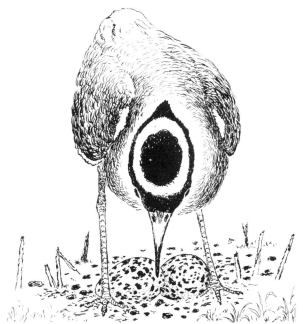

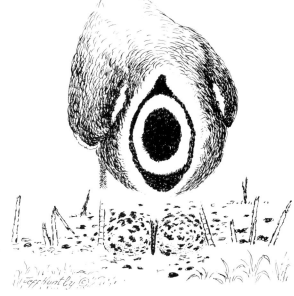

The Crowned Plover, aptly named *Vanellus coronatus*, sits on her eggs in an open field frequented by sheep. She must be a South African. Another Crowned Plover sits on her eggs in a vast open plane frequented by Thompson's Gazelles (or "Tommies" as Ernest Hemingway called them). She must be a Kenyan. Both north and south of the Equator, Crowned Plovers keep grazing animals, whether domestic or wild, away from their eggs by shooing them off. Their method consists in a sudden flashing open of black and white wings – usually enough to startle the animal from its grass-munching reverie. This display also includes a curious head-bobbing motion, as shown in the drawing. The crown of the head is black circled in white then another circle of black. Seen "front-on" it presents a weird gaping mouth with two white "eyes". These "eyes" in reality are two patches of white feathers just visible at the shoulders or wing joints of the plover.

In the drawing on the left we see a Crowned Plover crouching over her two eggs. In the drawing on the right we see through the eyes of a sheep. Outlines are gone and markings of eggs blend with light and dark mottlings of the earth. The bird's eggs become pieces of dry grass stubble, the tip of the beak a piece of charred grass stem, like the others near by. What remains is a black-ringed mouth that changes shape when the bird lifts her beak and the mouth seems to half-close. Then it opens wide again as she points her beak straight downwards. Most disturbing and strange. The grazing animal shies off and crops grass elsewhere.

These protective tactics apply to plovers with eggs. After the eggs have hatched a quite different strategy is used. It is a trick practised by several different ground-frequenting birds: the well-known "broken wing" act. If a person or a dog or some other enemy of birds unwittingly approach the two little plover chicks hiding sometimes quite far apart in the field, the parent bird will flop one wing down and drag itself along, leading the enemy away from the locality of the chick. The enemy is usually deceived by this ruse and the chicks escape detection.

A mother francolin loses all fear of man when she has chicks near at hand. My young daughter was able to catch a mother francolin in some dense grass when the bird repeatedly rushed at her feet in an attempt to drive her away from some little chicks hiding in different places in a large area of tussocky grass. The francolin was duly returned to her chicks, which by now were piping away rather as guinea-fowl chicks do in such circumstances.

Plover, courser, dikkop and many other ground birds' chicks seem to hatch in a running position. Scarcely have the pieces of eggshell fallen off the newly hatched chicks than they are scampering off to hide in separate places, thus increasing the chances of at least one of them escaping detection by their many enemies, both aloft and on the ground.

The Nyala

Some wildlife enthusiasts consider this fine antelope the most handsome buck of all. A fully grown nyala bull combines grace of outline with colour harmony and an impression of latent power. Its grey coat is pencilled with thin white lines as though some tailor had deftly drawn them with his chalk to break up the outline. Other splashes of white, together with a small amount of black and the curious orange coloured legs, make up a picture of quiet elegance as the buck steps majestically through the dappled sunlight of its domain.

This domain of the nyala must consist of lowveld "deciduous thicket" or riverine forest and dense leafy cover. Its range consequently includes only such portions of Africa as provide these conditions: the species was first described in 1849 from a specimen obtained at St Lucia Bay, Zululand. The north-eastern Transvaal, Mozambique, south-eastern Zimbabwe and southern Malawi harbour the nyala, and its future will depend directly upon the sanity of whatever governments happen to control these areas in the years to come.

In the case of southern Malawi the nyala was hunted to near extinction in the 1960's and if it had not been for the untiring efforts of Mr G.D. Hayes to win support for the establishment of a park for its protection it would certainly have vanished. G.D. Hayes, one of the founding members of the National Fauna Preservation Society of Malawi, saw his dream realised when President Banda ably supported his efforts in 1964 by ordering a borehole watering place for the nyala in the Lengwe deciduous thicket country. Lengwe and Kasungu were gazetted as National Parks in 1970. Dr Banda's action at that critical point in time was like a pivot about which the future of the nyala changed its direction from the precipice of extinction in Malawi. The borehole and pump provided water all the year round for the nyala and enabled them to remain in the more protected environment of Lengwe, not needing to wander far afield in search of water.

The story of G.D. Hayes illustrates how much good can result from inspired effort and from enlightened leaders giving their support. But how quickly Nature responds to these efforts to preserve the species! The nyala is again holding its own, at least as long as poachers can be held at bay in that part of its range.

In the mountains of Ethiopia running parallel to the Great Rift Valley the Mountain Nyala still survives but wars and rumours of war, drought, famine and political upheaval make the preservation of wildlife increasingly hazardous. The status of rare animals reflects man's activities – in fact their existence is an extension of man's self-government or absence of it.

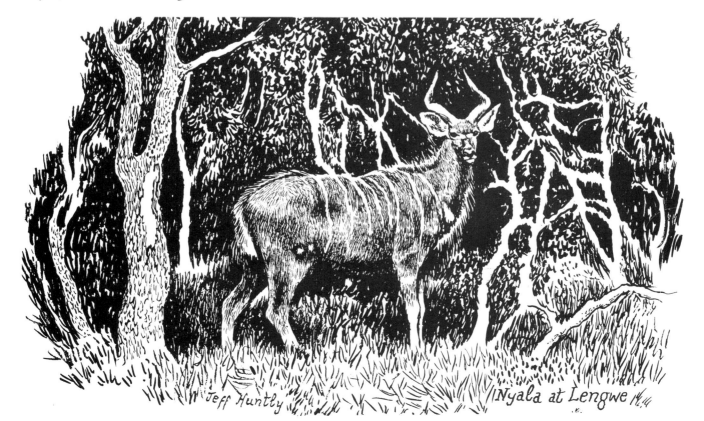

Jeff Huntly Nyala at Lengwe

A Moth's Intuition

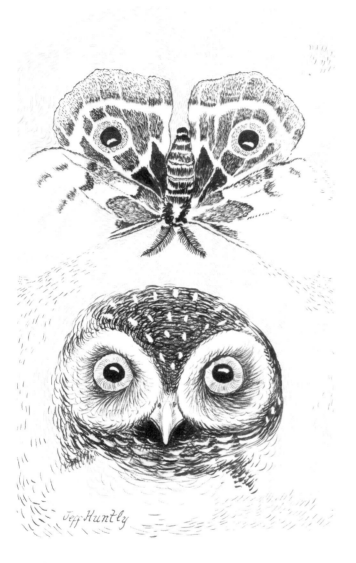

Jeff Huntly

The Emperor Moth *Imbrasia macrothyris*, named by Baron Rothschild in 1906 – like many other Emperors found in this country – offers much material for speculation. The markings on its wings are wonderfully adapted for its individual protection and for the preservation of the genus as a whole. Its behaviour when under stress, or when threatened by its natural enemies, indicates a great intuition or awareness of how to exploit the fears of its enemies. But when it encounters the simplest man-made device, such as a window, an electric light, or a wire screen, it is hopelessly nonplussed. The obvious intelligence that had protected it before and been its guide through all the perils of the veld and jungle, suddenly leaves it in the presence of man, and the moth flies madly round a light as though held by steel wires. This pathetic prisoner of light can only be set free from its bonds by someone compassionately turning off the light and thereby cutting those imaginary wires.

The world of nature should always be viewed with an open mind, and before jumping to conclusions it is wise to prefix a statement with words like "perhaps". If we make a bold assertion such as: "moths have no intelligence" we run into trouble and find that such a statement is full of arrogance. But let us be arrogant for a while and see where that leads us with regard to the Emperor Moths: "An Emperor Moth obviously knows nothing about the owl's eyes or a cat's face. How can it?" Well then, if it knows nothing about the creatures that it imitates then whose brushwork has painted the owl's eyes on those wings, even to include the white reflection of light seen in all living eyes? Does it end there? With wing patterns? By no means. The moth *Lobobunaea ammon* can imitate the quick lunges of the larger predators to petrify the smaller ones that threaten it. When under stress this moth jumps forward in a series of bumping nose-dives so that the huge "eyes" are tilted into full view. Seen from ground-predator level, the eyes would appear to lunge forward menacingly towards the enemy whether it were a bird, a toad, a rodent or a monkey. Suddenly presented with a pair of bloodshot eyes hurtling towards it, the predator might be excused for being put off its stroke or routed altogether. This temporary confusion is all that the moth needs to make good its escape.

But then, according to Arrogance, the moth is quite unaware of the markings on its wings and even more ignorant of the secret fears of birds and rodents that dread the baleful glance of an owl. So the moth's wings act of their own accord? Or do they obey the mind of the moth? And if the moth has no knowledge of birds and beasts, then whose intelligent fingers are pulling the strings to its advantage? Perhaps the same infinite fingers that "bind the sweet influences of Pleiades or loose the bands of Orion" and control the universe. How little we know.

Monkeys, Tree Frogs and Lengwe

At a slimy green water hole in a Malawian game reserve I made an unusual observation concerning Samango Monkeys and tree frogs. At the time I considered that my long wait in the sweltering heat had been amply rewarded and I was later told by the eminent authority on African reptiles, Dr Donald Broadley, that the incident may well have been unrecorded before.

A Samango Monkey was observed holding a large wad of "candy floss" and periodically dipping it into the water and then eating it. Other large wads of "floss" hung from branches overhanging the water, and these strange objects, Dr Broadley told me, were the froth nests of the Large Grey Tree Frog known to scientists as *Chiromantis xerampelina*.

The frog has an extensive range in lowveld areas of southern and central Africa, and its domestic life is remarkable. The nest is made from froth issuing from the female's body when she is laying her eggs. The male and female jointly take part in the strange activity of beating this fluid into a frothy substance by using their hind legs like an egg beater! Exposed to the sun and wind, the mass of foam hardens on its outer surface like a meringue. Inside this nest are the eggs, or, in process of time, half-developed tadpoles which the Samango Monkey makes into a protein-rich meal. My Samango ran off with a second nest and disappeared into the trees with it, presumably to share it with his mate.

The drawing shows the monkey dipping the nest into the water before eating the contents. This dunking was evidently to soften the hard outer skin of the nest. Yet another marvel in the complex mosaic of Nature.

The game reserve was the Lengwe National Park, and a few brief impressions may be of interest to those who have not been there, or who wish to visit African wilderness areas.

The immediate impression one gets upon entering the gate and driving through the northern area of the park is that it is untouched and that animals are plentiful and easy to observe.

Because of the nature of the vegetation (and this is true of the whole of the northern part of the park) one has a sense of being closed in by trees and thicket and expecting that the winding road will reveal a surprise round the next bend. It often does: such as a family group of warthog wallowing in a mud pool left by the rain in the middle of the road. There are bushbuck, particularly along Mbawala Drive, nyala, the tiny Livingstone's Suni crouching in the tangles and thickets on termite mounds and troops of baboon perpetually frowning at human visitors. I got my first glimpse of a Narina Trogon there.

Along the north thicket drive buffalo may be seen and if the visitor chooses the winter and dry months to tour Lengwe, he may travel much farther afield without danger of being bogged down.

Primarily Lengwe was born of the urgent need to save the nyala, which had been hunted almost to extinction in southern Malawi. Now this magnificent animal is once again well established and by far the main attraction of Lengwe. The great charm of this place is its solitude and silence, a place to commune with Nature far from the tyranny of traffic, deadlines, schedules and the pursuit of the money mirage.

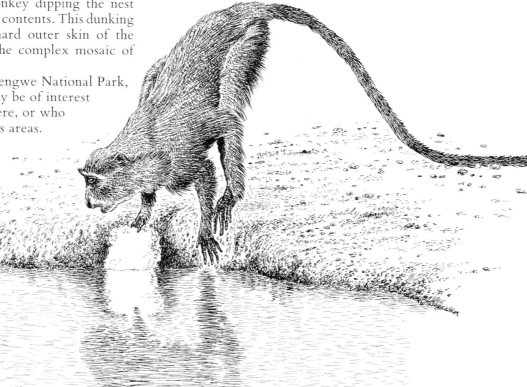

Banded Mongoose

For sheer ferocity these little predators have few equals. The species moves about in restless bands, sometimes moving close together like a rugby scrum with striped jerseys and a desire to push forwards. When suddenly confronted by an open space, such as a road that they have to cross, they hesitate, those in front hanging back partly sheltered by grass while those in the rear of the party push rudely forwards, causing peevish irritation and curling of lips to show fangs. They dash over the road, sensing their exposure and making it as short as possible.

Like the Dwarf Mongoose, the Banded moves in groups, but it is more of a wanderer than the Dwarf.

rambling farmhouse that we visited when my daughter was a little girl. The pet mongoose that belonged to a lady guest in the house was a general favourite, but it came into our room through an open window and bit the child as she lay reading a book.

Pet or semi-wild monkeys are also dangerous and unpredictable creatures. I recall another experience involving my daughter when we visited a game lodge. Several monkeys clambered over us and one fouled my clothing. None too pleased at this I took out a handkerchief and tried to shoo them away. That annoyed them, and one jumped on my daughter's chest, holding her by her shoulders and shoving its face into

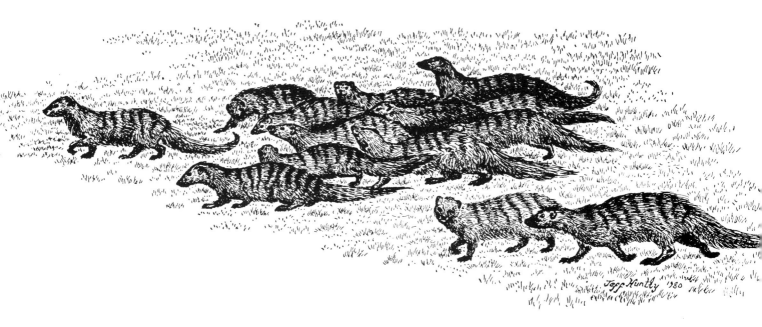

Ground-nesting birds, eggs and chicks, baby animals such as hares and every kind of insect, rodents, snails and various reptiles form its diet. Although playful when the mood takes them, they remain so with their own kind only. Like nearly all wild animals they make dubious pets and they can be a danger to children who try to touch them. For that reason they should not be kept in a household. Certain people have a natural rapport with animals and can handle them with ease and seldom be bitten. But as this quality is not universal it is always dangerous to take liberties with animals.

A Banded Mongoose had the freedom of a large

hers. She remained perfectly still and the monkey jumped off her! It had not bitten her, and I was astounded at her presence of mind in keeping still. If she had instinctively struggled or screamed it would have bitten her. Fortunately the owner of the establishment saw the whole incident, and the monkeys were removed before any other children came. A pair of mongooses was also removed.

Seen en masse mongooses can present a strange sight, like a furry carpet moving along of its own accord. Up to forty may sometimes make up this twitching carpet of bodies, but the bands usually number about a dozen to twenty.

The Mix

The genuine African Wild Cat is becoming more difficult to find in its original form, with the advancement and opening up of formerly wild areas by man. Where man goes so do his domestic animals – including his cats. The African Wild Cat freely interbreeds with the domestic cat, resulting in all kinds of hybrids, and these hybrids are fertile. Here is a species not so much threatened with extinction by being hunted, trapped or poisoned (which it is), but by the fact that it is steadily being watered down by domestic cat input.

In the distant future the 100 per cent pure African Wild Cat will be a thing of the past, as man invades the last of the wilderness areas and brings with him his domestic cat. Even if an area is proclaimed a wildlife refuge it is impossible to prevent feral domestic cats from entering the refuge and breeding with the remaining genuine wild cats.

The cat in the illustration is a blend, a hybrid, of the ancient African Wild Cat and the invading modern domestic cat. It was found as a kitten out in the veld in a hole in the ground by Mr and Mrs A.S. Gooch of Sutton Farm in Richmond, Natal. The starving, emaciated kitten was skilfully fed and lovingly brought back to life by the Gooch family.

The little creature appeared to have been abandoned to die in the hole or, more likely, the mother cat had been killed. The kitten at this stage was black but as she grew her coat developed the variegated stripes, spots and subtle colouring of the wild-cat x domestic blend. In fact she had a great deal of the wild characteristics about her: the ginger reddish colour behind the ears and the soft orange fur on the stomach plus the typical heavy stripes on the legs and black markings behind the feet.

However, the legs were too short for a genuine wild cat, and the walking gait was consequently not that of the true model. Both Astley

Maberly and Dr Reay Smithers in their authoritative books on African mammals refer to the longer legs and gait of the genuine wild cat – and that interbreeding with the domestic cat causes the loss of the longer legs. The voice of the true wild cat is deeper and more savage than its man-made counterpart. Also, the wild cat is a bigger and altogether heavier creature in keeping with its need to survive in the wild.

It was interesting to see the Gooch's hybrid and its relationship with their lively Siamese cat. Apart from the striking difference in colour and general physical appearance, it was their characters which were in such obvious contrast. The Siamese was beautiful, lazy and self-satisfied in the true Garfield manner. The hybrid was constantly active, mentally alert and intensely interested in everything around her. She stalked a wily crow stealing dog food, she took an unhealthy interest in the parrot, she took on Mr. Gooch in a mock fight, she wriggled and fought to be free if picked up, she shadow-boxed anything that bounced or rolled. All in all an exhausting but fascinating pet, unpredictable and mentally stimulating.

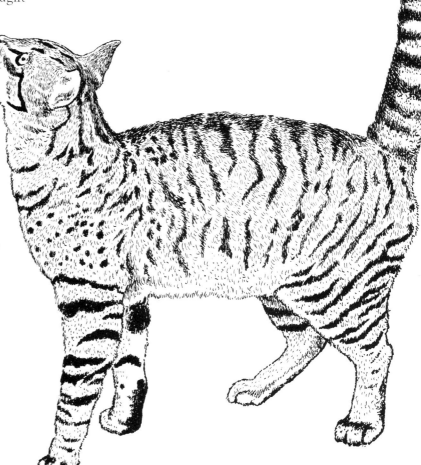

Swifts

Taking two contrasting life forms can provide points of interest that become sharpened in the mind. It is like a familiar word gaining new precision when it is examined alongside its antonym.

My own "antonym" for the swift is the mole. Swifts present themselves to the mind as the fastest, most dazzling, most etherial of the avian hosts. They have mastered and manipulated to their advantage the laws of gravity to a degree unmatched by anything else.

Even such a prosaic activity as taking a drink of water is turned by the swifts into a display of skill, speed and daring. From a great height they knife through the air with their sickle wings beating, then dive down almost level with the water. For a split second the wings are raised above the back and the mandible cuts a slit into the mirror-like surface. The bird climbs away from the water, its thirst quenched!

Poor mole, earthbound as a root! No endless sky, no freedom of flight or poetic grace. Yet even in your dark hole you feel the excitement of the approaching storm with its rolling thunder making your tunnels shiver.

Those thunderclouds and their rumblings spur the swifts to even greater animation, a more masterly buoyancy and higher spirits.

Racing before the stormclouds they may be seen plunging and wheeling in great numbers. This excitement before the storm also causes them to chatter and call gleefully to one another, and their collective notes are often the first intimation we have of their passing overhead.

Even the mole may feel vibrations in the earth from the thunder as he emerges momentarily from his endless digging. Then he quickly turns back to his burrowing. His happiness is a solid juicy earthworm – not an abstract thing, a mere mood of exhilaration triggered off by the sound of thunder.

Practical demands are, however, served to perfection in the swifts. Their four toes are directed forward to enable the birds to cling to perpendicular surfaces. They do not perch like other birds, so the foot has virtually become a device to hook the bird to a rocky wall. Although the beak is small the gape is large, well designed for gulping down quantities of aerial insect plankton. In this respect the system is like that of a whale, by which the animal or bird merely swims or flies through its food and ingests it.

These birds are often seen above the buildings of South African towns, sometimes gathering into chattering flocks. Their cries carry a long distance.

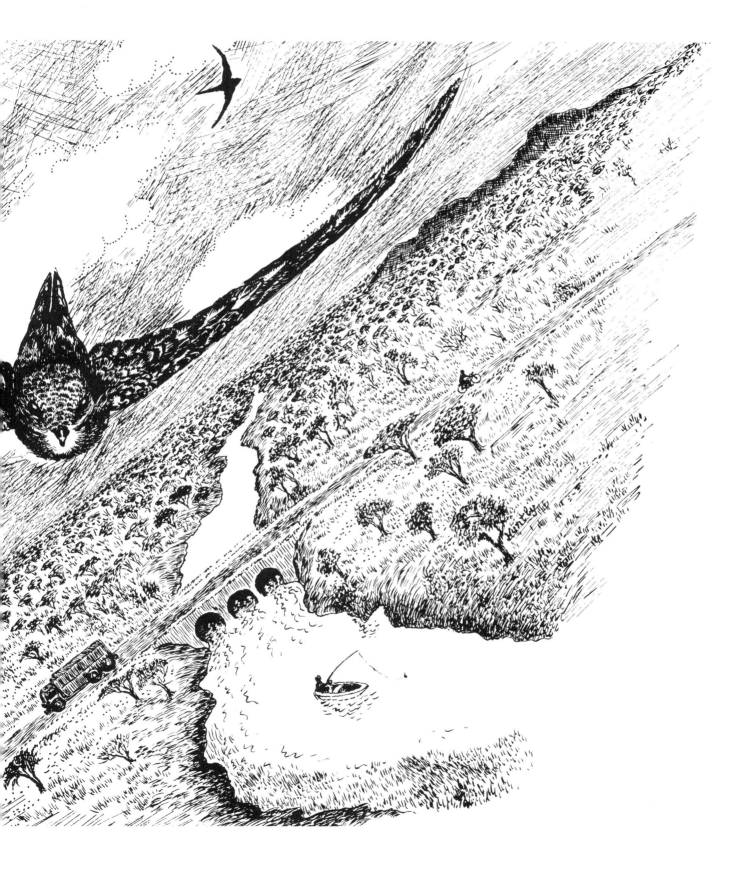

Bronze Mannikins

These familiar little birds carry on their business by consensus, always moving together in a group to feed, bathe, preen and finally sleep. Like other bird species that keep in flocks, they benefit in many ways through mutual guard-watching. The group-instinct system works on the principle that while feeding or drinking at least one of the group is on the lookout for danger. A dozen pairs of eyes collectively convey much more information to the group than a single bird fending for itself.

The group-bonding among mannikins is so strongly developed that it would be impossible ever to see one on its own for any length of time unless it had got itself temporarily separated by flying into some man-made obstacle or by diving for cover to avoid a hawk and being left behind by the flock. If something like that happened the lost one would find its way back to its flock by calling and being replied to in the reedy note of mannikins – distinctive, far-reaching and effective.

Wild mannikins have more lustrous plumage than captive birds. They have the advantage of finding a variety of food out in the veld denied the caged bird. An example of this catholic diet of wild birds is the green slime algae that grow among water lilies and sometimes on rocks just under the surface of the water. The mannikins reach down into the water with their beaks and pull up strands of the stuff, which they swallow like so much spaghetti.

Another food that they relish in season is flying termites. No family of birds disdains termites, and the mannikins are no exception. At one termite banquet that I observed the mannikins were joined by a few quail-finches. One of these little finches seized a winged termite and proceeded to swallow it. But the struggling insect was too big and would not go down. The finch refused to give up its prize and went on trying to swallow until it was quite exhausted. Its crop was either already crammed full of termites or the one that it was now trying to swallow was too big for its throat! Either way it was an impasse.

The Bronze Mannikin was introduced to science by Swainson in 1837 from Senegal, but of course it had been known to African and Bushmen tribes since prehistoric times. Because they feed in little flocks they can be caught in groups by means of cunning traps, and over the centuries they have provided many a meal to hungry people. This is even more true of queleas, which are sometimes harvested in thousands when their nesting grounds are discovered or in more modern times the birds are destroyed by explosives hidden in their sleeping quarters by day and triggered off at night, when the maximum number of birds are killed simultaneously.

Mannikins sleep on top of one another in a warm bunch in a specially constructed dormitory nest. The proper nest is a better made version as to size and shape: a large rough grass orb with a side entrance. No attempt is made to conceal these structures, and some of them are bound to be torn down by monkeys or shot through by stones from catapults.

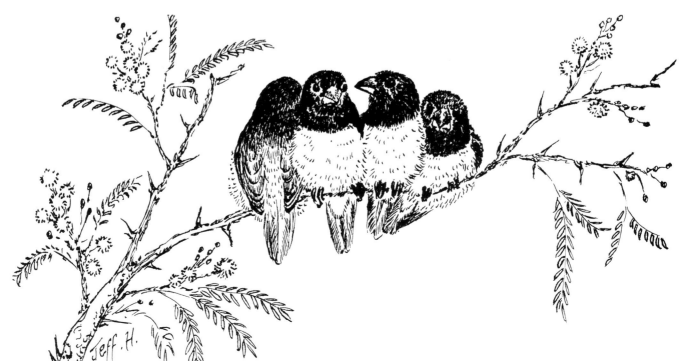

Lion

How would you classify lions? "Good" animals or "bad"? I knew a man who saw lions through the eyes of a defenceless peasant and later through the eyes of a tourist.

Our attitudes seem to play tricks with us, and we find some of our convictions slipping away and being replaced by contrary notions when experience compels us to change our minds.

To illustrate: I became acquainted with an African delivery-man whose job it was to collect mail and groceries at the village that served the game reserve where he worked. He was issued with an ordinary delivery bicycle but no gun for self-protection, and the return journey took him the whole day, because the road was sandy. Periodically he had to dismount and push his bike. Sometimes his blood would run cold when he saw lions resting under a certain copse of acacias that they favoured and from whence they watched him with idle curiosity. He cursed the lions and the unjust system. Some readers may remember him.

Contrast: From the inside of an air-conditioned Mercedes-Benz cruising slowly along a good road in Kruger Park, the lion does indeed typify game-viewing. A mere glance from his golden eyes and the proud, indifferent tilt of the head, and his thunderous, spine-tingling roar bring in large quantities of foreign money in the pockets of tourists, who return back home to their concrete jungles.

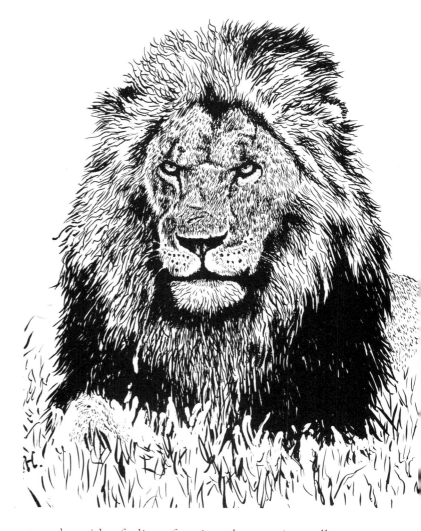

"Look out, Dad!" the kids shout from the back seat. Dad, looking at Leo, has driven off the tarmac and the big car is into the sand, up to its chromium hubcaps. It refuses to budge. Unfortunately some lions are lolling about in the shade not far from the stuck car. A lioness rolls lazily on her back, stretches her mighty paws, then props herself up on an elbow and stares. She can see movement inside the car, the figures are clearly visible. Unlike her companions, who go on sleeping, she watches with growing interest.

"Dad, can you start the air-conditioner again, I'm so hot!" says the teenager. "No I can't, it will overheat the motor or flatten the battery . . . or whatever it does."

"Have you got the spade to dig us out?" asks Mum.

"Of course I brought a spade. I can't get out and dig with that lion staring at us."

"It's not a lion, it's a lioness," says the youngest, and then: "Dad, can I go to the loo?" Soon everybody is shouting at once. Dad looks at the lions: "Horrible brutes! Why don't they move away and leave us alone?" By now everyone is sweating, no breeze stirs and it's an hour since they saw another car. He struggles with a feeling of panic and groans inwardly, suddenly realising that if nobody comes along this road they could spend five hours or more before a ranger is sent out to search for them. The lioness still gazes at them like a stuffed specimen with glass eyes in a museum. Only the end of her tail twitches.

"What does that mean?" someone asks about the twitching tail.

"Hey everyone, we're saved!" whoops Dad, staring into his rearview mirror at the rapidly approaching game ranger's truck with two assistants standing behind the cab. The ranger draws up, smiles and announces that their troubles will be over in a matter of minutes. Jubilation all round while Dad takes his last look at the lions. They no longer make his blood run cold – they now seem harmless, beautiful. Yet his brief experience has given him an inkling of the delivery-man's perspective of lions, even though in another part of Africa. Different strokes.

Lizards and Agamas

Africa is home to a great variety of lizards adapted to every conceivable type of habitat, and many of them sport vivid colours, which nevertheless always help to camouflage them.

The Kirk's Agamas in the illustration blend well with their surroundings. The male on the left has a bright orange head and vivid blue body. When sunning himself on granite boulders covered with orange lichen stains and areas of blue-grey and black weathered rock he is impossible to see. His mate on the right is "of stout habit" with a shorter tail than

Our giant blue-headed Tree Agamas leave the safety of their treetrunk for an occasional sortie across our lawn to pick up ants and other insects. I have seen the male visit the bird-bath during hot dry weather. He is a conspicuous object as he makes his way over an open lawn and would be an easy target for any passing hawk at such times. This agama is found in suitable habitat from East Africa to Natal, and was described by that tireless naturalist, Sir Andrew Smith, in 1894. He gave its "type locality" as "country near Port Natal".

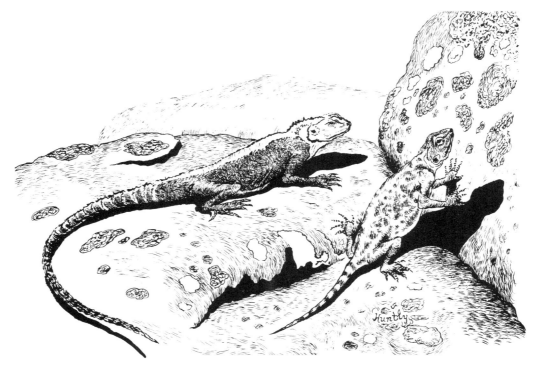

the male and coloured so differently as to appear to be of a different species. She is ornately dappled with wine-coloured markings, rather like Paisley pattern on a grey ground, and has a blue head. Perfect camouflage against lichen-covered background.

The Tree Agama can perhaps surpass the Kirk's Agama for sheer size and brilliance in the male. They live sedentary lives, usually facing head downward while clinging to the trunk of the tree of their choice. A pair living in our garden stay all year round in one particular tree. This tree has a suitable fissure under its thick bark, which has peeled away from the trunk, providing the heavily-built lizards with a secure home in the space between. Rock-dwelling lizards seek out similar fissures and crevices in rock faces where they hide from their enemies and lay their eggs.

Rock outcrops and kopjies throughout Africa are good places to see the most beautiful members of the lizard legion: Rainbow Skinks, Flat Rock Lizards, Rock Agamas and the huge Rock Plated Lizards. All these are coloured differently, from lush oranges, greens and blues to subtle lichen-imitating spots and stripes.

I once came upon a family party of rainbow-hued lizards sunning themselves on a rock fortress. They made a wonderful sight as they scurried over the black weathered granite seeking shelter in their rock clefts.

Rock lizards have become fairly tame round the grave of Cecil Rhodes in the Matopos of Zimbabwe. They have become familiar and unafraid of the many people who visit this famous site and do not harm them.

Fieldmice

Birds are encouraged in our gardens by the use of feeding trays and birdbaths, and we often find that fieldmice soon make regular visits to share the food. Depending upon the district, we may see either the Single-Striped Fieldmouse (foreground) or the slightly smaller and far better known Striped Fieldmouse with its four dark stripes separated by three creamy stripes.

The Single-Striped Fieldmouse is very alert, rather solitary, and "of stout habit". It is less ornate than its cousin, but nevertheless it is sleek enough in appearance, sandy brown with white underparts and large dark eyes. The shape of the eyes is accentuated above and below by lighter facial hair rather like eye-stripes in birds.

It enjoys maize-meal and will arrive at the feast by a regular route, making a pathway from a sheltering bush. It is very fleet of foot, extremely nervous, and prefers feeding near cover so that it may whisk away to safety at the slightest hint of danger. The fact that it is able to make use of the eyesight of Blue Waxbills has been proved by the little fellow in the picture during periods of close scrutiny through binoculars. During these periods of concentrated watching, the mouse was seen to bound away instantly to cover whenever the Waxbills made their alarm-note, "ddd-d-rrr!", from their higher vantage point on the feeding tray. There was no peering about to confirm what manner of danger the birds had seen. The warning was acted upon without delay.

When things were quiet again out he would come, with a bounding rush along the familiar route to the maize-meal, and begin eating again. The feeding motions are carried on with nervous twitchings, quiverings of the nose and minute beatings of the meal with the front paws. This curious mannerism appeared to be forming the meal into small mounds before being eaten.

Striped Fieldmice and Speckled Mousebirds occur side by side in many areas, and both gravitate to vegetable gardens for succulent greens. The mice vanish beneath the lettuce leaves at the first strident alarm notes of the birds. But those notes are acted upon in an amusing way in another quarter. A tiny grass-climbing mouse sitting high above ground on an exposed grass stem merely lets go his grip and falls through the air, "plop", into the dense cover below. Again "plop-plop-plop", and some friends and relations follow, leaving behind them the bending grass stems nodding up and down.

Weaver birds gather at every feeding place and snap away at the seeds beside the mice; and one of them is shown doing so in the drawing.

The Veld by Night

The moon dips behind the mountain like the white fin of a luminous shark. The edge of the mountain is a huge black wave moving down into the trough before rising again. Soon the fin disappears behind the wave, but its light still etches trees in black. These trees are stunted and old, bent into grotesque shapes from years of buffeting by the wind. They grow in rocky soil that holds little moisture. Yet these stubborn dwarfs survive on their inhospitable ridge, their roots clawing down rock fissures for the little water trapped therein.

The same species growing in deep rich soil far away in another part of Africa attains great height, with a sturdy trunk and branches; an elegant beauty with glossy leaves and scented flowers. Their mountaintop counterparts could hardly look more different.

Moonlit mountain-tops are more ethereal and transparent than the same scene in daylight. Silver light touches polished stones and they gleam dimly at one's feet, causing sources of light in the mountain-side which repeat the lights of the universe beyond. There is a sense of pulsating movement everywhere: flickering starlight, soft restless night breezes, shafts of moonlight slowly changing position, grass blades gently rubbing together producing sighing sounds, and the distant tappings of branches moved by the wind.

The veld by night is a glorious celebration of light, not darkness; of life, not death; from the little chirping crickets by the toe of one's boot to the flaming spirals of a vast nebula millions of light-years away. All of it; mountains, moons, oscillating stars, wandering winds and the tides of mighty oceans on this earth and surely others beyond the Milky Way telling to man of his Creator and of His ordering of every part of it. "Thou shalt not kill," He said; and Moses brought those words written on stone down from a mountain-top. Looking at the stars and the black vault of space the Psalmist asked: "What is man that Thou are mindful of him?"

From such a reverie I am brought back to the present by a strange sound that startles me. Momentarily I cannot place it, and I feel a tingle in my scalp. But I recognize the sound and relax. A nightjar has circled round me and whilst he does this on soundless wings, he makes ghostly gulping noises – ghostly because the sounds come from different directions apparently with no single source. In this dim silvery twilight the bird cannot be seen; only its weird call can be heard – now close to my head, now above, now behind, now far off.

Black Sunbird

Depending upon the light when one gets a close look at this velvet-black sunbird one may either think of it as exquisitely beautiful or as sooty-drab and colourless. Seen in bright sunshine the male Black Sunbird shows a gleaming emerald crown and an iridescent purple or mauve throat patch. The colour seems to be intensified by being set in black, rather like a jewelled bracelet glowing brighter laid on black velvet. By contrast to the resplendent male the little female is a dark mottled mixture of brown, grey and black with some whitish-grey on the belly.

The illustration shows the female making a hovering approach to her nest, which hangs above the gate to our house. The constant traffic below seems not to bother the birds in the least; and since this is the third year in succession that they have made their nest there one must conclude that the site is a deliberate

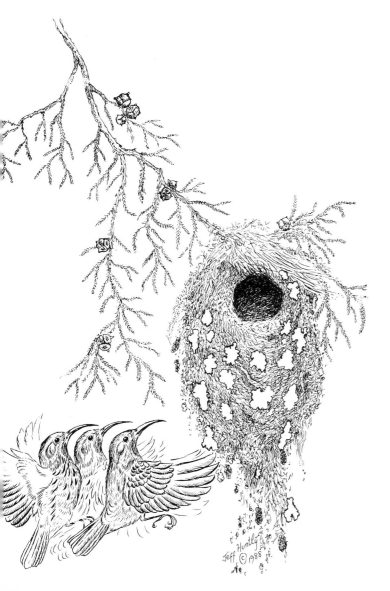

choice for safety against predators. It also has what I think of as "the surprise factor". Nobody would imagine that birds would choose such a place to nest – therefore the nest is overlooked. We seldom see what we seldom expect.

This nest is incidentally near a bee-hive in the hollow trunk of the huge tree whose branches reach down above the gate and to which the nest is attached. It is not clear whether the busy thoroughfare is the attraction or whether being near a bees' nest is considered by the birds as a discouragement to predators. My guess would be that simply being near a human habitation is the determining factor, since there are many records of various sunbird species nesting near the kitchen door of farmhouses (that door being the most frequently used thoroughfare) or on a veranda creeper of a country inn. I once occupied a makeshift studio in a farm outhouse and its one large window had a well-made security cage jutting out from it like a box. Although grenade-proof it was not bird-proof, and I was delighted when a pair of Scarlet-chested Sunbirds elected to build their nest against this unlikely support. I was able to watch the female creating her nest directly in front of my desk and then rearing her two chicks.

When the female feeds the chicks one may sometimes catch a fleeting glimpse of the long slender tongue. This long curved instrument is silvery coloured and it is seldom seen properly because when extended to suck the nectar in flowers the beak is thrust among the petals. Again when feeding chicks, the head disappears momentarily into the nest and it is impossible to see the silvery hollow needle of a tongue.

The Black Sunbird and indeed all sunbirds have a wild jinking flight that makes them an awkward target for sparrow-hawks and other airborne predators. Sometimes the Black Sunbird will be found far out in an open vlei or bare grassland visiting aloe flowers. It is in this situation that the unpredictable flight is most needed, since the all-black bird is a conspicuous object flying away from the protective cover of its usual tree habitat. If it flew in a straight line it would be easily caught.

Reedbuck and Wild Dogs

In the old Africa, wild dogs performed a necessary function in nature, killing weak or sickly antelope, thus helping to keep the stocks more vigorous. Thus they helped in the general scheme of things to keep proper balance, maintaining the laws of natural selection and the survival of the fittest.

The reedbuck in this story might have survived this experience but for the meddling of men.

Often I would pass along a certain road in a game reserve and see a reedbuck resting in a grassy hollow near a muddy pan. He lay there contentedly licking parts of his body, enjoying a regular siesta. On one occasion I saw the buck dashing across the veld with a pack of about fifteen wild dogs in hot pursuit. The buck ran to the pan, plunged in and swam to the deepest part. The wild dogs stood on the bank watching his progress. Suddenly the head of a crocodile appeared beside the buck and made a lunge at him. The buck deftly swung away and the crocodile, which was quite small, missed. This again brought the buck to the middle of the pool, and the crocodile began to close in for a second attack. Again the buck evaded its jaws which seemed to gape ineffectually. This time the brave antelope swam for the bank farthest from the dog pack. It emerged and stood exhausted with trembling limbs, trying to regain its breath and strength. Presently it made a dash towards some distant scrub, but the dogs soon caught up with it and headed it off. Realizing that its only hope lay in getting back to the water,

it leapt past two dogs and plunged into the pan again.

Once more the crocodile came at him, and once more the buck shook it off. The crocodile tried to grip him by the neck, but failed. The reedbuck was by now exhausted and it emerged from the water for the last time. One of the dogs loped lazily round the pan, and the buck stumbled off, stiff-legged and glass-eyed. The dogs had all converged on him by now and formed a tight ring round him. The circle closed, and all the dogs lifted their bushy tails simultaneously and their white fluffy undersides gave a macabre gaiety to the scene. From white to bright red as they tore him to pieces in a swift execution; for his blood covered the savage dogs' heads like glistening masks. First one and then another dog would emerge from the scrimmage carrying a slab of dripping flesh, to be instantly gorged. They would then dash to the pan for a drink and return to the mêlée for more.

Soon nothing remained of the reedbuck but the head, spine and feet. When I came back next day even those had gone, having been removed during the night by other scavengers.

How had man meddled? The crocodile had been artificially introduced as an additional interest for tourists. A reedbuck in a similar plight with no crocodile to contend with might have eluded the dogs by keeping to the water, "sitting it out" as it were, until they gave up and departed. In ancient times the drama could have turned out differently.

Veld Fires

Part 2

Certain bird species are drawn to the scene of a veld fire, and their restless activity can be of great interest to the spectator.

Drongos and Yellow-billed Kites, rollers and White Storks are the earliest on the scene; they seem quite fearless of the flames and smoke in their eagerness to catch their prey. The advancing flames send hundreds of insects into the air, while rats, mice, snakes, lizards and frogs break cover and fall easy victims to storks and eagles attracted to the feast. You may see drongos and rollers dive almost through the flames in pursuit of an insect. Normally all these creatures are difficult to find, when suddenly the fire makes them literally "easy meat". Amazingly, White Storks seem not to be affected by the heat of the recently burnt ground, although they do seem to walk faster than usual through the smouldering ashes after a mobile menu.

Snails suffer much at the scene of the burning, and their charred shells lie about like burnt-out tanks on a miniature battlefield.

The storks' menu would read differently from that of the smaller birds also attracted to the fire, for the storks take larger prey. A banquet lasting two hours reads something like this:

Hors d'oeuvres	–	locusts and beetles *á la grillade*
Entrées	–	lizard, frog and chameleon *rôtis*
	–	rat *á la minute*

Unhappily the menu would also include roast baby birds and baby hares.

The most interesting small birds that make it their business to attend veld fires are the finch-larks. They may be quite absent from a district for a year, then suddenly arrive in large numbers after a burning. Books on African birds tell us that the finch-larks live on grass seeds exclusively, but that seems unlikely, since they swarm to a burn where all the grass and its seeds are destroyed. But thousands of insects are exposed or lie about ready to eat, and it would seem finch-larks, like ordinary larks, do eat insects. A menu for small birds after a burn includes such delicacies as detached musical thighs of cricket, barbecued grasshopper and well-singed fly.

No fire would be complete in Africa without the prompt arrival, from dizzy heights and far distances, of the coursers. They are attracted to burnt areas like iron filings to a magnet. When they breed their eggs are laid among bovine or antelope droppings, which themselves are rounded charred lumps in the burnt grass. The eggs are densely covered with criss-cross black markings and are amazingly well camouflaged against the charcoal of their background. When courser chicks lie still among the burnt grass stubble they are as hard to see as the eggs. Later when they are nearly fully grown they accompany their parents, and one may observe them, usually in parties of four (two young of the season and two parent birds). All this is true of Temminck's Courser, the species most likely to be seen in the greatest number of places in southern Africa. Coursers are also found on airstrips, ploughed fields, golf-courses and fire-breaks. They run swiftly away from the human observer keeping a constant distance from him when followed. When they stop to make their own observations they always peer over a shoulder, keeping their backs to the person following them.

The Blue Python

I once observed an extraordinary shiny black object in the distance while walking across a large newly-ridged potato-field. The thing shone in the late afternoon sunlight and at first appeared to be the curved sides of two black car tyres seen with their top halves showing above the deep ridges of the ground. It was a most extraordinary sight, and I walked slowly towards it still not realising what it was. Then the curve of a third tyre could be seen, and through binoculars I saw a reptilian head slowly appear over the ridge. The python moved slowly over the endless humps, his tongue always leading the way as it flicked in and out.

Whenever his head disappeared below a ridge I walked rapidly forward, but I stood motionless for a moment before the expected reappearance of those cold eyes, grinning mouth and groping tongue. Getting to within four paces of him I crouched down before the head reappeared, and the snake slowly made its way over the ridge. He ignored me; or perhaps he had no idea what I was. I might have been a rock in the middle of that vast open expanse of soil and ridges.

When the snake was first seen it appeared to glitter slightly, perhaps because of the low angle of the rays of the sun causing the "wet-look" surface of fresh skin to reflect the blue of the sky. It is so dark that it picks up the blue tones of the sky. Very shiny black dogs and other animals similarly reflect the blue sky on their hair.

The great four-metre body passed near me, and I watched the slow rhythm of its bones "walking" inside the leathery skin. The forward-moving impulse of hundreds of covered bones could clearly be seen to pass like a gentle ripple along the whole length of the body. The latent power and subtle poetry of movement is very satisfying to watch.

At that moment the flickering tongue vanished, and somehow the snake became aware of me. He lay motionless for a time, as though turned to stone, and then raised his head quite high above the ground in the strangest manner, as shown in the drawing. He appeared to be looking straight up into the sky but those eyes were staring at me from that additional height – staring sideways and very still, the tongue having now been retracted. There was a large antheap nearby, and he brought down his head and picked up a little bit of speed to disappear down a large hole at the top of it.

My African assistant ran to the house one day to report a python squeezing a duiker to death in an open space of wasteland. As we neared the spot the bleatings of the little buck could be heard. While running down to the place I had some vague idea that I should watch the whole tragic event from some distance and not interfere with nature. But I couldn't do it. The little buck gasped for breath and I was reminded of someone making long deep sighs of intolerable suffering. The reptile's coils appeared to cover every part of the buck, but the brave creature still kicked for dear life and had in fact inflicted a wound in the snake's side. I went forward, and the snake released its grip. The little duiker staggered to its feet and ran unsteadily away. I followed it for a short while to see if it was going to recover and it appeared to improve with every step. It vanished into some greenery, and I felt quite elated.

On my return to the battleground I found that the python had already gone under a low bush; only about a quarter of its body stuck out from the leaves and this was very slowly moving away. I had an almost irresistible urge to bend down and pull that tail, but fortunately I desisted.

Rhinos and Michelangelo

The story of the decline of the Black Rhino is the most horrific chapter in the annals of the impact of man on Nature in Africa. From something like 63 000 in 1970 to 4 500 Black Rhinos now left is a sad comment on our stewardship of the earth's riches, its mysteries and marvels. Something like 58 000 rhinos gunned down in less than twenty years!

On the one hand we have small dedicated organisations fighting a desperate battle to save threatened species, and on the other we have Arab and Asian wealth operating complex black-markets in rhino-horn. The poacher who does the dirty work is merely the extended arm of the dealers. He is paid a small pittance for risking his life to crocodiles when crossing the Zambesi River and to the bullets of the anti-poaching units. The smooth-tongued and smooth-fingered middleman makes a fortune with his illicit rhino-horn. A year or two ago a pair of rhino horns could fetch R40 000. What will the figure be if and when the Black Rhino's numbers fall to below a hundred? The scarcer the commodity the higher the price.

So? So, what if the Black Rhino and the Asian Rhinos become extinct? The world will survive without them. It can also survive without the works of Michelangelo, Redwood forests, butterflies, poetry, the Mona Lisa, eagles and the gorillas of the Virunga Mountains. It can also do without swans and Swan Lake. The swans will die anyway from the pollution of the lakes. Future orchestras will play Tchaikovsky without having seen a live swan – the younger musicians anyway; and their younger listeners will not have seen one except in books. A few generations ago British kids could chase swarms of butterflies of numerous species. Now the butterflies of England have mostly gone, some for ever, because of destruction of their habitat and the widespread use of agricultural insecticides.

If the Heads of State, the Presidents, the kings, the sheikhs, the princes of these Arab and Asian countries could be won over to the idea of saving threatened species before it is too late, then there would be hope for the Black Rhino in Africa. We would then be dealing with the real cause of poaching. At present we fight a losing battle with the poachers themselves, whose determination to get rhino horn will increase as the bribes and payments increase in ratio to the decrease in numbers of rhino.

Our Friends, the Trees

It is difficult to find anyone who dislikes trees; rather it seems that trees are loved universally, in varying degrees, especially in England and parts of Europe. Trees were once worshipped in England rather after the manner of grove-worship described in the Bible (Gen.21:33, 1 Sam.22:6). A possible curious left-over of this practice was the burial of local parishioners "when their time came" beneath the spreading branches of the ancient yew tree in the church grounds. Some yews in Hampshire and neighbouring counties had so many graves dug beneath them and barrow-loads of roots cut from them that their lives were shortened.

A love of trees survives up to the present time. Examine the reasons for this and it is not difficult to see that although humans have power to destroy trees the trees in a sense can retaliate. People in fact depend upon trees to survive, and it is this vague recognition of interdependence that causes distress at the sight of trees being felled. One of the most horrifying sights ever portrayed on TV was a primeval tropical forest being put to the flame in Brazil. Vast areas of jungle trees – "the green lungs of the earth" – put to flame, individual giants of great antiquity lighting up like towering infernos. All this done so that the ground could be sown under grass for beef-cattle.

What are the consequences of making such far-reaching changes to the environment? Will Nature retaliate in the long run by turning the burned-up country-side into a desert? If the tropical rain-forest is completely destroyed all over the world, will man set in motion a chain of events that he will not survive?

Ancient tree-species, specially adapted to growing in mountain gullies and along mountain streams, have a remarkable ability to stand up to floods. I have seen wattle trees and wild indigenous trees growing close together up these gullies. The wattles are planted like any other crop, close together, and have a root system not well adapted to holding a lanky tree upright when the weather gets rough and the floods descend. The wattles become sodden with rain and top-heavy, and a sudden gust of wind blows them over, sometimes resting criss-cross against one another over the gully. The top-heavy trees, with their small pad of roots, lie strewn about or propped up by the sturdy in-digenous trees.

It would be of great advantage if the timber companies concerned increased the width at present allowed for indigenous trees growing in gullies. That would ensure better protection to the soil itself, prevent gullies from getting any bigger and also give better protection to the wild-life dependent upon mixed species of trees, shrubs, bushes and creepers that have specially evolved for growing in gullies.

The illustration shows an indigenous tree doing work in a gully. But the most important part of the story of this tree is not shown. The story of a strong root system beneath the ground holding the soil. When these roots mingle with those of the next tree and countless more in countless gullies all over the land and neighbouring lands and neighbouring continents one stands in awe of these mighty doers of good – their feet holding our world together; their arms aloft holding masses of leaves to shade us and feed us.

The Unknowable

We look at the workings of Nature and often marvel at them, sometimes feeling superior to all creation because there is nothing as clever as we are with our technology, our ability to destroy huge cities at the press of a button, our ability to wipe out the rain forests and exterminate species after species to make a better world, a world controlled by machines in which everyone may share acid rain and exhaust fumes. *Homo sapiens* . . .

had broken off from the main body of their "snake" they would have shattered the illusion and would have been gobbled up by birds.

The question arises: How do these creatures know what a snake is like – they are blind, and know nothing of the fear of birds for snakes – that they might exploit that fear to their own advantage?

And the question remains unanswered, together with that other: Can you give the breath of life to

Yet the simplest things baffle our cleverest minds and warn us that our Creator knows what He is about, that to preserve life is divine, and that that applies to the humblest forms of life.

The drawing shows a multitude of little maggots proceeding to some destination known only to themselves. Their method of locomotion is to band together one on top of another collectively forming the shape of a snake.

I have seen this phenomenon once in my life as I walked along a footpath. I nearly stepped on a dark grey glistening snake lying in the path and I made a startled jump to avoid it. Looking more closely at it I saw that the snake's body was made up of slimy grey maggots that glittered in the sunlight. This amazing imitation of a snake would certainly fool any bird, which would give it a wide berth. I watched the progress of "the snake that wasn't" for half an hour, and during that time not a single maggot broke away from the caravan. If any of these lowly creatures

any living thing? With all your marvellous powers and inventions of destruction you cannot make an ant lift his antenna!

There is something gratifying in all this, to realise that certain things will remain locked up in the Unknowable, to human minds at least.

Like bird song I want some things in this life to remain unexplained; I don't want some biologist to tell me what a Nightingale is saying, or assure me that a crow has no sense of humour and doesn't do aerobatics for the fun of it, or that dogs cannot experience feelings closely parallel to our own. If some of my convictions are illusions let me keep them. The scientists go too far with many of their careful avoidance of every anthropomorphic simile. Many of the beliefs that they confidently hold are later proved to be illusions. The Red Indians of old understood the true feelings of animals and birds and said that they were closely similar to those of man.

The Convolvulus Hawkmoth

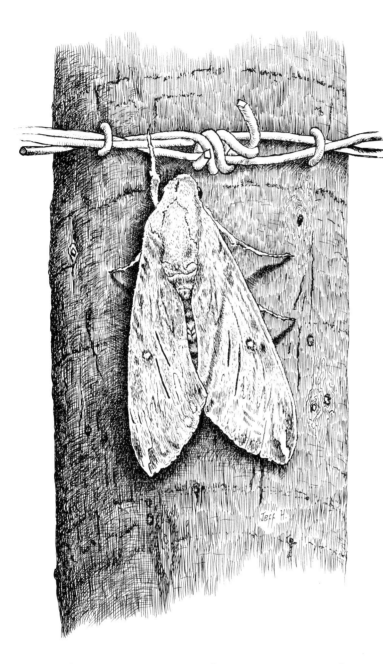

The type specimen or rather type species was first named by the father of taxonomy, Carl Linnaeus, in 1758. He named it *Sphinx convolvuli*, but it was later renamed *Herse convolvuli* in 1815. It is the only species of its genus *Herse*.

Linnaeus knew about its larva feeding off the leaves of the convolvulus, hence the name. The caterpillar also feeds off the leaves of the sweet potato – that hardy ground creeper that African peasant cultivators grow on the tops of mounds dug with their hoes. The caterpillar, like those of many hawkmoth species,

has a distinctive tail-like appendage growing from its rear-end. This tail is covered with tiny nodules, which gives it a granulated appearance. When the caterpillar changes into a pupa the long tongue actually grows out from the main body of the pupa like a small loop. The best way to describe this is to liken it to the handle of a wine-jar – the top of the brown wine-jar being the head of the pupa from which the tongue makes a small arch. This pupa with its jug-handle is instantly recognised as being the chrysalis stage of the Convolvulus Hawkmoth.

By day this hawkmoth rests on fence-posts out in the open or on tree trunks or telegraph poles. It relies upon its grey colouring to camouflage it and merge with its background. The moth in the drawing had settled on a fence-post in its customary manner, but it did not appreciate that the pole was impregnated a long time ago with creosote and, although the wood no longer smelt of creosote, the pole was black. The blackness contrasted with the light grey sunlit wings of the moth and I could clearly see it from a long way off!

An interesting characteristic of the markings on this moth's wings is that it has two dark lines on either wing which resemble any dark lines or cracks on the surface of the pole – thus helping to conceal it! Some wavy patterns and vague circles mimic the wavy patterns and knot-holes found typically on wooden poles and tree-bark. But not every specimen has these lines – some are plain grey, others are more distinctly marked.

The only colours found on this hawkmoth are the abdominal segments and are invisible beneath the sloping roof-like wings when the moth is at rest. The colours are rose-pink and set in alternate squares of colour: pink, black, pink, black all the way down the abdomen. As in the case of other hawkmoth species, the colours are only put to use by the moth when it feels threatened. At the approach of some tree or pole-climbing animal or reptile the moth suddenly opens its wings and the flash of colour momentarily startles its enemy, giving the moth enough time to fly off in that split second. Thus it is that a life is saved by that moment of confusion, and the moth lives on to perpetuate its life-cycle.

The long tongue allows this species to reach far into the deep trumpets of tubular flowers such as those of the tobacco plant. Something to remember when you light up and enjoy . . . The Convolvulus is responsible for pollinating many deep-throated flowers in the veld. The illustration shows a moth with antennae folded back out of sight. Size 110mm.

Coqui Francolin

This little fowl was first described by Sir Andrew Smith in 1836 from the Rustenburg district of the Transvaal in South Africa. He contributed greatly to our knowledge of natural history in those days, particularly with regard to the game birds, which must have been of special interest to him.

Dr Austin Roberts in an early edition of his famous book makes the interesting observation that Sir Andrew, when naming the bird, probably asked its name of his Sechuana servant and was given the general term used for quail: *coqui*. Roberts goes on to say that quail-partridge would suit it well in any case because of its size.

I enjoyed a charming interlude when watching some of these birds one frosty morning. I thought of Red Indian smoke signals. A male was observed standing on top of a small black anthill and making curious grating calls. "Paerp-paerp-erp-erp-erp-erp!"

Because the air was so cold and crisp each note that he uttered left a white puff in the air – momentarily – just in front of his beak. It was a pretty effect, lasting only a split second, and because he kept repeating his call I was able to enjoy the sight for a considerable time. A second cock echoed the call from a different anthill some distance away as though mocking the first, note for note.

The Zulu name *i-Swempie* is onomatopoeic and exactly describes the more frequently heard call of these little game birds. On a still day in the veld, when all nature seems in a mood of reverie, the silence is pleasantly broken by a distant "swempi-swempi-swempi. . ." The call is of two notes, evenly spaced and very much a characteristic sound of the African veld.

The Coqui, or Swempie Partridge has the singular habit of creeping slowly across a sandy road. In some game reserves, such as the Kruger and Wankie, where they are common, one may approach them very closely by car. Instead of dashing or flying across the road, in the manner of guinea-fowl, the Swempie crouches low down as it creeps slowly across the open space and can be examined closeup in a way that no other game bird would allow. Once into the grass again the birds simply vanish, so perfectly do their colours match the speckled, stripy grass.

When walking through the veld they will rise explosively from under one's feet – or so it seems. They sit tight until almost trodden underfoot, and if several get up at once they go off in different directions – possibly a trick to confuse their enemies, as they are then impossible to mark or re-locate again. Like most francolin they refuse, or are reluctant to rise into the air twice in succession. This reluctance, I believe, originates from a fear of attracting overhead birds of prey. To illustrate: I once repeatedly put a quail to flight, or possibly two quails in succession, while walking with a group of tribesmen. On the third flight the quail was taken in mid-air by an eagle, which the men assured me had followed us after it has seen the quail's first or second flight.

Footnote: i-Swempie may be heard from Natal to the southern coast of Kenya, with a race in Equatorial West Africa- the Upper Volta Coqui.

The Aardwolf

An Adept Impersonator

The aardwolf in this sketch was found dead on a road, and I assumed that it had been dazzled by car lights and struck down. Apparently these animals are baffled by powerful lights, unlike jackals, who get out of the way of impatient motorists.

I examined a curious feature of the aardwolf, the tough facial mask covering the entire muzzle, and felt it with my fingertips. It felt like slightly damp fine sandpaper.

One could see how the animal's habits, the result of its questing intelligence and adaptability, formed its outward appearance.

Because its life is spent pushing its face into holes that it digs into termite nests, its body has thrown up a protective shield of tough skin round the muzzle. The same effect is seen on the soles of people who have walked barefoot for a lifetime.

The aardwolf can erect its mane and a lot of other hair besides, in an abrupt manner, apparently doubling its size and confusing its enemy long enough to allow it to escape. It imitates the roar of a lion, a sound out of all proportion to its size. If these tricks fail to deter an enemy, it can eject a foul-smelling liquid as a last resort.

The aardwolf, then, is a clever impersonator of others, a four-footed fake, a roaring eater of termites, living its Jekyll and Hyde existence in vacated antbear holes and emerging from them by night, a habit perhaps adopted as a means to avoid mankind.

Wondering how such a large animal could find enough termites to sustain it, I opened a typical termite mound and found the answer: in the heart of the nests there are larger cavities where thick clusters of termites in various stages of development are housed. Some of these clusters provide enough nourishing insects to fill a teacup, and they are well within reach of the aardwolf's digging forepaws.

Fish Eagle

"The ferocious, overbearing, and tyrannical temper which is ever and anon displaying itself in its action is nevertheless best adapted to his state, and was wisely given him by the Creator to enable him to perform the office assigned to him." John James Audubon wrote these words with his quill pen in the now classic *Ornithological Biography*, begun on November 20th, 1826. He was writing about the Bald Eagle, later to become the national emblem of the USA and which is the New World counterpart of the Old World African Fish Eagle and Pallas's Fishing Eagle of India.

He wrote vividly of the Bald Eagle (or White-Headed Eagle, as he called it) and he made an exciting painting of it. He could have been describing the African Fish Eagle, so close is the resemblance between these two, both in appearance and behaviour and in their fate at the hands of Man. The scientific name of these two eagles indicates their close relationship: *Haliaeetus leucocephalus* for the Bald Eagle and *Haliaeetus vocifer* for the Fish Eagle of the Old World.

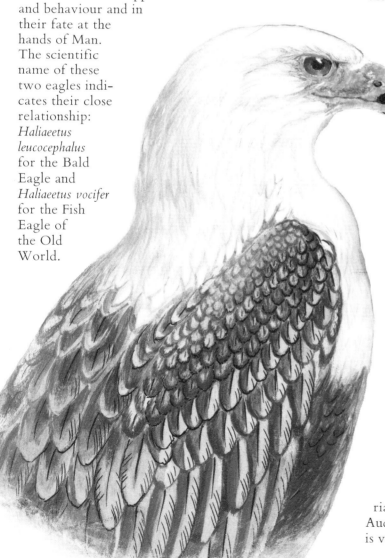

At various stages of their history both birds have been ruthlessly shot – in Alaska a bounty was paid for the paired feet of the Bald Eagle because it caught a few salmon, which Man wanted all to himself! In both continents the introduction of D.D.T. has seriously threatened the survival of these great birds. Fortunately Rachel Carson's *Silent Spring* made a timely appearance to create a general awareness of the dangers of unrestricted use of lingering pesticides. This awareness has helped environmentalists in their fight to save endangered species, but much still has to be done to overcome ignorance, greed and apathy, attitudes that threaten not only birds and animals with extinction, but even Man himself.

When the Bald Eagle and the Fish Eagle are young they are brown and mottled and easily mistaken for "hawks" and shot. When fully mature both acquire their beautiful white heads and illogically obtain protection through sentiment and are less often shot. The same stupidity operates in the case of the Bateleur Eagle. It also has the misfortune of going through a brown phase in its youth and being ruthlessly shot by mistake for a "brown chicken hawk". When it acquires its full adult colouring it is not so often shot!

In character the Fish Eagle and the Bald Eagle are savage, and both go in for a bit of piracy when given the chance. That happens when an osprey (or Fish Hawk, as Audubon called it) is seen carrying a fish. Both eagles in their separate continents will attack the osprey and force it to drop its prey. The threat seems to be enough, for the osprey drops its fish and decamps in deference to the eagle, which then takes over the booty. But usually Fish Eagles catch their own fish, with a magnificent dive with cruel talons that hoist the struggling fish out of the water. The prey of both eagles includes nestling herons, swans, odd bits of offal washed up on a lake or seashore, and unwary or wounded birds.

In Africa Fish Eagles relish barbel, and appropriately their American counterpart was painted by Audubon in the act of feeding on a catfish, which is very like the barbel.

Baby Elephants

Visitors to game reserves where elephants abound should pay particular attention to young or baby elephants whenever the opportunity occurs. In the dry season herds of elephant may be closely observed as they congregate round a pan or wallow in the shallows of a lowveld river. The young elephants in these mixed herds provide much entertainment for the human spectators.

A young elephant, somewhat older than the little fellow depicted, came upon a Saddlebill Stork at a pan well known to tourists in the Wankie National Park. The brightly-coloured bird arrested the attention of the youngster, who immediately charged it with the intention of driving it away. The big bird deftly stepped to one side, eluding the charge. It was plain that the Saddlebill had no intention of leaving the water-hole, which he evidently considered an excellent spot for a day's fishing and frogging.

Again the little elephant rushed at him, squealing with rage because the black and white object before his eyes kept moving just out of reach. The commotion drew the attention of another youngster from the herd, and together they gave chase. They presented an absurd picture from behind, like small boys in loose pyjamas, the elastics of which were about to give way. Deciding that the Saddlebill was now utterly banished, they ran back to the herd with much boastful trumpeting.

The Saddlebill meanwhile strode round to the opposite side of the pan and began feeding again, maintaining an aloof air, as though it were beneath his dignity to contest the matter with such striplings.

Zebras are also the object of angry attacks by young elephants, who delight in routing them from water-holes. Such childish antics foreshadow the formidable power of the adult elephant in the years to come. I once saw about a hundred buffalo scatter like so many leaves when an ill-humoured bull elephant took exception to their presence at his favourite watering-place. He quickly took possession of the pan for his ablutions, while the buffaloes retired to a safe distance and discreetly waited for his hour-long bath to end. It was evident that he detested their smell – exactly like that of domestic cattle – for he sometimes held aloft his erect trunk and sniffed in their direction.

The only other occupants of the pan were a pair of African Hawk-Eagles who remained impartial spectators of the affair. They stood motionless in the shallow water cooling themselves for a considerable time. By a strange coincidence a flock of guinea-fowl had fled from the pan because of the fierce hawk-eagles and they, like the buffaloes, now patiently hid in some thickets to await the departure of their arch-enemies.

If you are ever in a position to watch elephants with young at a water-hole you may observe the marvellous care that they take not to trample the little ones. In fact, observing the intimate relations between parent and offspring through binoculars can prove a humbling experience and extremely interesting. At this time the mother elephant can be dangerous to anyone approaching too near, perhaps with a camera, and several occasions are on record of even the most experienced veldsmen being killed through such an error of judgement.

The Cape Buffalo

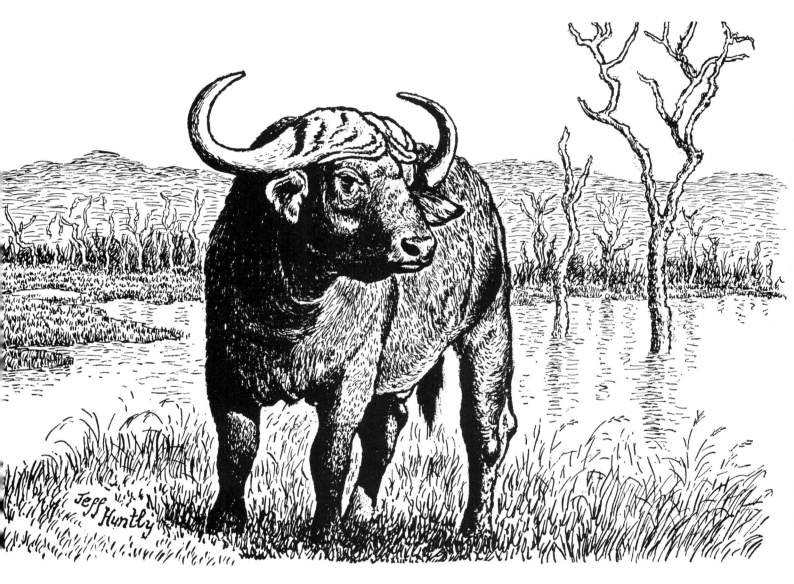

Jeff Huntly

The Cape Buffalo is my favourite veld–dweller, and the sight of these cunning, bellicose animals *en masse* stirs my imagination. I love them for their untameableness, their refusal to bow the knee to their age-old enemy, man, and for the savage bravery of an old bull when making his last stand, awaiting the approach of the great white hunter who has mortally wounded him with a .375 Magnum.

Some years ago I sat on a hillside overlooking an open stretch of vlei occupied in its entirety by a large herd of buffalo. The sun had set and they had bedded down for the night. Their brooding presence could be felt that night at short intervals whenever the breeze changed direction and wafted that familiar cattle smell up to me.

Buffalo *en masse* like this are so like domestic cattle; the smell and sounds are similar, and one can well understand that they represent the breath of life to the cowboy, gaucho, Aussie stockman and African herdsman alike.

It would be interesting to see a buffalo herd of 500 years ago through H.G. Wells's Time Machine. I think they would have been more noisy than present-day buffalo, taught by harsh experience of mankind to be silent wherever they go.

This is particularly true of their nocturnal drinking at a pan and moving out into open vleis to get at the fresh green sprouts that they relish. At dawn they leave these exposed situations and take cover again, always with quietness .. quietness.

Secretary Birds

It was my good fortune to witness an aspect of the private life of a pair of Secretary Birds. These magnificent birds reveal very little about themselves, as they are very intelligent and therefore fully aware of the necessity to keep as far away from human beings as possible. However, at the beginning of the breeding season we may catch a glimpse of them because they are so preoccupied with their own affairs.

I walked across some wide open savannah country and heard for the first time the sound of the male Secretary Bird when he is intent upon mating. This weird noise came from high above as the birds sailed down like two old biplanes about to land. The female kept ahead of the male and flew towards a line of gum trees. Again that sound! But how to describe it? A resonant snoring sound, a prolonged deep rumbling croak, an old-fashioned car hooter? None of these is quite accurate but they all convey the rough idea.

Now the birds touch the ground, and immediately the female runs with wings held up. They partly disappear behind some tall grass, but their wings remain visible, like the dorsal fins of a pair of sharks slicing the water. The female runs towards the line of gum trees and twists and turns between the trunks with the male in hot pursuit. Backwards and forwards they go until she abruptly breaks cover and moves into an adjacent field. Here she takes to the air and flies heavily to a distant copse of wild trees.

I cannot keep pace with them, but through binoculars I can see the whole event repeated among the wild trees. Round and round they dash with wings held up, until once more the female takes off and they are finally lost in the distant haze. This arduous nuptial chase covered an area of three adjoining farms, which gives some idea of the birds' need for space. Perhaps it is a type of natural selection, ensuring that only the strongest and most determined males succeed in mating.

It is sad to reflect upon the future of the Secretary Birds in southern Africa. As a species it hangs by two fragile threads of environmental requirements: large open spaces with short grass and no human beings. The worst possible combination for all walking birds! The open spaces get smaller and smaller and the numbers of people increase year by year. Without warning the year – the week – the day – will arrive when the big vulnerable birds will be gone for ever.

Sand Martins

Sand Martins because they nest in sandbanks, Rock Martins because they nest against rock overhangs, Cliff Swallows because they nest on cliff faces. Martins and swallows are scarcely distinguishable except for a superficial outward appearance in colour. The martins are the dull ones and the swallows more colourful, mainly blue-black, white and red or copper. Martins are the mouse-coloured swallows that fly up and down river, just above the surface, so that their inverted reflections keep constant pace with them. In my experience they seem to keep fairly near their nesting colony when flying up and downstream.

I found about twenty Sand Martins flying ceaselessly up and down a certain stretch of the Dusi River, near Pietermaritzburg, on 24 June 1985. Round a bend in the river there was a cliff-like sandbank into which the martins had bored their nests. These tunnel entrances were in a row along a particular stratum of the bank, so that they appeared to be all level with each other. Dry grass hung over the bank providing a degree of concealment to the tunnels. From time to time parent birds would fly up and disappear into a hole, presumably to feed chicks inside. Adult birds seemed never to stray very far from the nesting bank, finding enough food to keep them satisfied all within that stretch of river. It was as though invisible boundaries kept them flying in those precincts, self-imposed limits so to speak. Small insects and flies hovering above water level provided a constant source of food for these interesting birds.

In Volume 3 of *The Birds of Southern Rhodesia* Captain Cecil Priest makes an observation regarding these martins that I have not been able to find in any other bird literature, either from my own collection of books or in the public libraries (although it might well be referred to in ornithological journals). He says that martins have a viscid saliva that he believes helps them in capturing small aerial insect food – prevents the insects from slipping out of the gape on being taken.

Years ago I found a single nest of these martins in the side of a pit dug for building sand. I was surprised to find nearly fully-fledged chicks on 25 July, midwinter, as I had thought they bred in summer. They made their presence known by their soft "churru-churru-churru" calls that issued from the hole every time I peered into it with a torch. They spent most of the day near the entrance of their tunnel waiting for the abrupt arrival of their parents carrying beakfuls of insect food.

The chicks presented a strange appearance when huddled together at the entrance. They wore pale-coloured skin round their gapes to enable the parent birds to see exactly where to thrust the food when they arrived so suddenly in the dark chamber. The chicks shiver when a parent approaches. This shivering facilitates discernment by the parent and pinpoints the exact position of the mouth outlined in white. The feeding is accomplished in a matter of seconds. A parent dives from the sky and shoots up into the hole with scarcely a feather brushing the doorway. In a flash the bird emerges again and flies far out of sight away from the nesting area – perhaps as a protection, not lingering in the vicinity, which could draw attention to the site.

Assembly-line Violence

About a year ago, just before moving to a new home, I watched a TV programme for the last time just before packing the set in its box in preparation for the removals van. I was about to switch off the programme when the next one began. It showed three men in the act of terminating the life of the fourth one - or trying to. He was punched in the stomach, kicked and left unconscious by the three, who then set his house on fire and left. I pressed a button to change channels; and the alternative show was advertising an upcoming movie: This one showed three men threatening a fourth in a dark alley. This time the victim had a razor thrust up his nostrils. So I switched off the set and packed it in its box . . .

Nobody in my family cares much for TV, and we kept putting off erecting an aerial – if and when we ever gave it a thought. Later, when I unpacked the set, and got it temporarily in operation, I realised that a year had passed since I had last watched anything on it. As the picture materialised I found myself watching a famous muscle-bound macho man spraying his opponent with bullets as they sped along the street in their respective cars. The hero did four things simultaneously: drove a car at high speed through the traffic, kept a matchstick between his lips, kept those lips set in a perpetual sneer and shot his opponent through the car window as the cars temporarily raced abreast. I switched to an alternative channel, to find two men knocking each other senseless in a boxing ring . . .

All this violence is imported from that great bastion of liberty, civil rights and righteous government, the U.S.A. The country that gave the world Abraham Lincoln and Martin Luther King. The strange anomaly is that a people with so much potential as a civilising and peace-keeping force should also be the greatest manufacturer, exporter and consumer of simulated violence in the world. This fast-selling product leaves the Hollywood conveyor-belt to find its way into millions of homes worldwide; to be watched by children in their millions, regardless of the protests of their parents, most of whom have given up the struggle because violence has been around for so long and in such great quantity that it has become part of "normality", part of "civilisation", like washing machines and supermarkets.

The main wow-factor in these films is a hero who can snuff out human life with bored nonchalance. You see Schwarzenegger kill and maim five opponents in as many seconds and stroll away casually without change of expression.

How strange the anomalies and contradictions. We have real violence going on in Afghanistan, Central America, Angola, Iran, Iraq. It flows in a steady stream on the news, year after year. The real thing. But that's not enough: we must needs also have simulated violence to be entertained, to feel normal, to be part of that civilisation. We ignore the advice of the most civilised and gentle of all men when He said: "Consider the lilies in the field, how they grow..." The prophet Elijah had to learn that the real power of the universe was not in violent tempest, fire and earthquake but in a still, small voice (1 Kings 19:11-12).

Questions for Dads and Sons

This is a difficult piece to write, because I want to reach the heart of the hunter, the rich man who can afford to give his young son a rifle, perhaps with a telescopic sight.

I want to write in such a way as to stir compassion in the hearts of all fathers and sons who hunt.

That makes me sound as though I'm speaking on God's behalf, and those fathers and sons will reject the lot of it; what's written will be wasted.

No one listens to the jabberings of an eco-freak, and no hunter can bear sentimentality. Sarcasm will only harden him, it has no quality of reconciliation.

So what is left? As I said, it's hard – not so much because hunters are heartless, but because traditional attitudes are hard to change.

Perhaps questions can reach where pleas and hard words cannot. Questions a hunter may ask himself:

Have I ever pulled the trigger just as the animal moved, thus sending a bullet into his haunch instead of his heart, and he's off and there's no possibility that I can ever find him? He could take three days to die.

Do I think that hunting is a sport after that? Can I enjoy it any more? Shall I tell my son, or shall I lie about it when he sees me cleaning my rifle?

Didn't the bushbuck stand still?

I've just shot this duck. Do I know why its scientific name is *sparsa*? That means it's sparse in numbers, scarce, perhaps soon to be an endangered species.

Am I quite sure that it hasn't got six chicks somewhere among those reeds? Now that the parent is dead, the six will soon die too. Damn! That's ruined my day.

Why do ducks sometime hatch chicks out of season? I can't remember. What am I going to say to my wife when she sees it? I can't tell her about those chicks. I can hear them piping away in the reeds.

Am I enjoying this outing? Hemingway and Selous and Roosevelt were hunters, and they were famous and great, weren't they?

But I wish I could get rid of the sound of those ducklings calling their mother. Mother? That's right, she's only a duck, but she's a mother!

When a tribesman uses a wire noose to catch a buck, is he more cruel than the hunter with a bow?

A compound bow can cost R400 to R600, and when your monthly income is R3000 that isn't much. But a tribesman on R15 a month?

Imagine yourself a tribesman. You crave meat above all things. Not surprisingly, so does your son. You cannot possess a gun, so you make a snare.

One day you catch a buck and your family has meat, the first good meal in six weeks. The memory of it! Your family called you a great father and you felt proud for many days afterwards.

But consider the deadly compound bows and hunting with them, the ultimate sportsmanlike way to hunt. Questions might be:

Does the animal really stand any chance? And if it does, so what?

If I let the arrow fly and it's a bit off the mark, do I spend a sleepless night because the buck bleeds and bleeds as it drags itself about?

And if I do sleep, does that mean I'm asleep in more ways than one? Asleep to the need for compassion?

What am I teaching that boy of mine whom I profess to love?

Will he go against me one day for my sport?

Awkward questions, troublesome truths . . .

They are subjects to be avoided carefully at the next hunters' braai, but which nevertheless haunt each one of us in one form or another.

Jeff Huntly

The Ruby Flower

A helicopter speeds above fields of snow and ice, the bleak treeless landscape that once formed a barrier to all except a few hardy trappers and Eskimos; a forbidding barrier protecting the polar bear; a vast white world of silence where the bear was king and where he could observe and hear from afar the heavy plodding footsteps of man. He would slip away then, keeping low to avoid being seen and so live on. But now . . . the helicopter banks and circles as the pilot spots a polar bear down below. The metal dragonfly lands, perspex doors open and the man gets out holding a rifle with a telescopic sight. The bear is already dead, having been shot from the air. The man is photographed, foot on bear and smile on face, then two other men from a second helicopter skin it. This is known as "taking the robe", an expression used long ago when Red Indians, cowboys and trappers skinned bison.

Soon the trophy is complete with head and paws intact. Carefully cleaned, carefully wrapped, carefully packed; then away goes the metal dragonfly with its transparent eyes. It circles the skinless carcass with its stump for a head and four stumps for paws. As the aircraft gains height the carcass looks pathetically small lying at the centre of radiating rivulets of blood that instantly freeze. From their height the men take a last look at their work. Unwittingly they have created a work of art; from up there the carcass is like a ruby flower complete with radiating petals.

Like the polar bear, the kudu is rated among the greatest of trophies in the world. The spiral horns are measured in a certain way, and these facts are reverently recorded in the pages of a famous book. Princes, sheikhs, presidents, sultans and tycoons have their names in this tome – this record of what was once considered brave deeds and sportsmanship. Once . . . witness a flourishing industry today, to satisfy the hunting instincts and inflate the macho "image" of the new generation.

Meanwhile, back at the ranch (literally, for there are a lot of kudu surviving in African ranching areas) the kudu is doing a good job of keeping his end up. As a species he is cunning and possessed of acute hearing, sense of smell and sight. He keeps in cover. He is quiet, and outside game reserves he manages to survive in a surprising number of places, often near to man. Unlike the exposed polar bear he could give even a helicopter the slip among the dense mopane bush or thorntree cover or vast savanna bushwillow (Jesse Bush) thicket in some parts of his range. The fact that his proud head graces the wall of many an exclusive club, hotel, farm veranda or bar does not mean that as a species he is easy to hunt; but rather testifies to his wide distribution and great numbers.

Snake Weasel and Moles

In a previous article I described wild life artist Shirley Walsh's sighting of a pair of Snake Weasels engaged in a strange whirling motion in the middle of a tarmac road. In exactly the same place, months later, I saw an equally curious sight – a Snake Weasel chasing two Golden Moles across the road. The moles "ran" in that extraordinary manner unique to moles. The whole body seems to quickly wobble like a jelly inside the apparently loose fitting skin. Although a great deal of effort was involved in running, their progress seemed very slow compared with that of the Snake Weasel who came after them and began biting one of them.

Unfortunately the Snake Weasel caught sight of the approaching traffic and he turned around and

Weasels preying on Golden Moles, although two books reported mole-rats and referred to the Snake Weasel hunting rodents in their underground passageways. It was one of those "lucky strikes" one has on rare occasions usually after months or years of seeing nothing at all of Snake Weasels. Although I had walked the veld for years in other parts of Africa where Snake Weasels occur I never saw them until I moved to Natal and saw them on four different occasions all at World View, Pietermaritzburg or on Old Howick Road just below that prominence.

The Snake Weasel's body is ideally suited to slipping down into the burrows of moles, mole-rats and various other underground dwellers – probably the gerbils of larger size (Genus: *tatera*) whose burrows would

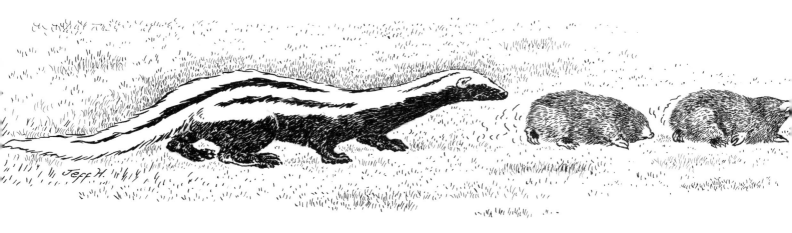

dashed back into cover – unfortunate for him, for he lost his prey and unfortunate for me, for I lost a rare chance to see how he got his mole. Everything seems to happen at once in these encounters and I barely had time to see the Golden Moles disappear into some grass on the roadside. There was nowhere to stop and in any case the Snake Weasel had probably returned to its hiding place or had gone underground – perhaps in search of more moles.

From witnessing this brief episode I realized that this Snake Weasel had flushed the moles from out of their subterranean burrow. From seven authoritative books on African mammals which were consulted I could find no mention made of Snake

accommodate the Snake Weasel. Two famous artist-naturalists in England and North America respectively record Weasels as hunting various rodents and moles in their subterranean passages. So there seems to be nothing surprising in their African counterpart hunting moles in the same way. The artist-naturalists were Archibald Thorburn, who made exquisite paintings and personal observations from life of the Weasels in his *Mammals of the British Isles* (1921) and John James Audubon who made voluminous notes and paintings of American Weasels in his mammoth undertaking *The Viviparous Quadrupeds of North America*, completed in its third and final edition in 1852.

Dormice

The various forms of Dormice are all interesting and some are prettily marked such as the Black and White Dormouse, descriptively named Gemsbokmuis because of its resemblance to that handsome antelope. No less beautiful is the Rock Dormouse (illustrated) with its large dark eyes for seeing at night, its soft grey back and pure white underparts exquisitely contrasting with the delicately-coloured pink of its nose and feet. The fore feet might be called hands, for they are used as such when the animal feeds or clambers up rock faces and treetrunks. The bushy tail completes the squirrel-like effect with the long twiddling whiskers adding a note of humour.

A family of Rock Dormice shared my studio with me when that outbuilding abutted a rocky kopje. I found them interesting and entertaining creatures and, although they sometimes caused damage to property, I enjoyed their company. Occasionally when I worked late into the night I would notice a dormouse watching me, peering down from the safety of a window pelmet. An electric light cord stretched from the pelmet across some open space to a lamp on top of the high bookcase. If I arrived suddenly at the doorway and switched on the light I would see the cord jiggle from side to side, having just been used as a tightrope. Often at these moments the dormice would utter a most curious sound, which I interpreted as derisive laughter between themselves at my futile attempts to see them tightrope-walking. This sound can be perfectly imitated by taking a match half out of the box and closing the drawer of the box against it. If the matchstick is then held under pressure and drawn quickly backwards and forwards it makes a buzzing, squeaking sound, or a choppy chuckling sound like the one the Rock Dormouse makes.

Rock Dormice have flattened skulls to help them to creep into narrow rock crevices and split boulders. They have four toes to the forefeet and five to the hind and they can easily clamber up rockfaces. I watched a dormouse flatten itself against an almost sheer rockface and swarm up without hesitation. It was completely spread-eagled and its movements reminded me of a furry spider going up a wall.

The tree frequenting Arboreal Dormouse was found by Dr Austin Roberts in the abandoned nests of weaver birds, and he also records in the *Mammals of South Africa* that Sir Guy Marshall found the Kellen's Dormouse nesting in the football-sized nests of one of the community spiders. They hollow out the spiders' hotel and line it comfortably to their own specifications. Marshall said the spiders hung about in the near vicinity after having been ousted by the mammals! Similarly I found the Scarlet-Chested Sunbird usurping a large silver nest of these same Community Spiders. The spiders, which are small (about the size of tinned green peas) became a source of food to the Sunbirds, who picked them off the twigs where they unwisely hung about.

Rock Dormice are pugnacious and will attack a stick or finger poked at them if they are trapped in a cage or other confinement. I was brought one of these animals by a tribesman, and it served as a model for the drawing, after which it was released. While in its temporary cage it showed a courage quite unlike any ordinary mouse.

Footnote: In a way Rock Dormice living in farm buildings are the nocturnal counterparts of the diurnal lizards. Both creatures derive a good livelihood catching insects attracted by electric lights to the buildings.

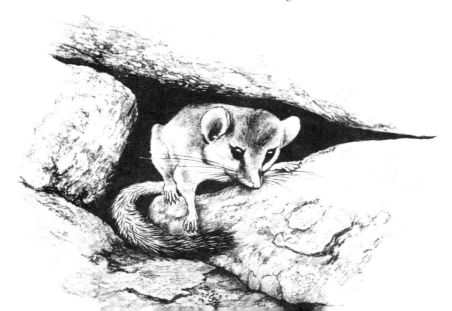

Bee-eaters

Migratory birds such as the European Bee-eater (illustrated) move in a perpetually sunny world. When our planet tilts its lower half and brings the southern landmasses into more direct rays of the sun, an innumerable host of avian migrants move in time with the tilting. Only a handful of millionaire human globetrotters can match these sun-seekers.

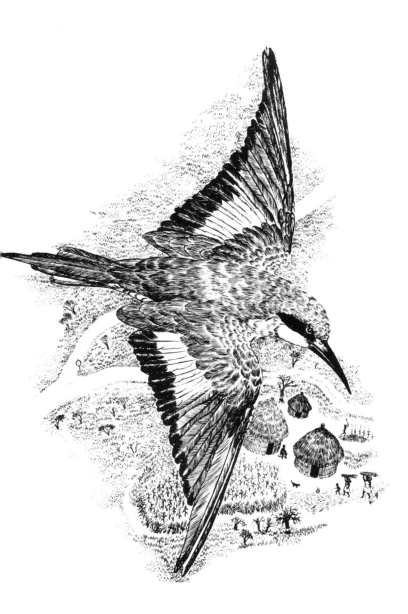

Few migrants can compare with the European Bee-eater for rainbow colours, elegant design and speed of movement when flying. The other African bee-eaters are less given to globe-trotting, being content to move seasonally more or less within the African continent; except the Blue-cheeked Bee-eater, which travels farther afield to breed.

The Bee-eaters have some strange habits – the extremely beauteously hued Carmine Bee-eater, which is mostly pink, often rides on the back of the giant Kori Bustard, to fly out from that convenient mobile platform and catch any insects put to flight by the Bustard's feet. One may see a Drongo doing the same thing from the back of a grazing horse.

The Little Bee-eater found in many parts of Africa is a great catcher of small blue butterflies. It is less inclined to fly vast distances like its bigger brethren and it is less gregarious. Sometimes one may see only a solitary individual or a pair sitting sunning themselves near a sandbank into which they have bored their nest-hole. At the approach of night and when not sleeping in their nest burrow they may sleep huddled together on a twig – sometimes in a group. This sleeping in a cluster is also practised by the Swallowtailed Bee-eater, presumably when not breeding. At daybreak I was once the interested spectator of a small flock of Carmine Bee-eaters that suddenly peeled off from their formation high in the sky to skim down almost at ground level and circle round a lamp-post in a village street. Although it was daylight they may have been hawking nocturnal insects that had remained in the vicinity long after the street-light had been switched off. It was a marvellous experience to be surrounded at close quarters by these, the largest of African Bee-eaters, which one normally only hears passing overhead making their distinctive deep-sounding "croo-croo-croo", as always at a great height and too far off to see clearly.

On another occasion, I watched a small group of Swallowtailed Bee-eaters that had discovered a bark beehive lashed to a branch in a high tree. The bees were passing to and fro at the entrance to the hive and the birds sat about among the dry leafless branches and snapped them up with a dexterous swoop and clipping-shut of the beak. As it was winter and therefore not their breeding season, the birds looked drab and dishevelled, not the sleek gleaming creatures of the colour-plates of bird-books. They stayed at the beehive for nearly an hour, stuffing themselves with bees.

Baobabs

My father Norman Huntly, told me an interesting story about a certain baobab of great size and therefore of great antiquity. The local tribesmen of those times (c.1907) in the Rusambo district of Rhodesia (now Zimbabwe) regarded the tree with awe, and some believed that at certain times, particularly in the rainy season, it "spoke". Norman recalled that one day while at work on some mica claims he heard sounds coming from the direction of the big tree. He described them as "something between the lowest notes of an organ and the rolling of distant thunder". It was as though the great baobab were muttering to itself, from time to time lapsing into silence, then once again resuming its arboreal soliloquy. He said it gave him an eerie feeling and pleasurable excitement when speculating on the cause of it.

He walked towards it, not without some embarrassed trepidation when he felt his scalp tingle as the sounds grew louder. Soon he stood beneath the towering trunk and noticed that the sound seemed to come from that part of the tree where the branches radiated from the trunk. Accordingly he looked for a means to climb and found a smaller tree growing near enough to the baobab to form a ladder. It was then that he also noticed a doorway cut into the trunk which had been completely blocked up with stones, evidently many years before, for bark was beginning to cover them from the sides. The Kori-Kori tribesmen of those far-off days used to cut entrance holes into the sides of old hollow baobabs whenever suitable ones were found along their pathways. These hollow trees provided shelter for the night to anyone overtaken by darkness when travelling between kraals.

Clambering up the smaller tree, he reached the first of the huge branches and was able to pull himself up and stand. A great rushing noise greeted his sudden arrival at the top of the trunk, nearly causing him to slip. He kept his balance and saw the cause of the mystery. The cavernous hollow of the trunk had become overgrown with bark forming a large natural depression in which rainwater accumulated. It made an excellent watering place for all the birds of the district, and they came to bathe in it. The fluttering of many wings simultaneously on the water caused vibrations to pass down over the hollow drum below and made the strange organ sounds.

The rushing noise that almost caused him to fall was the concerted effort of many birds to get into the air when his head appeared so unexpectedly in their midst.

Babes in the Wood

The life drawing depicts three baby hadedas in their nest of sticks in natural woodland on a mountainside. I was fortunate in being able to look into the nest with binoculars, since the tree was slightly below me in a ravine. The young birds and their nest were extremely hard to see, so well had the parent birds selected the site. Moreover, the chicks were dark brown, mottled with fluffy down, and merged so well with the colour of the nest as to be almost invisible except through binoculars. I was able to draw them by close scrutiny through the lenses without disturbing either the babes or their mother, who sat near the nest.

Hadedas are good parents and make up for their badly constructed nest in the tender care they lavish on the chicks. I visited the nest during a storm and saw the mother bird sheltering the chicks with her body and half-open wings. It was heart-warming to see the little woolly heads peeping out from under their mother's wings. She stoically remained at her post, sheltering the youngsters while the rain poured over her. Water dribbled down her long curving beak and she flicked it off periodically.

The drawing session introduced me not only to the hadeda domestic scene but to the sound made by fledgeling hadedas. This curious little sound is a miniature version of the hadeda call so familiar to people in many parts of Africa. By having to remain for an extended period near their nest I became aware of the sound, which was made by one of the chicks at roughly twenty-minute intervals. It was a drawn-out, high-pitched squeak, and it reminded me of one of those rubber toys squeezed by children. If I had not been near the nest for a long time observing them so closely I could never have guessed what made such an extraordinary sound.

One's first impression of hadeda chicks is that they have beaks more like those of geese rather than the long curving bills of their parents. As they grow and lose their down so the beaks lengthen to become the efficient soil-probing instruments specially adapted to digging for earthworms. The beak and body of the hadeda seem too big for the legs, which by comparison with other walking birds seem ridiculously short. The broad wings ensure great dexterity in flight enabling them to twist and turn between branches and trunks of their nesting sites. The tail feathers are short and fit within the outline of the broad wings.

Hadedas belong to the Ibis family, which has got stuck with an onomatopoeic name in all the languages. The South Sotho name of "Man'an'ani" comes nearest to an onomatopoeic rendering of the birds' braying voice. The other three Ibis species in southern Africa are relatively quiet birds compared with the hadeda.

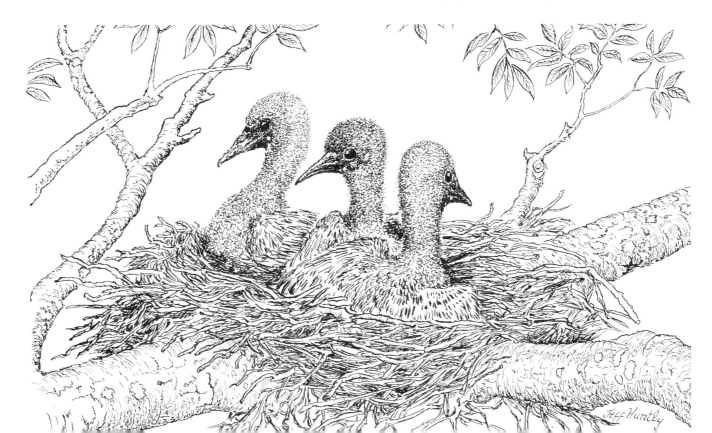

Blue Duiker and Crowned Eagle

In places where the Blue Duikers' range coincides with that of the Crowned Eagle, the secretive little antelope sometimes falls victim of an attack by the Crowned Eagle. Both stick to moist forest areas and the Blue Duiker is adept at finding trails beneath matted bush and overhanging branches, twigs, stems and leaves. Occasionally, however, the antelope ventures out into a forest road or fire break, perhaps tempted there by some fresh green sproutings. Leaving the dense overhanging protection of twigs and branches he is temporarily exposed to the Crowned Eagle.

I was "astonished beyond measure" one day to find a freshly killed Blue Duiker lying by a forest track. It had obviously been overpowered by some very powerful creature. I immediately said "leopard" to myself and thought the little buck had been killed by one of these big cats and abandoned there. But upon closer examination I realised that a Crowned Eagle had swooped down upon the buck, killed it in its huge talons and had begun to disembowel it. A huge gaping cavity had been made in the buck's stomach and large internal organs removed. These parts had been placed neatly on one side so that nothing remained inside the stomach and chest cavity.

Amazing to relate was that the eagle had neatly clipped tufts of buck hair from the stomach area before it had made any incision into the actual skin. I marvelled at the razor-sharpness of a beak that could cut tufts of hair – each tuft cut with a straight edge to it and also placed neatly to one side separate from the pile of stomach and chest organs. One may see identical tufts of hair with a straight edge where the scissors have cut on the barber shop floor.

The eagle had selected and eaten the meat around the ribs: what we would refer to as the spare-ribs. Evidently something had disturbed it and it was nowhere to be seen. I had a feeling that it was waiting in some nearby forest tree so I only lingered long enough to make notes and take some flash-photos. I was fortunate to have my flash camera as it was getting dark under the overhanging wattle trees on that road. I had not properly finished sketching and making notes however when a tractor, with two men on it, bore down the road towards me. Knowing that the men would take the antelope if they caught sight of it, I began a distraction behaviour activity of my own – after the manner of a ground-nesting bird wishing to detract a predator away from her eggs. I hopped on one foot feigning injury and the two men stared at me in astonishment! They rode straight past the dead buck not noticing it and as they drew abreast of me they smiled when I waved to them. Soon their noisy tractor had gone beyond a bend and I was able to examine the area around the buck for what I needed to prove that this was indeed the work of a Crowned Eagle. I soon found what I wanted: some eagle feathers (several from the legs and one breast feather) and, more important, a perfect eagle footprint with deep holes where the claws, particularly the huge hind claw, had sunk into the damp earth of the forest roadside.

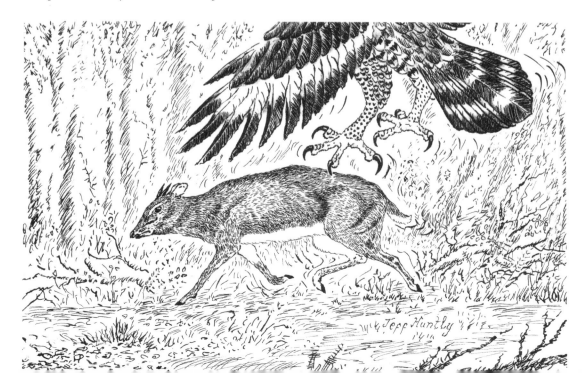

Habitat Destruction

Here it is: one of Africa's many engines of destruction made to carry bags of grain, poles or fire-wood. Apart from its job of carrying loads it also wreaks havoc on the dusty roads on which it is used. Its wooden wheels bite deep into the top-soil made soft and friable by the sharp hooves of oxen or donkeys employed to pull it. In a year or two the track deepens until it becomes a young gully. Old gullies have steep sides, are dark at the bottom and can swallow people, oxen, tractors or anything else that falls into them.

But another vehicle is an even worse gully-maker and must have played its part in the creation of the Sahara Desert: the forked treetrunk sledge. This creation is still made in many parts of Africa by converting a heavy forked trunk into a "Y"-shaped sledge. Some thin poles are fixed across the "Y" to make a platform to carry a load. This hellish contraption is then harnessed to four under-nourished oxen and driven its dusty way to the local meal mill or to the country store where the grain is sold.

I once trudged beside a whiskered whip-wielding old peasant and asked him what he would do when the road washed away into a gully, which his sledge was creating. He looked surprised at being asked to consider something that would happen as far in the future as two or three years. "We'll have to go on a fresh strip of ground next to the gully," was his reply.

From these two destructive creations of hard-working peasants sometimes living close to starvation we may turn with regret to two sophisticated engines of destruction created for the pleasure and leisure of wealthy, tanned and thoughtless Americans, Australians and South Africans – the beach or dune buggy and the high-power boat. These machines are another nightmare to conservationists and environmentalists. They rip up fragile, interdependent ecosystems, pulverise any ground-nesting birds' eggs, shatter the silence needed by breeding birds or mammals in shore-line bush and cause disintegration of the dunes by ripping up thin plant-cover.

Power-boats with a noise-factor of three lawn-mowers running amuck send birds exploding into the sky in panic. Pelicans, cormorants and all other lagoon and shore-line species are adversely affected by power-boat disturbance. These fast-moving boats leave a heavy wake that washes eggs out of floating nests.

Eggs of jacanas, dabchicks and others nesting near water level on floating vegetation are often washed away by the wake. If the din of engines continues long or regularly enough the birds move to quieter places. Likewise the mammals that prey on them, like a chain reaction. Otters, water-leguaan, water mongoose, serval, etc., etc. "We'll have to go" they say.

Some Female Contrasts

and Vanishing Trees

If you fly over any part of the African continent you will notice, as you approach an airport to land, that the town is often surrounded by a treeless area. Regardless of the size of the town, there is always this wide circle devoid of trees. Small African villages illustrate this phenomenon best, because the entire picture spread out below can clearly be seen.

In the centre of the picture is the village or small compound. Radiating from the centre, like spokes of a cartwheel, are footpaths made by women on their incessant journeys to collect fuel from the surrounding veld. They cut young trees or long thin branches and

acquired from years of walking with some object balancing on their heads – firewood, a pot of water, a sack of meal, a basket of fruit: anything; if it can be balanced on top of a head up it goes. Some of the girls have sleeping babies slung at their backs.

Directly above these women the stewardess does *her* final walk between her charges to one end of the aircraft. She wears high heels; her gait is therefore more stilted than that of the barefooted carriers only a hundred metres below. She learnt to walk that way at deportment classes and always to smile and humour the passengers regardless of their manners. Air

tie them in a bundle to be carried home. This mode of collecting firewood goes back to prehistoric times and, like so many things in modern Africa, provides an example of extreme contrasts between the "developed" and the "undeveloped".

As the jet comes in to land the stewardess makes her last check on her passengers, attending to the comfort of grey-suited "executives" and the two little girls playing with Dad's highly complex, expensive pocket calculator. Dad is asleep anyway, not even his bright-eyed children could keep him awake on this, his umpteenth jet trip on business. Just below the passenger plane as it makes its landing approach we can see a line of women walking in single file along a footpath. On their heads they balance long bundles of firewood. They walk purposefully, swinging along barefooted and with natural grace

hostesses and peasant wood carriers pass one another momentarily – the one to go home to a microwave oven in a flat in a highrise block to prepare her meal in seconds; the others to an open wood fire between three stones upon which a simmering pot of beans is balanced.

Jets and bare feet, microwaves and wood fires almost side by side, within hailing distance of one another.

With the passage of time the paths leading out from the towns get longer. The women have farther to walk to fetch their firewood. Suddenly their traditional method becomes obsolete. Villages can no longer be moved to new areas where trees are abundant. The vanishing trees and, eventually, the vanishing people.

Fieldmouse

Part 1

Wildcat Catches the Mouse

While driving along a deserted farm road one late afternoon, I noticed an animal far ahead of me. I stopped, switched off the engine and trained my binoculars on it.

It was a wildcat, trotting slowly along. From time to time it would stop and peer intently into the grass on its right. Presently it stopped and crouched, tail extended and head level with the ground, staring at a particular spot.

I strained hard to keep the binoculars steady and pressed them against the windscreen, for by now I had been holding them in position for several minutes. I felt sure I should see something interesting if I were patient, for never before had I seen a wildcat without its being aware of my presence.

Soon the cat moved swiftly, shooting out a paw; and a fieldmouse was in its claws. The whole action took scarcely a second, and the mouse seemed almost to run into the waiting cat.

The cat ate its meal, stopping from time to time to listen and peer furtively about in that savage, suspicious manner of a feline. Having eaten the fieldmouse it licked its paw and was gone.

I was puzzled that the mouse had run, as it seemed, straight into its waiting claws, so I made a careful inspection of the place. I found the answer.

Fieldmice use regular pathways beneath the tall grass; in fact these paths are more like tunnels, and one of these little highways crossed the road at the point where the cat was waiting.

It seems that fieldmice scurry about looking for their last meal of the day just before sunset, and this one had blundered into the cat.

It was quite evident that the wildcat could hear the soft patter of feet and occasional squeaking issuing from that small area as he went down the road, and when he found the crossing-place he waited there, expectantly, immobile, silent as a stone; totally efficient.

Wildcats are very secretive, and afford few opportunities to observe their ways.

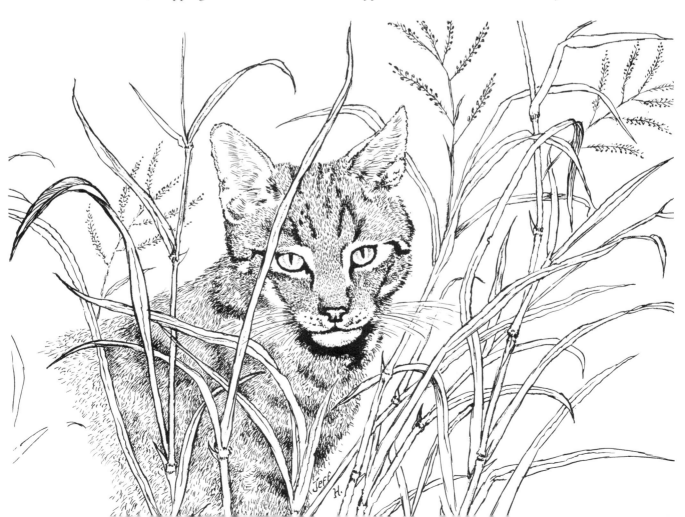

Wattled Crane

The greatest of the African Cranes, this species is also one of the most wary and unapproachable of all birds. It has good reason to distrust its traditional enemy, Man, and this constant alertness is no doubt one of the main reasons why such a large terrestrial bird has survived up to the present day. Its habitat and particularly its psychological requirements of wide open spaces providing quiet solitude are incompatible with man's expanding "progress". More and more open grassland will be smothered beneath dark alien forest to supply the ever growing demand for timber.

The cranes, bustards, storks, Secretary Birds and other less spectacular species which rely on open grassland for their survival will be hard pressed to find suitable conditions. Even the little Blue Swallow is living on borrowed time in the face of habitat loss due to afforestation. History will record whether efforts now being made to save the species from extirpation were successful or not. Such long periods of time are involved and so subtle are the changes that are being wrought everywhere that a species like the Wattled Crane could quietly, almost imperceptibly reach the point of no return just as the Passenger Pigeon, the Dodo and the beautiful Huia of New Zealand have done in their several and tragic ways.

The Wattled Crane is fully aware of the need to make a nest beyond the reach of jackals and other predators. Its choice of nesting sites on islets in wetlands proclaims its intelligence. These boggy situations are difficult, if not impossible to traverse, even by humans. Thus the great bird evades its enemies by its own cunning. Two pinkish-beige mottled eggs form the clutch but only one chick is reared. This craneling is quickly led away from the nest as soon as it is able to walk strongly and its feet find support enough on matted wetland grass and sedges. They can wade through the shallow water around their nest when the need arises. The nest is hidden in dense wetland grass, sedge or reeds. It is made of this piled-up vegetation, its base resting in a soggy mass.

Cranes are famous for their dance displays most often made just before the breeding time. The birds indulge in ceremonial posturing and strange movements, some of them comical, all of them beautiful.

Crowned cranes may sometimes mimic one anothers' movements – a curious ceremony in which the females' posturings are immediately repeated exactly by the male.

The dancing of cranes has enormous appeal to people who can so readily appreciate these courtship rituals. The poetry of movement, obvious excitement and spectacular visual impact are all unforgettable. Even when quietly strolling along or resting immobile in reverie the Wattled Cranes draw the eye and rivet the attention. They are an extremely valuable asset to the country's tourist attractions and, if properly conserved in areas specially suited to them, will draw people from overseas. Unfortunately such a possibility is beyond reach at present and may always be so on account of the birds' need to fly huge distances, far beyond the borders of protected reserves.

The sight of Wattled Cranes and antelope in mixed groups must have been more often seen by hunters and travellers of long ago than today, although such scenes from the "Old Africa" may still be seen in some areas. No doubt Wattled Cranes and antelope felt secure in each other's company. A memorable sight at all events.

Wetlands

The wetlands of Africa are very valuable. They form a vital part of the environmental-ecological health of the continent and therefore of its people. Yet vleis, marshlands and river banks are carelessly abused, exploited and destroyed by the very people whom the continent supports.

In many African states crops are grown in vleis and on the sloping sides of river banks. This causes soil erosion and the denuding of topsoils. In one area government field workers erected wooden beacon markers along boundaries of wetlands to preserve them from peasant farmers. This was done in conjunction with village-by-village instruction programmes to teach people to cultivate away from river banks and vleis and to keep on one side of the line of beacons. I visited the project a week after the instructors had left. All the wooden markers had been removed for firewood and women were digging happily away in the protected areas! Age-old traditional methods of cultivation were ingrained; but that government is making some progress in breaking down the fatalistic attitude of only thinking of short-cuts and never planning to conserve anything for tomorrow.

The butterfly in the drawing is a true wetland species found in suitable places in Natal and northwards. It is the Marsh Commodore *Precis ceryne*, and it is shown feeding on the clear deep-blue flowers of the Vlei Salvia with a Red Hot Poker flower to the left. These and other flowers adorn the wetlands and attract birds, butterflies and hawkmoths. Although Marsh Commodores and Red Hot Pokers are found in Natal the Blue Vlei Salvia *Pycnostachys*

stuhlmannii is Central African – but the conservation message is the same worldwide.

Wetlands are threatened by some of the most advanced farmers who need additional land for their crops or herds. The marshlands are drained or otherwise utilised, and Wattled Cranes, Crowned Cranes, Marsh Harriers, Flufftails and many other birds are hard put to it to find suitable wetlands with sufficient privacy for them to breed. The Wattled Crane is desperately in need of quiet wetland retreats in which to breed. But these places are becoming fewer each year. Who cares? Some dedicated farmers; yet such people are still too thin on the ground. The Natal Parks Board and National Parks people can't do it alone – they can't be everywhere at once. Farmers can do so much to save the Wattled Crane, perhaps in the nick of time by working out alternatives to using wetlands. Perhaps the Wattled Crane will survive extinction, but if it does it will be by a hair's breadth in South Africa. To the north its prospects seem better; but only where the human population has not overreached itself by way of the Unthink Factor.

Marsh Commodores and wetland flowers may seem to have little importance to the survival of mankind. But they are in fact living pointers or witnesses to the general well-being of the environment. Like the Peregrine Falcon – if he still flies it means that mankind is doing something to control insecticides. Falcons aloft mean that we are still all right and not tarnishing our entire world. At long last we see hawks as our necessary friends, not to be ruthlessly shot because they take the odd chicken.

Skulls

The three skulls are from birds killed by cars on a main road. Top: European Bee-Eater, centre: Barn Owl and the small lower one a Blue Waxbill.

Some interesting points immediately become apparent when the skulls are examined. Barn Owls appear to be larger than they really are, and European Bee-Eaters when flying about appear visually smaller than they really are. The entire skull of the Blue Waxbill fits into the eye socket of the owl.

The skulls of bee-eaters and owls are so thin and light as to be translucent and reminiscent of a ping-pong ball. The large eye-cavities indicate the importance to birds of these windows of the body – even more so to those birds that fly at night; thus the largest eye-spaces are found in the skull of the owl.

The skulls also show how a bird's way of life shapes its outward physical appearance. The splendid rapier-like beak of the bee-eater ensures that its possessor seizes the bee and kills it in that portion of its bill where stings are ineffectual. A bird with a short beak, like the waxbill, could be stung on its tongue, throat, palate or eye, and so perish. Notice how far the bee-eater's eyes are from the tip of its bill.

Barn Owls have effectively dealt with countless millions of rodents all over the world and are very beneficial to man. Eyes like powerful light-gathering binoculars, rat-piercing hooked beak and clawed feet combine to make nature's finest controller of the rodent hosts. These features were recorded by the pioneer American wildlife artist, John James Audubon. His pair of Barn Owls with a fieldmouse high above a moonlit landscape is monumental. Audubon painted the night convincingly, and it is easy to understand why his work has never lost its charm. The element of surprise never wears off.

The seed-cracking instrument of the Blue Waxbill is probably shared by a greater number of bird species than any other avian eating utensil. The skull shows how the feathers hide the strong triangular base of the beak. When twenty of these little birds eat together on a feeding tray the combined sounds of seeds being cracked open is amusing and easy to hear from quite a way off. But the sound of a big flock of queleas all cracking seeds simultaneously is astonishing as they approach the hidden observer in a field of grain. Suddenly they spy him and rise like a thundercloud; and they look like a cloud as they pass overhead.

Owls and bee-eaters could scarcely be thought to have much in common, yet they share the strange habit of regurgitating the indigestible parts of their food. Owls throw up pellets of bones and teeth. The pellets of bee-eaters contain beetle wing-covers and other insect hardware, and the common Little Bee-Eater may often be observed characteristically flicking its beak sideways to throw out a pellet. These curious objects may be seen beneath their regular perches near their nesting burrows in a sandbank.

Woodpeckers

This famous, almost worldwide family of birds is considered by some to be the most interesting of all avian families. In England we find the large and beautifully attired Green Woodpecker, while in the New World live the brightly coloured black, white and red woodpeckers of several species.

Africa and India share between them the more sombrely coloured woodpeckers, although these Old World species are intricately patterned with spots, dashes and stipples with, in the males, a beautiful cap of vermilion. When in the action of jack-hammering his way with his chisel beak into a dry tree stem, his red cap becomes a blur of colour and the beak seems to multiply itself into many images. He is aptly called the Feathered Carpenter by Frank Finn in his amusing *Birds of Calcutta*, and Audubon, the American woodsman, wrote humorously of one woodpecker species: "Even in confinement the Golden-winged Woodpecker never suffers its naturally lively spirit to droop. It feeds well, and by way of amusement will continue to destroy as much furniture in a day as can well be mended by a different kind of workman in two."

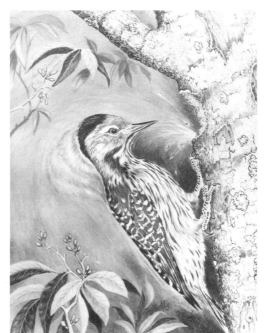

John James Audubon also wrote copiously on the Ivory-billed Woodpecker, which even in his day (the 1820s) was being ruthlessly hunted for its scarlet crest and ivory bill. He called it the Chieftain of all the woodpecker clans because it was the largest and most handsomely coloured. Its rich colour-scheme reminded him of the artist Vandyke's palette. It is indeed a tragic indictment of the American people that this masterpiece of creation, with its great zest for living, should have been hunted to extinction to gratify the whim of idle-rich visitors travelling on Mississippi steamboats. The scarlet crest attached to the ivory bill could be bought for a quarter at any steamboat stopping-place. Some Indian chiefs wore entire belts studded with these cruel decorations.

We jump in time from 1827, with its senseless barbarity towards nature, to the present, and ask ourselves whether men have changed very much in such a long time. Apparently not, for the ratio of those who care whether species become extinct and those who don't is much the same. There were a few dedicated conservationists in Audubon's time who foresaw the extinction of species. There are a few now who fight a losing battle against incomprehension or indifference to hat should be done. Although African woodpeckers have not yet shared the fate of some of the American counterparts, they face the inevitable destruction of their habitat in many parts of Africa as natural woodlands are cleared, either for peasant cultivation or for exotic pine, wattle or gum plantations.

Only a widespread programme to educate peasants and their children and absentee landlords and their children can avert the fate of extinction for the Wattled Crane, the Bearded Vulture and the Bateleur Eagle – front-runners for the Extinction Stakes. Which of these three will be gone for ever by the year 2000? Great birds such as these need comprehension of their welfare outside the game reserves more than they do inside them if they are to survive at all.

Pied Crows

Crows are possessed of keen intelligence and prove it at nesting time, as even a cursory examination of one of their nests will show.

A typical nest recently examined reveals a lot about the wily birds – where they go on their errands and the decisions they make in their choice of materials for their home. The sticks that form the large untidy base of the nest are found only along the streams and rivers where they accumulate among rocks and branches at flood time. The sticks lodge there after the water has receded and become as bleached and dry as old bones. They are strong but extremely light, and when put together they interlock perfectly, which is why they are chosen. Being so light in weight they are easy to carry through the air to the high bluegum tree where the nest is made.

Having been interlaced to form a strong platform near the main trunk of the tree, the sticks are now ready for the softer padding of the interior.

Here we find a mattress of reddish-brown hair and it is easy to imagine the crows pecking away at the rotting carcase of an ox found some distance to the south. A herdboy following the crows would have found the ox, carelessly buried and later dug up by jackals. Other material includes the rust-coloured fibre of strips of bark left lying about by Africans making the bark string used in thatching their huts.

Pieces of black cloth, strips of bright blue calico and ordinary white string make up the rest of the padding in the form of a shallow, snug basin. Four beautiful eggs, the normal clutch for Pied Crows, lie in this setting of russet hair. Contrary to some reports, there are not parasites or lice in this particular nest, although it has a strong "gamey" smell from the bovine hair.

The position of the nest in relation to the trunk of the gum tree is judiciously considered. Its position partly against the main trunk ensures the minimum of buffeting from strong winds and good anchorage for the platform.

Pied Crows choose a gum tree separate from plantations, and if we could observe them over a very long period we should no doubt find that they do that also for a good reason. These crows are regularly parasitised by the Great Spotted Cuckoo. If the cuckoo deposits its egg before the crows have laid theirs, the crows bury the cuckoo egg beneath a layer of warm nest lining. Thus they escape the burden of having to rear the unwelcome cuckoo. They share this curious habit with the American Yellow Warbler.

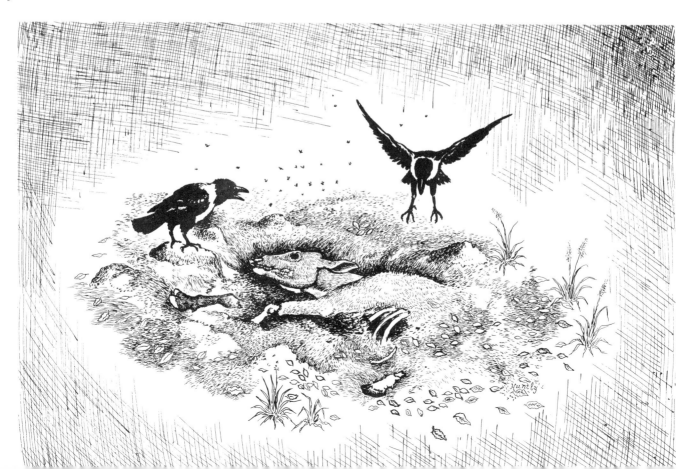

A Science-fiction Fungus

Puzzling and weird, like some science-fiction creation, this fungus may occasionally be found growing in dead organic matter, particularly among mouldy twigs lying under wattle trees. The following description, particularly the references to human faeces, are entirely my idea. Your first visual impression is of a bright red flower shaped like a star with five two-pointed petals. The impression of something beautiful instantly vanishes when you examine the star more closely. For inside the star is a circular shaped mass of glistening brown jell, a wet mucky substance – an exact replica of human faeces! The world of Nature spares you nothing and although you may recoil with disgust at the thought of describing such a thing, yet you are compelled to by the sheer marvel of such a phenomenon! Furthermore, the resemblance to faeces only lasts a short time when it attracts flies. For the rest of the day the resemblance disappears and the sticky substance becomes jet-black. This may account for descriptions in books only referring to the black tar-like appearance. For eighty per cent of its life it remains in its black phase – the wet light brown phase is overlooked.

This incredible creation goes by the name of *Aseroe rubra*. When making this drawing I noticed many insects, particularly flies, crowding or swarming around the "mushroom". An authority on mycology told me that the insects eat the foul smelling substance which is filled with spores and, when they fly away, the spores pass through their digestive systems and are deposited far and wide in the droppings of that insect. The spores also adhere to the insects' feet or mouthparts or proboscis and travel wherever the insect travels! Thus it is that this fungus solves its problem of spore dispersal! A method as bizarre as anything you could ever find in Nature and as anything ever written in a fairytale.

When I first found one of the "mushrooms" I noticed a few egg-shaped structures close to it. These turned out to be the initial stage of *Aseroe rubra*, the sphere in which the spores are made. Inside this orb, which looks like a cobra's egg, is a thick grey jelly. When the spores are ready (or "ripe") they burst from the sphere and are carried upward by a hollow stem, at the top of which is the simulated red lily with its simulated excreta and its simulated excreta smell. If you can imagine an arm reaching upward through mouldy leaf and twig-litter, holding a tray of sticky cakes, you get the general idea. The cakes attract the insect customers who in turn spread the spores to distant places, sometimes many kilometres away.

Only a fraction of the numbers of spores distributed by flies ever reach ideal situations for *Aseroe rubra* to grow, which is why it is seldom seen. Another grotesque species is named *Anthurus aseroiformis*. Instead of sprouting a red star on top of a hollow stem it sprouts red tentacles from its egg-shaped base and looks like some earth-bound octopus squatting in the shadows.

The study of mushrooms and fungi – Mycology – is a complex world with a scientific language of its own. This little sketch merely touches the tip of the gigantic iceberg, yet tries to pose a simple question: How do such things come about? How does the mushroom "know"? "As thy soul liveth, o King, I cannot tell!" (Samuel 17 : 56) And whereas Abner did find out the answer to King Saul's question we will never know the answers to many of Nature's riddles. Perhaps the Creator will keep it that way lest we become too puffed up with ourselves, not realising how little we know.

My thanks are due to Mr Rob Scott-Shaw of Natal Parks Board for help in the preparation of parts of this article.

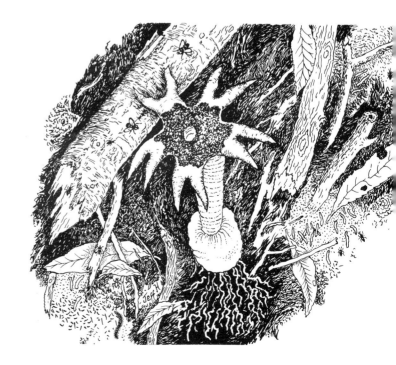

The Bateleur

Its Character and Ways

I know a game farm where the owner has an extensive aviary adjoining his house. It is designed in such a way that you can see into it when having a meal, for the large dining-room window forms one side of the aviary. I sat nearest the window enjoying roast beef while being closely scrutinised by two vultures and a Bateleur Eagle on the other side of the glass. The vultures sat hunched on the window-sill watching my every mouthful and they dribbled saliva from their great hooked beak-tips. Droplets could be seen on the glass. I sadly looked at the roast beef, and rather than be put off I asked to be excused to sit elsewhere. This brought loud merriment from my hosts and other guests, and I realised that it was a trick played on newcomers.

Two Bateleurs lived with an assortment of vultures, Wahlberg's Eagles and a distracted kite that flew up and down the enclosure. My host explained that the huge aviary was in fact a hospital for wounded or abandoned juvenile birds and that they were released when fully grown or recovered from their injuries. He had a marvellous rapport with all animals, particularly birds of prey. His favourites were the Bateleurs, which, unlike the vultures, made the most of their confinement by strutting about inside the cage and showing off to visitors. My host had a large floppy dog, which he made to sit with its back to the cage, and when it wagged its tail the Bateleur would pounce on the twitching object if it came through the wire. The dog would pull his tail away in the nick of time, and the Bateleur would ruffle out his neck feathers like a lion's mane and make an elaborate ceremonial bow. I swear that the three of them knew exactly how much spectators enjoyed their performance. Bateleurs are natural clowns and make affectionate pets. Apart from these great birds, my host had a warthog called Dudleigh, which liked to be scratched on its belly. It would trot up to surprised visitors and roll on to its back for someone to scratch its tummy with a shoe or a stick!

The Bateleur was a natural subject for two of the finest artist-naturalists of the past: Claude Finch-Davies and John Millais. Finch-Davies made several superb paintings of Bateleurs, one of which depicts the cream-backed form, which he believed to be the Blue Nile representative of the species. Finch-Davies, an officer of the South African Mounted Riflemen, painted the rare cream-coloured Bateleur in November 1917 – besides almost every other South African bird and all the colour-phases of its raptors.

John Millais, a gentleman-adventurer and son of the famous Victorian painter, John Everett Millais, wrote and illustrated his classic of the sportsman's life: *A Breath from the Veld* (1895), the record of his idyllic life on the South African plains, often living with Boer families with whom he had a great affinity. Apart from his illustrations of Bateleurs, he describes his interesting personal theory as to why the Bateleur flies with its head pointing downwards and tilted to examine the ground over which it has just passed. Looking where it has been rather than where it is going, so to speak. Millais said that its prey freezes until it thinks the eagle has passed, and it then relaxes and moves about the grass again. Whereupon the Bateleur wheels round and returns like a thunder-bolt out of the sky and seizes the prey; hare, rat or bird. Millais drew the Bateleur in flight showing this curious position of head tucked under the chest, which is unique among eagles, and a highly specialised technique for acquiring a meal.

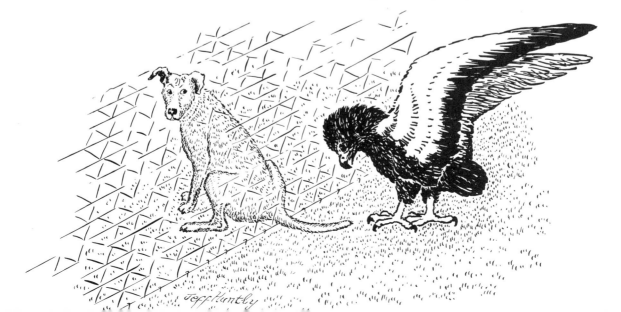

Riders of the Thermals

Warm air rises, and migrating White Storks make full use of the thermals that provide them with a buoyant cushion of support as they glide along. The sagacious storks follow the heated land masses on their journeys, which are in effect a constant pursuit of the shifting warmth of summer. As the planet tilts its northern half farther into the warmth of the sun, so the storks follow its beams and desert the now cooler south. Six months later the position is reversed and they follow the sun south. The sun is their symbol more truly than the mythical firebird, the Phoenix.

Eastern European birds siphon down the Dardanelles and over the Lebanon across to East Africa, which is their main route - with many stopping in between – right down to the Cape of Good Hope. And if ever a bird species needs good hope the White Stork does. Hundreds of them have been shot while passing over the Lebanon by mindless and callous soldiers for no purpose but to satiate the lust to kill.

Western European birds fare better passing over Gibraltar and, incidentally, like the eastern birds, avoid the Mediterranean, where presumably the absence of landheated thermals would exhaust them. So the birds we see each year in Africa have had to run the gauntlet.

I remember as a child seeing great flocks of these White Storks in Rhodesia in happier times for them. Since the end of the second world war storks have vanished from Switzerland and Sweden. The numbers of breeding pairs in Holland have fallen by eighty per cent, and other Western European states have lost half their storks. The decline is not only the result of the wicked carnage over the Lebanon but perhaps even more the effect of an ever more hostile climate for wildlife: pesticides, draining of marshlands, electrocution from power lines, the general spread of the concrete jungle.

Throughout Europe, especially the Scandinavian countries, Holland and Germany, the White Stork is protected as much by sentiment as by law, and it is woven into folklore, song and myth. Its presence on rooftops has always been regarded with favour; some householders even provide nest-sites on their roofs.

It is interesting to read from *The Manual of British Birds* by Howard Saunders, 1889, that "immense numbers migrate through Egypt as far as Natal and Cape Colony, where a few pairs are said to breed when locusts are abundant." Now the numbers are no longer immense, but even up to the present time they breed sparsely in the southern Cape; one nest near Bredasdorp is frequently photographed by keen ornithologists.

Fortunately the White Stork is venerated by some African tribes, particularly Moslems. In Morocco it is regarded as a sacred bird, and from earliest times it has nested on housetops there. Wealthy Moors maintained rehabilitation enclosures where injured White Storks were cared for. It is to be hoped that the practice still continues.

An extensive coordinated Stork census has been conducted by ornithologists. The result is eagerly awaited by conservationists everywhere.

Snares and Ironies

The chief advantage of making a snare is that it requires the minimum of effort and it can be set at intervals along game-bird paths over a wide area. The more snares the greater the chance of success. It's just like roulette or a raffle.

When the bird pushes through the opening the noose closes round its neck. The long stick holding the noose is not anchored to the ground, nor does it need to be. When the bird drags it away the twigs left on its one end soon snag in the grass, and the more the bird pulls, the more the noose tightens.

The trapper is supposed to make a daily inspection to see if anything is caught. If after a week the traps yield nothing then they are merely not visited again and are left in the "set" position. This applies to wire buck snares as well, and one often finds the remains of buck still held by the wire noose but not collected by the trappers.

The poaching problem bristles with troubles and woes for those attempting to combat it. The conservationist's argument finds no response because of hunger and the human craving for meat, in turn exacerbated by overpopulation. The conservationist's efforts are frustrated and game laws become a dead letter when only certain sectors of the community are expected to obey them.

Hunting safaris bring their "vital foreign currency". The hunting fraternity is well known for its efforts in support of conservation. The world-wide million-dollar industry of trophy hunting is threatened with extinction along with endangered animal species. The ultimate irony.

The African snare has a much older history than trophy-hunting, and is more deeply ingrained in tribal character and tradition, and therefore is much more valid in his eyes. Traps are for food. Telescopic sights are for fun.

It is always the wild creatures who are the losers. Perhaps the only ray of hope lies in allaying suspicion of birth-control and the intelligent cropping of prolific species such as impalas and springbuck in certain limited areas where it is practicable. But the rapid increase of the human population cancels out every scheme to slow down the destruction of wild animals and their habitat by man.

In Africa the wire snare is responsible for the terrible agonising death of every species of animal and bird. Roan, sable and kudu are not too big and strong to escape a horrible death from a thin loop of wire embedded in a foreleg. Not even the elephant and rhino escape this diabolical device. The irony is that the wire snare only became universally used after the arrival of the white man, when rolls of thin wire became easily available in any rural trading store.

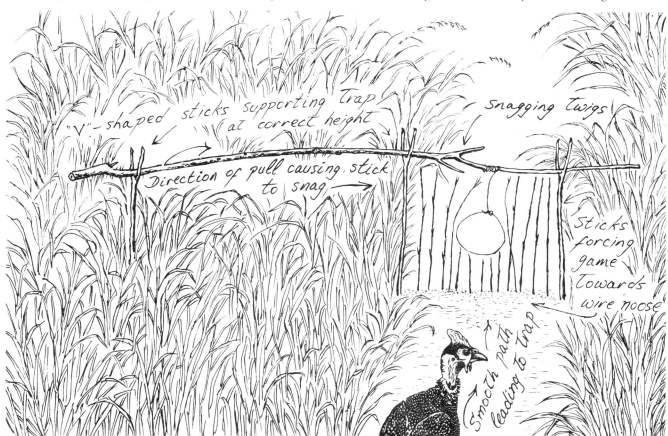

Palm Swifts

Part 1

Streamlined, delicate-looking but actually tough, the silvery Palm Swift is more interesting than the various black or pied swifts that are more typical of the family. They are seen in various African Towns, and possibly they would be more numerous if palms were allowed to retain their old dead leaves. The dead or partly dead palm fronds hang down like a hula grass skirt round the trunk and Palm Swifts dwell beneath the skirt.

I lived in a town where palms retained their dense masses of old fronds, and I was able to observe a huge colony of these swifts.

They were up and about just after first light and could be seen flickering about above the traffic for the rest of the day. Their palmtree dwelling-place was a beautiful avenue between two parallel streets. Another forest of palms observed in a remote area of true wilderness, contrasted with that in the city, but the swifts were just as at home in either setting. On one of my visits to the urban palms very early one morning, I noticed a Palm Swift lying on the tarmac, apparently having been struck by a car. It was still alive and unmarked, and while it recovered in my hotel room I used it as a model for the illustration.

I was now able to see how these birds grip the parallel folds of the palm leaves. Two toes with hooked claws open at right angles to the leg, while two open the other way, thus roughly forming the shape of a "T". The claws gripped my fingers when I carried the bird. Another interesting point is the manner in which the swift defecates without soiling its long slender tail feathers, so essential in maintaining proper efficiency in flight. The body momentarily curves upwards, the tail going up to an angle of 45 degrees and the excretions shot out.

The entire resting, sleeping and nesting periods are carried out in an upward-sloping position wedged between palm leaves. The nest is glued by saliva to the palm leaf, and when the white eggs are laid they are also glued down, so that even if hanging perpendicularly between the leaves they cannot fall out. When brooding the mother bird faces head upwards with her feet hooked into the nest material, which consists mostly of feathers glued to the palm leaf.

Palm Swifts are sometimes preyed upon by Pied Crows, and I watched a crow disturb the entire colony of swifts early one morning. He flew up and down between the palms, happily croaking away to himself, having evidently just dined on swift chicks. The swifts dashed about at high speed, criss-crossing one-another's flight paths in their alarm. While so engaged they emitted a sharp sound like "teep" – quite unlike their normal chittering cry. This is definitely an alarm signal, and whenever it was made the birds quickened their pace as though a wave of panic swept through the flock intermittently.

Nest with eggs glued to it

Palm Swifts

Part 2

The crepuscular hours, when the sun is just about to appear at dawn or slip down behind the western horizon at dusk . . . these moments are of great interest to the human observer of Nature.

I used to be a regular visitor to a large grove of palm trees during the crepuscular hours. Palm Swifts had their strange hanging dormitories in the dead palm leaves hanging like hula skirts high up each stem. The swifts intensified their flickering aerial manoeuvres over and round the great grove. It was consistently noticeable that their restless activities reached a peak of excitement just before they retired for the night and at dawn.

By 6.45pm they were tucked into bed – literally – for the dry leaves hang like so many folded blankets. At that time only a few stragglers flew about, but soon they too dived down, then curved sharply upwards under the shelter of the skirts into bed – all in one graceful movement. For a long time afterwards they continued twittering and chattering, there being no strict rule of silence after "lights out".

Another bird species shared the palm-grove stronghold. A flock of Bronze Mannikins could be seen in the evening flying from one palm to the next until at last deciding to sleep in a particular tree in the middle of the grove. They occupied the flowering portion at the point where the stems of the fronds radiated outwards. An excellent and inaccessible citadel against predators.

On one occasion I reached the palm grove before 5.00am, but the swifts were already out and about – only a few though, most of the population still holding a great dawn chorus of chitter-chatter. By 5.30am crowds of them were on the wing, crisply lit up by the dawn rays. A definite pattern of keeping in pairs was evident, two birds flying together crisscrossing through the flock, which itself was made up of other pairs, more or less. These were the married couples – always keeping abreast of each other or flying in tandem intermittently.

The behaviour of these swifts changes entirely on appearance of a predator such as a crow. All the swifts in the colony fly erratically and with quickened pace emitting an alarm call of "teep" (not apparently recorded in standard reference books). They also follow a nest-raiding Gymnogene in a protesting grey cloud. This is a pirate hawk that raids birds' nests generally and nest colonies in particular.

The drawing is of a Palm Swift skeleton picked clean of flesh by ants that infest the ground below the palms. As can be seen, the toes and hooked claws are well suited to gripping the vertical palm fronds. The skeleton reveals the strange arrangement of the leg bones and the boat-like keel of the breastbone. The eye sockets are large for the size of the bird and indicate the importance of eyesight to the life of swifts. Their bones are light and perfectly suited to a life of continual flight.

Huntly

Snake Simulation

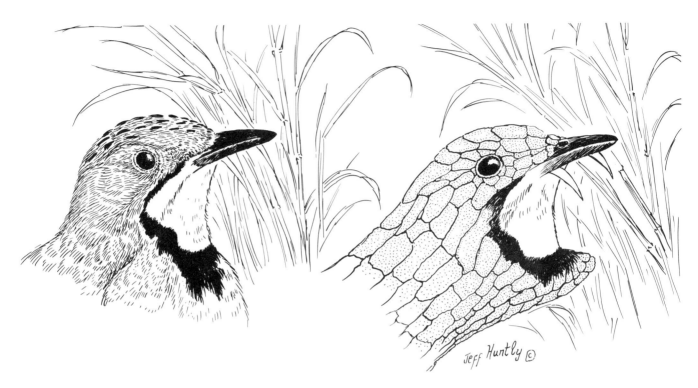

Jeff Huntly ©

While standing in a queue at a post office I noticed a photograph of an Orange-throated Longclaw on a wall behind the counter. From where I was standing the orange throat-patch, surrounded by a black bib and dark beak, appeared to be a gaping mouth. The bird's eye heightened the illusion of some imaginary reptile; for many snakes, leguaans and some amphibians, such as the bullfrog, have gaping mouths, often yellow, red, or some other shade to give them a fearsome appearance.

A visit to the museum made me even more certain that the longclaws make use of this throat colour pattern to warn off cattle, buffalo and antelope from their nest site. The "false mouth" effect may also help the longclaw to fool a ground predator, such as a mongoose or a rat, just long enough to make an escape.

Imagine yourself a peaceful cow cropping grass in a vlei where some longclaws have a nest. As you progress towards the nest you are suddenly confronted by a "mouth" with two staring eyes. The mouth jerks towards you in a threatening manner and you go on staring at it in that slow uncomprehending manner of cows. The gaping snake's mouth moves closer, and you back off and seek pastures new, or at least elsewhere. The bird returns to its nest and settles on the eggs. Mission accomplished.

When she has settled on her eggs the orange throat is hidden. If a Marsh Harrier should pass overhead, only the brown back of the longclaw is exposed to the sky, and even that it usually impossible to see, being broken up by light and dark markings on the back and by strands of grass partly covering the nest and casting shadows across the sitting bird.

My belief concerning the "gaping mouth" effect on grazing bovines was apparently confirmed by the discovery of a Pink-throated Longclaw's nest hidden in some undisturbed grass. My friend Steven Lees had found the nest in marshy ground and noticed that most of the grass had been cropped down by feeding cattle, with the exception of a small area round the nest.

"Why?" asked Steven.

"Why what?" I replied.

"Why didn't the cattle eat the grass over the nest?"

We asked an ornithologist, who had lived long in the area, and he confirmed that some ground-nesting birds drive off cattle, or at least hold their ground, at the approach of feeding cattle. He cited various plovers that he had watched driving off feeding sheep which had approached too near to their eggs. The Pink-throated Longclaw's nest had remained unharmed, although cattle had fed all round it. The theory could have been proved with our pair of longclaws if we had been able to spend long hours observing feeding cattle.

The Familiar Chat or the Spekvreter

When the Boers trekked they took with them an excellent and easily available lubricant for the hubs of their wagon wheels.

A wooden barrel or heavy iron pot was hooked on to the rear of the wagon. It contained tallow from fat-tailed sheep (or any other animal fat) and it was the only grease available to the trekkers on their long journeys into the interior.

It was not long before a little bird discovered that the fat was much to its liking, and over the years it learned to associate wagons with food.

When the wagons stopped rumbling over the veld and farms began to appear, the birds had firmly established the habit of visiting wheel hubs and became familiar objects round the homestead. Thus they acquired the Dutch name of *Spekvreter* and later the English name of Familiar Chat.

It is to be sincerely hoped that names such as this, with its historical significance, will be retained, for they add charm and poetry to our wild things. *Spekvreter* is one of the many apt and descriptive names bestowed by the Boers on birds.

The late Harry Cook of the Witwatersrand Bird Club wrote to me regarding the Boer name of the Stone Chat or *Dagbreeker*. He described how the Boers referred to the faint morning glow and "the light of the little horns" because at the time when the *Dagbreeker* first began to call you could only just discern the silvery tips of the horns of the oxen. That faint glitter of horn tips from dozens of oxen signalled the awakening and bustle of preparations for an early start: "Opstaan! Koffie drink! Inspan! Trek!"

In later years the tallow of the fat-tailed sheep was replaced by ordinary commercial wagon grease, and the little birds no longer hung about the wagons, although to this day they retain their association with farm out-buildings particularly where these are situated close to their natural habitat: rocky mountainsides and slopes, dongas or gullies.

The Familiar Chat may be recognised by its quiet and unassuming manner, brick-red tail with dark centre strip, as shown in the drawing, with brown upper parts and lighter underparts which complete the neat and dapper appearance.

The tail is raised and lowered in characteristic fashion, and so are the wings. These movements are calm, not agitated, nor as continual as in the restless wagtails.

In both West and East Africa races of the same bird are known as the Red-tailed Chat, and although such vast distances apart the species holds true to all its preferences in habitat and habits.

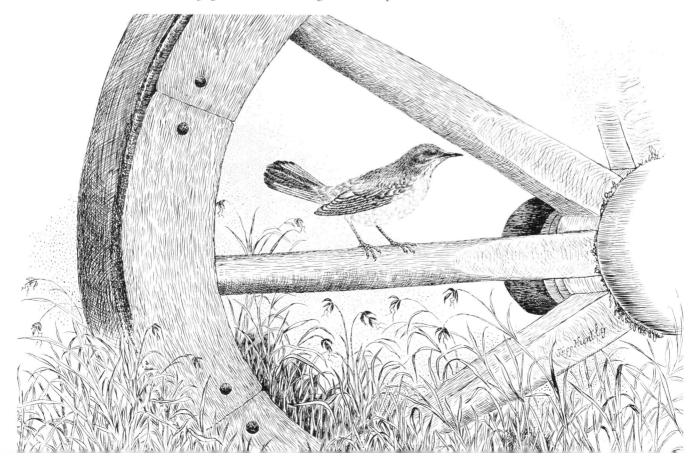

Blue Swallow

In the light of public interest in attempts to save the Blue Swallow from extinction I felt a need to elaborate on an earlier article concerning the most beautiful of the swallows.

My family and I lived for five years in the foothills of the Chimanimani Mountain range in eastern Zimbabwe. This area constitutes roughly the middle of its range, for it is found to the north in Malawi, parts of Tanzania and Zaïre and then south to a small area of the eastern Transvaal and Natal.

A pair of Blue Swallows nested on our verandah for five years, regularly arriving in the summer to breed and departing northwards at the approach of winter. We liked to think that it was the same pair, and possibly it was, setting off annually on a long journey to spend half the year in a warmer area of their choice, perhaps in north-eastern Zambia or even Uganda.

Ours was one of three farmhouses, all with verandahs. The neighbouring house was deserted for most of our stay and it seemed significant that our Blue Swallows always chose to nest just above a busy thoroughfare (a pair of French doors) leading into our sitting-room. The brooding female seemed to have complete confidence in us and grew progressively tamer. This strengthened our belief that it was the same bird all along, or the same pair.

One day, just before Christmas, the male flew into the sitting-room where our Christmas tree stood. He circled rather slowly round the room and then settled on the top of the tree, as shown in the drawing. I longed for a camera and flash to record the scene, but had neither handy at the time. He sat there for a long while, catching his breath, and eventually flew out through the French doors uttering a few twittering cries of relief.

The fourth edition (1978) of *Roberts* (McLachlan & Liversidge revision) makes the significant remark that the Blue Swallow has "recently taken to breeding on buildings". Thinking back on my experience with our pair I remembered how the landscape had changed from what was once open mountain grassland to the choking encroachment of coarse bracken, scrub and wattle, and with vast areas of sloping montane grassland given over to commercial pine forest. No longer were the birds able to find open antbear holes, bracken-free dongas, gullies or potholes in which to make their nests. Likewise in Natal their ancient habitat is now covered with sugar cane, wattle and other exotic plant or tree cover, concealing or obliterating nest sites. The eastern Transvaal habitat has gone over to vast tree plantations, with the same result for the birds. So the birds have adapted themselves to nesting in man-made structures.

I am convinced that our pair chose the proximity of human beings as a protection against natural enemies. They could just as easily have chosen the deserted house next door. Another reason for their choice was the presence at the deserted house of Greater Striped-breasted Swallows and swifts, both of which behave aggressively towards Blue Swallows. By one of those quirkish ironies the Blue Swallow would probably fare better if it bred in the less developed north of Africa, where its habitat is still intact.

The strictest protection of existing nest sites on private farms and the acquiring of land as a protected habitat for them seems the only hope of preventing eventual extinction of the Blue Swallow.

Black-bellied Korhaan

The Black-bellied Korhaan is the shyest fowl of the veld, with quite a few tricks that it uses to elude detection.

Its enemies are legion, from eagles, large hawks and many carnivores to hunters and even cattle, which disrupt and disturb its breeding grounds by kicking the eggs.

Recently, I saw a clever ruse by one of these birds to avoid being seen by my two dogs and myself as we walked across some open vlei.

I had noticed a slender, charred tree-stump protruding from the ground near an antheap. Now the veld is scattered with charred, blackened tree stems and stumps which, because of periodic veld fires, are a regular natural feature of the countryside.

As I had passed this particular antheap every day for weeks I knew it well, and I had never before noticed a black stump sticking out of its side. Out of curiosity I trained my binoculars on the stump, and it became a clearly defined korhaan.

Then I understood the purpose of the black underparts and underside of the neck. The upper half of the bird is a mottled beige, exactly the colour of dry grass. When it sits on its eggs or crouches down in the short grass it is virtually impossible to see.

This korhaan is a perfect example of disruptive colouring. Because the upper half of its body blends with the background of dry grass only the bold black underparts are visible. The black area no longer looks like a bird because the top half appears to be missing, and so at a distance it seems to be something that it is not.

All this is true of the male, but the female is also provided with protective colouring. Because she sits on the eggs and chicks more than her mate does, her underparts are not black.

She sits flat on the ground and therefore does not need the male colour-scheme. Her drab colouring exactly resembles the mottled fawn-grey of stubble and sandy wasteland, which is the preferred habitat of korhaans.

She, too, can look like a dry stump or stick, but in her case not a charred one. She can stand still and look like one of the many bleached branches or slender stumps of ant-eaten trees dotted about the veld.

Seeds in Transit

The hard seedbox of the common Devil Thorn or Boot Stud Thorn, with its twin up-pointing spikes, has since earliest times been carried considerable distances stuck between the hooves of animals. Later, with the introduction of pneumatic tyres on wheeled vehicles, it has continued its trans-continental hitchhiking, ensuring that the species settles in all kinds of different situations, some in places more favourable to it than others. For example, if severe drought causes a setback to the plants in one place those seeds that were carried earlier to another region with more rain will flourish, and so the species is always doing well somewhere. Later, in better times, the healthy seeds will find their way back to their former haunts when game animals and cattle move back again. Thus the stronger or better-nourished seed-stock is more likely to be kept replenished and able to start new colonies. In this plant one may see an example of Charles Darwin's theory of natural selection in action. The fact that the plant is so widely distributed bears testimony to the success of this system and the accuracy of Darwin's observations and the conclusions that he drew from them. The scientific name of this ground creeper is *Dicerocaryum zanguebarium*, and it is found from Natal to Kenya on the east and from the northern Cape to Angola on the west: virtually the whole of Africa bar the true deserts and the equatorial jungles. The plant has a delicate trumpet-shaped flower of lilac hue (A) covered with fine maroon hairs on its exterior. The smooth interior of the flower encourages visiting insects to enter and pollinate in exchange for a sip of nectar. The fine hairs on the exterior, by contrast, are probably designed to discourage small and delicate caterpillars' biting mouths. The dry hard seedbox (B) is shown piercing a bicycle tyre and a careless human foot.

No doubt the detestable Black Jack (C) will travel the farthest if the gentleman wearing stockings, having brushed against the weed, climbs aboard his light aircraft in Pietermartizburg and removes the irritating seeds on landing at an airstrip in the Free State or elsewhere.

The veld abounds with a miscellany of seed-carrying devices of curious design. Some winged seeds are shaped like settled moths, and some settled moths are shaped like winged seeds or hanging seed-pods (D). When a gust of wind loosens the dry pod it whirls away like a propeller far from the parent plant. When *that* seed grows its seeds will in turn be propelled to new fields, and so the species moves slowly across a continent, each pace a year and each year a pace – so slow, so sure!

Flying Snakes

During a time of my life when I worked as a prospector I experienced long and regular contacts with wild nature and in the best possible way: on foot and in the company of the veteran African prospector Mr Pione Mpandhle, or "Plum" as he was known to his friends. Over the years a firm friendship grew between us, and he shared his knowledge of bush life and prospecting for chrome ore in particular with me. He always maintained the natural silence

The snake rose off the ground supported by the bending grass stems and flew away like an arrow quite high above the ground.

Years later I wrote to Dr Donald Broadley, Senior Curator at the National Museum in Bulawayo, and he confirmed that there were indeed other authentic reports of mambas flying along grass stems, although it was a rare sight. The Olive Grass Snake apparently also performed this feat.

common to most men of the veld, remarking that he "didn't like people who yapped"... particularly on a long march in the blazing sun.

One hot day, Plum and I, together with three assistants who never stopped talking, were climbing through a barbed-wire fence, when a large snake rose up between us, giving us a brief glance before speeding away like some supernatural vision. It was no ordinary departure of a snake, for this creature seemed to fly over the grass instead of undulating through it. It was a marvellous sight – a floating serpent such as one might see in dreams of levitation. It was probably a Black Mamba on account of its great size.

The explanation of this serpentine vision was this: there was a strong breeze blowing, which caused countless thousands of grass stems to bend in unison.

The reference to "the fiery flying serpent" in the Book of Isaiah (Isa.14:29) might well be applied to a racing mamba supported by wind-swept grass stems. Tales of African snakes were bound to reach Biblical lands through travellers and traders, thus proving that some of them were authentic. Sir Percy Fitzpatrick, in his *Jock of the Bushveld*, gives a vivid description of a Mamba sailing along very tall grass as it escaped from a bush fire.

The flying snakes of south-east Asia of the genus *Chrysopelea* employ a different method of flight when they sail from a high jungle tree to a lower one. The slightly hollow under-surface of their bodies creates a cushioning effect so that they partly float, like rubbery parachutes.

Cape Clawless Otter

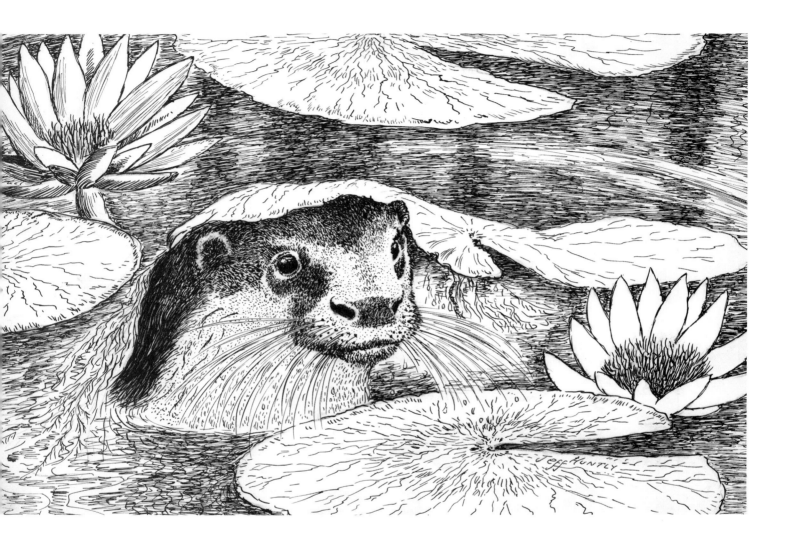

I have a theory about wild animals and birds that has been put to the test many times and not found wanting: if a person - or a group of people – are preoccupied with something and paying attention to it mentally, animals or birds will get on with their own affairs often in close proximity. The moment one's attention shifts to focus on the wild life they become restless and ill at ease and finally take off.

I was painting by the water-side at a large dam and totally preoccupied, when I became aware of dark shapes swirling in the water near me. I resisted the temptation to turn and look quickly; instead I slowly altered my gaze keeping my hat down over my eyes, and I was able to watch the wonderful sight of two Cape Clawless Otters gambolling in the water. They dived in a circular motion, one just behind the other like a muddy car tyre being revolved while half sub-

merged. The place was partly covered by waterlily pads and green waterweed, and sometimes the otters would stop their game and stare at me through their whiskers and through pieces of green weeds caught round their eyes and noses. One of them popped up to stare at me from beneath a lily pad. The pad tilted like an outlandish green hat.

The farmer upon whose dam I was working had reserved a large area of it as a private water-fowl refuge, and although great numbers of wild duck and geese made it their home they seldom nested there because of the otters. Not wishing to shoot his otters, he had in the end to content himself with feeding the geese and letting them swim in great numbers on the dam by day, but nest and sleep by night at a far distant dam.

Sable Reveries

The illustration shows a bull sable displaying his power and authority over his herd. The strongest and fiercest of the bulls in a herd will keep other males in subjection or drive them away altogether. I saw this display only once in a period of a year, during which I saw the herd almost daily. The bull had climbed up an anthill and stood for some time, immobile, stretching forward with scimitar horns tilted for maximum visual effect. No doubt other members of the herd were as impressed as I was, for he made an arresting feature in that wild, drab landscape of leafless grey trees, dead stumps and withered grass. The Wankie Game Reserve kept a permanent hold on me from that time on, and I would willingly live a hermit's life somewhere in the middle of it so that I could watch and assimilate its moods and solitude; day after day piecing together Nature's interrelations for no particular reason other than self-gratification. The living silence of a great wilderness is its charm. One longs for a flicker of comprehension of this fact when watching films on TV, with their cacophony of man-made sounds as background.

Edmund Caldwell, the much-loved illustrator of *Jock of the Bushveld* made a fine water-colour painting of a bull sable in the display attitude, although he does not show it standing on a prominent anthill.

Austin Roberts in his *Mammals of South Africa* (1951) gives the reader a full account of these brave antelope and describes a bull displaying from the top of an antheap. I remember as a youth of impressionable mind seeing a photograph of the film star Roy Rogers squatting next to a magnificent sable bull which he had shot "on safari" in Mozambique. I loathed him for his unthinking infantile grin as he clutched a rifle with one hand and the noble head with the other.

The sable is linked historically with the artist, hunter and naturalist Captain Cornwallis Harris. He collected the original specimen that introduced this species to Science. It was described in 1838, and Cornwallis Harris made a water-colour painting of it in his refined, delicate, linear style. Some years ago sets of his prints were still obtainable, but his work is not otherwise generally known. Cornwallis Harris hunted at a time when the South African plains seemed to have unlimited game animals. He met and vividly described Mzilikazi, the Ndebele king "surrounded by wild and sanguine spirits" (his followers).

Later J.G. Millais came to South Africa to experience the life of a wealthy sportsman and left his record in the classic A *Breath from the Veldt*. He too made some very realistic drawings and sepia paintings of the sable or Harris Buck, as it was called in those days.

The Giant Sable of Angola has its last resort in a wedge-shaped piece of land between two rivers – the Cuanza and the Luando, and in a minute area called the Cangandala Reserve. In 1968 this remnant was classified as "very rare". With the subsequent upheavals since the departure of the Portuguese it seems that their future is a very bleak one, although a yet small remnant may survive.

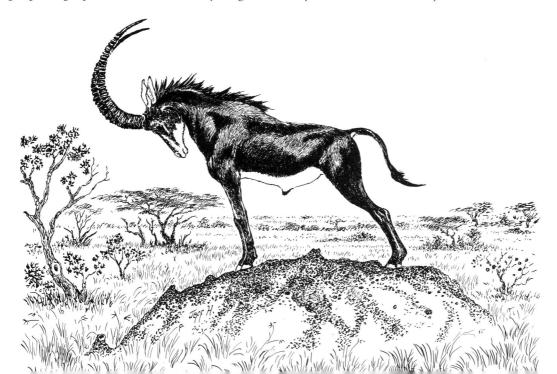

Mocker Swallowtail

If this is not the most amazing butterfly in the world then it must be the most confusing. Intriguing too. Its range is enormous: throughout all tropical Africa and including Madagascar and the Comoros Islands. But it is not its great range that distinguishes it. Other species can beat it on that score. It's the females! Now, the mail Mocker Swallowtail is yellowish-cream with black bands and tails on the hind wings, as shown in the drawing. All the males have this basic black-on-cream design with slight variations of the pattern for the Kenya coastal region and the west African form, the Ethiopian and the southern African form. The Ethiopian male shows the greatest difference in that the hind wings are all cream bar a few black splotches.

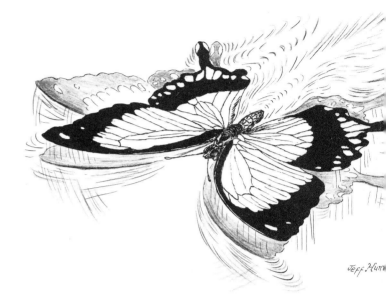

Jeff Hunt

But those females! In South Africa the female Mocker Swallowtail is a nearly exact copy of the poisonous Monarch, which belongs to an entirely different family of butterflies. All predators know that Monarchs are poisonous and leave them alone. Thus you see how the female Mocker Swallowtail gains protection against birds or any other butterfly predator by appearing to be a Monarch. The Monarch is coloured brown with black and white wing-tips.

In Tanzania the Mocker Swallowtail female is a copy of the black and white Friar, also a completely different family of toxic butterflies. The imitation is so good that you need to be a butterfly expert to tell them apart.

In Kenya the Mocker female is a copy of yet another toxic butterfly, the Layman, black, white and yellow covered in splotches of white on black. In Uganda the female Mocker Swallowtail is a good copy of the yellow, black and white Wanderer Butterfly _Bematistes poggei_, also distasteful to predators.

But to scramble our brains a bit more, you have another butterfly of the _Acraea_ family which in turn copies the Wanderer. And another Acraea that mimics the Monarch mentioned earlier. Are you confused? Wait, there's more to add to your confusion: In Ethiopia the female Mocker Swallowtail, which, up until this sentence has copied four disparate families of butterflies now does a volte-face and mimics her own husband (so to speak). I mean, here she is in Ethiopia looking just like her male counterpart: black on yellow and complete with tails on her hind wings – the only female Mocker Swallowtail with tails.

In South Africa the Monarch is copied not only by the female Mocker Swallowtail but by many other butterfly species who gain protection by looking like the toxic Monarch. They literally fly under false colours, just as many politicians do, and go about appearing to be what they are not.

So if you see a _genuine_ African Monarch floating along in his lazy, self-possessed manner you may be fairly sure that you are looking at the real McCoy. But if your Monarch flies with agitated swift movements, its got to be your female Mocker Swallowtail whose flight gives her away. Her deceit stops short of actual flight movements and, as though not quite daring enough to imitate the relaxed, taunting flight of the Monarch, she gets all of a flutter and gives the game away by her swifter wing-beats.

The skimmers are an amazing adaptation by an avian form of life to a particular niche in the environment. Because they live on glaring sunny sandflats and sandbars along the edges or in the middle of large rivers and estuaries their eyes are protected from the glare by having pupils that close up to a slit in bright sunlight. Then as the sun fades towards evening the pupils open up. They open to their widest aperture in moonlight. Instead of going to bed at sunset skimmers fly just above still waters with their lower mandible slitting a long cut in the glassy surface of the water. Rather like undoing a very long zip-fastener. A hundred metres long sometimes. This attracts the interest of any small fish (minnows or fingerlings) that may happen to be anywhere near the line of disturbed or "unzipped" water. The skimmer turns at the end of his line and skims back along the same track. With the lower mandible immersed he cannot miss a minnow, and the upper beak instantly snaps shut and the fish is swallowed.

Skimmers have sometimes been found to contain a bellyful of oily yellowish fluid, which may be a variation in their diet of freshwater algae. This could as easily be scooped up in the same manner as the fish.

Juvenile skimmers have conventional beaks like ordinary terns, which suggests that skimmers are a kind of tern, which over the ages adapted themselves to fishing still waters in the evenings or early mornings or by moonlight – at any rate whenever the wind was still.

Their wings are exceptionally long and are flapped languidly above their black backs when they unzip a lagoon. This high-above-back position keeps the wings out of the water. Simple and practical. They do not allow close approach by man, which is also a simple and practical way of self-preservation. When off duty they sit on sandspits, loafing away the hours; heedless of the blazing sun and, if there's a breeze, they will face into it, their red beaks all pointing in the same direction.

They nest in hollows in these sandbars laying tern-like eggs, which are stone-coloured and covered with black marks. In India and Africa their nesting colonies are shared by pratincoles and other terns.

Skimmers are found in the Florida Everglades, in India and various parts of Africa. The American is *Rynchops nigra*, the Indian *Rynchops albicollis* and the African *Rynchops flavirostris* – but the skimmers are all very similar. The beak of the African is red-tipped with yellow, as is the Indian. The American's beak is red-tipped with black.

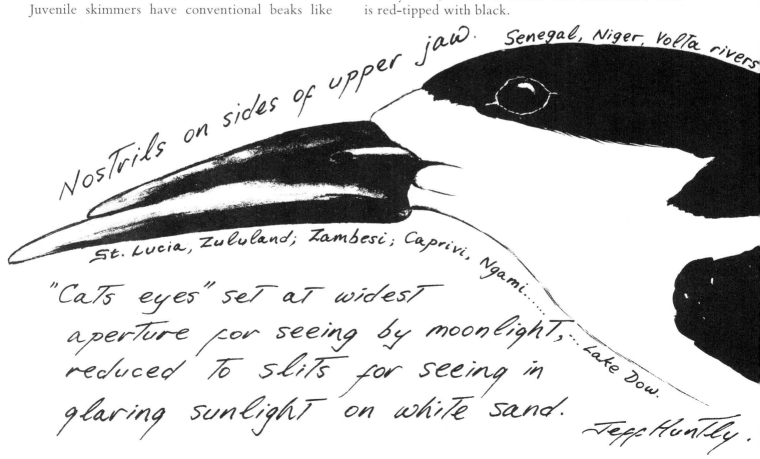

Nostrils on sides of upper jaw. Senegal, Niger, Volta rivers

St. Lucia, Zululand; Zambesi; Caprivi, Ngami....... Lake Dow.

"Cats eyes" set at widest aperture for seeing by moonlight, reduced to slits for seeing in glaring sunlight on white sand.

Jeff Huntly.

A Shimmering White Moth

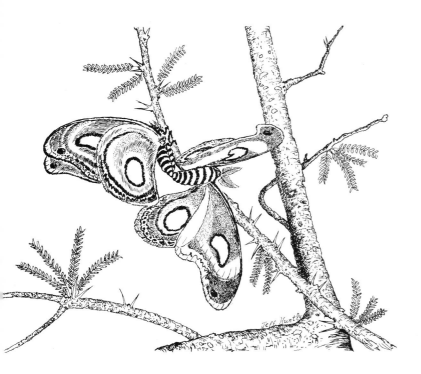

As sometimes happens in our contacts with nature we may not see a particular species for half a lifetime of hoping to see it in its wild state. Many years pass and some particular bird, animal or insect eludes our best efforts to find it and eventually we cease to look out for it. Then suddenly, without expecting it, we see it twice in as many days!

There are two similar species of Emperor Moths that had dazzled me when as a child I first saw them in a collection of moths shown to me by the lepidopterist E.W. Lannin of Bulawayo in what was then Rhodesia, after whom, incidentally, the rare hawkmoth *Nephele lannini* was named in 1926. The two moths that fascinated me seemed to be made of thin sheets of mother-of-pearl, gleaming white with transparent eye-spots on their wings and delicately outlined on the edges of the wings with maroon, pale green and gold. They were the Southern Atlas and the White-ringed Atlas Moths.

Something like forty years passed and I never saw either species again since that day with Mr Lannin in far-away Bindura, where I was born and where I had my introduction to the delights of roaming free in the African veld. People such as E.W. Lannin, Captain Cecil D. Priest and others shared their time and interest with me – an interest that has grown with the years. One day, walking in Bisley Valley just outside Pietermaritzburg, as I passed beneath a small Acacia tree I noticed a curious object lodged among the feathery acacia leaves. At first glance I took it to be a brown snake curled round the thorny twigs among the leaves. Closer examination confirmed that it was not a snake at all. Just a length of rust-coloured inner tree bark thrown carelessly into the tree by a herd-boy, I thought to myself. But it wasn't a piece of tree-bark rope, either, such as young herd-boys cut for rope and call *ntambo*. This was not *ntambo*, nor a snake. It was a pair of White-ringed Atlas Moths joined together in the act of mating. In an instant forty years vanished and I seemed to be standing with kindly Mr. Lannin poring over his glass-topped cabinet and his perfect examples of White Atlas Moths. The rusty-coloured coil that looked like a snake was actually the markings of the undersides of two pairs of wings. Seeing them thus they seemed to me to be quite the most beautiful things in creation. I immediately made a detailed drawing of them, taking an hour over the work for I was not sure how long they would remain locked together in that acacia tree.

I need not have worried, for I found them next day in the same place and more or less in the same posture. The weather was sultry, with thunder and dark threatening storm-clouds. Having taken another look and made another drawing from a different angle, I walked on looking in other acacia trees. I was astonished to find another pair also in the mating act not far from the first pair. I hoped to see them fly, and gently nudged them with my stick. Instead of flying away they fell, still joined together, on to the grass and dead leaves near my feet. They were playing possum, or shamming dead. They had virtually vanished into thin air for, although I searched very carefully in that small area of grass and leaf litter, I could not find them, so well did their patterned colours camouflage them! I had, accidentally, or rather fortuitously, witnessed a superb example of a pair of large Emperor Moths doing a vanishing trick, perfected over the ages, to give their enemies the slip and live on to mate and create more like their beautiful selves.

Multimammate Mouse

Compared with birds, the smaller mammals live out their lives in great secrecy, usually under cover of darkness or beneath grass cover or even underground. Their private lives are unobserved because so unobservable, and they are generally known only to a few scientists who study them.

Occasionally, however, some circumstance may cause animals to reveal an aspect of their lives before they disappear again into their carefully-preserved obscurity. One such circumstance is a grass fire, a disaster to all grass-dwelling animals and birds. I found a large expanse of vlei-ground recently burned, and there in full view were many runways used by a legion of Multimammate Mice. The dry grass-cover had been removed by fire to reveal these winding mouse-ways – which when the grass covered them had been completely invisible to predatory hawks, owls, servals, jackals or anything else bent upon catching a rat (there being no great distinction between a small rat or a large mouse in the case of the Multimammate Mouse). The grass runways were really like tunnels before the fire and had led from one mouse-village to another. The mouse-village is a definite cluster of holes in the ground covering an area of about two square metres.

Pathways made smooth by hundreds of pattering little feet led from one village or colony to another. Interestingly, there were also definite middens or mouse-latrines established every so often along these highways. They were on one side of the pathway and not in it. I could not find droppings carelessly left in the runways, which were clean. Only in strictly demarcated areas. Even the rats – of which this species anyway – can teach humanity a thing or two about cleanliness, as any visitor to public parks might verify!

Although so fleet of foot, Multimammate Mice perish in great numbers during a veld-fire. They seem to do the wrong thing in their efforts to escape the flames. I found one crammed beneath a flat stone, where it must have imagined it would be safe. The stone of course got too hot and the mouse was baked in seconds. I found others dead in their holes just beneath the ground - overwhelmed either by heat or smoke. Many other mouse-corpses could be seen squashed flat on a tarmac road by passing vehicles. They had attempted to escape the fire and exposed themselves briefly in a dash across the road: in many cases successfully but in many others not.

I have seen one of these animals swim a distance of about 105 metres. I was able to pace out the distance because a large bridge crossed the river near by, allowing me to measure quite accurately the length of this swim by such a small terrestrial animal. The mouse determined to cross the water to get away from my dog, which was hunting for it on the bank. It swam slowly in a series of zig-zags, and I watching this feat in disbelief for a long time, until the mouse emerged on the far bank and promptly scuttled off into the shelter of some tall grass.

The Rare Pink-throated Longclaw

Jeff H.

Of the three species of longclaw this is the most beautiful, and being a rare bird it has evaded observation by all but a handful who know where to find it.

In the African continent its range extends from western Kenya to Natal and Zululand, but only in places well suited to it: open stretches of marshy ground thickly covered with short tussocky grass. When these places dry out the birds move to an adjacent wetter district or even farther afield, literally following a moving habitat. In this respect they resemble the Broad-tailed Swamp Warbler.

These remarks are based on observations I made of a certain marshland over a five-year period. When the area dried out during a drought the Pink-throated Longclaws vanished, only to return when the wet marshy habitat was re-established.

It was in this place that I witnessed the curious and poetic aerial display of the male bird. In the early hours of dawn it would rise into the clear sky and fly in wide circles singing its song, which can be written as: "Tee-you . . . Tyip-tyip-tyip-TEE-YOU". This display flight conducted during the silent moments just before dawn is unforgettable, especially if the circling bird is seen through binoculars and its exquisite colours are intensified by the golden rays of the sun, already bathing the high-flying bird but not yet reaching the observer far below. The entire throat, chest and underparts are suffused with rosy pink; a bird to evoke Homer's "rosy-fingered dawn".

A nest discovered by a birder friend, Steven Lees, in December 1979 contained four eggs, and together we kept up a sustained observation of these rare birds, hoping to obtain photographs. We always kept at a distance from the nest to avoid upsetting the birds – or worse, drawing attention to the position of the nest.

It was sited in a very wet area of the marsh under a tussock of wispy vlei grass that completely shielded the eggs from the rude gaze of the outside world. The eggs themselves were very dark for longclaw eggs – in fact they resemble the dark grey mud of the marsh in which they were situated and were impossible to see through the thin screen of overhanging vlei grass.

Heavy rains filled every depression in the marsh, and ultimately the nest was surrounded by water like a little moat round a castle. We abandoned any ideas of building a hide from which to photograph the birds, as it would have attracted too much attention. We concluded that the choice of nest was deliberate in that it would tend to be avoided by people, cattle and small ground predators because of the deep mud.

Another original observation of mine concerned a warning note made by the cock whenever I approached the nest. It consisted of a mellow high-keyed note like someone striking a tuning fork: "ting . . . ting . . . ting . . . ting-ting-ting". The warning note caused the brooding hen to slip off the nest and fly to safety.

Professor Gordon Maclean invited me to mention here that the written description in the new *Roberts' Birds of Southern Africa* of the main call (used when displaying at dawn) is taken from my Veld Sketchbook article. Unfortunately I somehow omitted to include the tuning-fork warning notes of the male. These calls are *not* like those of the common Orange-throated Longclaw. The nest of this species is less bulky than that of the other two species, being more like a true pipit's nest.

By walking through the marshy place where these birds lived I was able to find out what they do at night – how they sleep. In the half-light before dawn I flushed a Pink-throated Longclaw from dense wispy vlei grass. There in the grass was a deep "form" similar to that made by a Scrub Hare, only smaller. There was a freshly-made white dropping, but nothing more, indicating that the form was only used for one night. This is a protection against predators, for a sleeping place used too frequently is more easily found.

Water Mongoose

My only sighting of a Water Mongoose was in a place far from water. It had been attracted to an antheap near an isolated farm road. The termite-mound was active – a swarm of winged termites issued from holes at the base of the mound and the Water Mongoose fed on them in that furtive suspicious manner of most predators, looking about him from time to time, sniffing the air for danger, then returning his attention to snapping up termites. At all times he kept partly concealed by bushes and weeds and seldom ventured into the more open areas where some storks were also collecting the termites.

Like many animals and birds a Water Mongoose will go to great lengths to feast at an active termite-mound. I was afforded a good long view of him from my car. Under normal circumstances these animals keep to cover near streams and marshes and move about by night, especially where their old haunts have been settled by man – which is inevitably happening more and more all over Africa. Many animal species have responded to this invasion by their arch-enemy by becoming more nocturnal in their habits than formerly, when they had the continent and its glorious sunshine pretty much to themselves. Even within the memory of many of an older generation huge areas of Africa, including the South African lowveld, Botswana, Zimbabwe, Malawi, Zambia and north-wards, now swarm with people where once the silent peace of Nature reigned.

Having to take up a nocturnal life to avoid mankind (who is so seldom kind) has been a recent adaptation resorted to by many formerly diurnal species. Some nocturnal species have learned to keep silent while living in proximity to man. All have made adaptations to unnatural habits out of the need to survive. All dread the strange biped with his invisible wire snares, invisible thunderbolts of death from rifles, and his terrifying ability to change the face of the earth with bulldozers, chainsaws, tar and cement; man, who professes to be civilised yet indulges in an insatiable love of violence towards his own kind; and even in most of his entertainment.

My glimpse of the termite-eating Water Mongoose confirmed what I had read about its appearance as "looking black at a distance" and being larger than the ordinary mongoose. The colour is very dark brown, which helps to conceal the animal as it keeps to shadowy cover. Of all mongoose species it is best adapted to living near and often in water, although the Egyptian Mongoose and one or two other species are recorded as taking aquatic insects, amphibians and crabs. The White-tailed Mongoose also frequents riversides in search of nesting water-birds or their eggs and chicks, amphibians and crabs.

There is an interesting parallel to the Water Mongoose among the civets and genets. It takes the form of the beautiful Aquatic Civet from the dense ancient forests right on the Equator in the middle of Africa. This fox-red animal with a black tail is rare and little known and would make an ideal subject for study in its last remaining haunts. Its scientific name alludes to its fishy diet: *Osbornictis piscivora*.

Comparisons and the Red Lechwe

The saying "Comparisons are odious" does not apply when comparing countries and animals – in fact, such comparisons are both pleasant and interesting.

Compare Natal and Botswana, for example, and we have two parts of the African continent so different as to seem to belong to separate planets. Natal, with its close horizons in every direction, with undulating country and dark restful greenery pressing in upon the sight; Botswana, with its wide open vistas, the limitless horizon like the prairies and its endless yellow grass. Vast level plains uninhabited, save by the wildlife, are just as awe-inspiring as the mighty Drakensberg. But the awe is of a different flavour.

The boundaries of South Africa, Botswana, Zimbabwe and Zambia cluster and jostle one another along the Chobe and Zambezi Rivers in that geographical freak known as the Caprivi Strip. At the time of my visit some years ago the Red Lechwe and the Puku were present, but the status of Puku in that area now seems obscure. The Red Lechwe were observed feeding on aquatic grasses growing along the edges of the many pools and the ox-bow lakes comprising the Chobe River flood-plain. Watching them for long periods through 13 x 60 binoculars, I was struck by their handsome colouring: a bright ginger wash along the neck and back fading into yellow ochre on the sides and with white underparts. The graceful horns are long and lyre-shaped and proclaim from afar that this is the male. The female shares the colouring but not the horns. During one spell of tediously long observation (for which I had hoped to see them do something interesting other than cropping grass for three hours) they suddenly bounded into action without the usual accumulation of uneasiness and tension of antelope about to bolt for safety. No: one moment they were at peace and the next they were galloping straight across the shallow water sending up a white cloud of spray. But even in this spontaneous burst of action the four males in this herd held back to allow the seven females to cross the water ahead of them. My telescopic lens was fortunately correctly focused on them at the right moment, and I have before me now the picture that triggered off a host of impressions of the Chobe. These impressions are like little pictures coming to life or sleeping butterflies, flying up from a bush that I have just kicked. They circle and dance above the bush momentarily, then settle again . . . or get filed away.

I believe the lechwes' panic was caused by a change in the wind bringing them a startling whiff of lion.

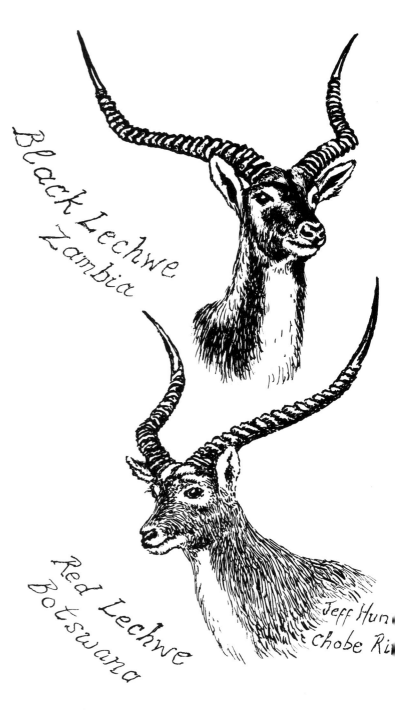

The lion was later observed hiding in very short grass. Its scowling image also found its way down the tube of the telescopic lens.

Part 1

The most remarkable aspect of the life of the Water Leguaan is its association with termites. The female leguaan digs into the side of a termite mound situated not far from a stream. She then enters the little hollow or cave that she has made with her claws and lays her eggs. She departs "knowing" that the termites themselves will rush to the place in their mound where the breach has been made and repair the damage. In so doing they cover the eggs, thus protecting them from the outside world. The eggs are now fully insulated from excessive heat or cold and receive all the benefits of excellent air-condi-

between their former citadel and their new watery home. Eagles, hawks and other predators relish young leguaans, so their mother chooses a termitary near water.

Some years ago I examined a dead leguaan evidently killed by a passing car, for it lay on its back by the roadside. This one had the most curious ticks attached to the ventral area of its body. The ticks were coloured exactly to match the yellow and black design on the leguaan's belly. I have never seen any other tick remotely like it and I assume that it has evolved specially to live on the leguaan.

Jeff Huntly

tioning provided in the termite mound. Months later, perhaps up to ten months later, the young leguaans hatch and dig their way out of the mound.

The disturbance caused by their digging causes hundreds of termites to converge on the scene to repair the breach and this time provide the young leguaans with their first meal. So in this association the leguaans benefit entirely to the detriment of the little termites. It seems probable that the same termite mound can be used year after year for this purpose.

After dining off the frantic termite repair teams the youthful leguaans make quickly for the nearby stream into which they plunge for safety. If their mother had chosen a termite mound too far from the water she would have endangered the lives of her offspring, who would have had to run the gauntlet

The point I mentioned in my article about the Tree Leguaan hiding in parasitic tree mistletoe in Damaraland reminds me of the Black-Necked Heron. In certain dry parts of Africa this heron has taken to catching doves drinking at desert water holes or pans. This habit of dove-catching is not found in other areas where doves are plentiful and where the same heron has its habitat. In the same way leguaans living in areas where there is no tree mistletoe would not have learned the crafty trick practised by the Damaraland leguaans. The Damara ones hide in flowering mistletoe to ambush birds in search of nectar. The heron and the leguaan in these two situations have learned a local trick, so to speak – an adaptation to their particular environment which their congeners in other areas have not learned.

Dream Landscape

Years ago I visited this solid granite hill, and although under trying circumstances, I was able to absorb the strangely beautiful mystic atmosphere of the place. I vowed that I would one day return to it under more peaceful conditions to explore its secrets and investigate its wildlife and the curious plants and trees that grew there.

When I look at the drawing I made of it at the time I realise that whether I fulfil my dream to go there again or not does not prevent me from describing my experience and response to that granite landmark. "Whalebacks" or inselbergs are found in many parts of Africa, and they are quite unlike anything else both in appearance and in the specialised life forms that have adapted themselves to living on them.

One could imagine that a mountain of solid granite sticking up from the level plain of savannah bush country would be unpleasant to climb because of the glare of the sunlight against the bare rock: acres and acres of sloping stone. But it is not so. On the contrary, a walk up those sloping sides is pleasant and refreshing. The whole mountain is weathered black. This blackness absorbs the harsh glare, and a cool breeze comes up from the plain below to fan your brow and carry with it the scent of flowering Msasa trees (*Brachystegia speciformis*).

One marvels to see large trees of a different species seeming to grow out of solid rock near the summit and halfway up. Their roots delve deep down into narrow cracks and fissures in the stone surface. Inside these slender chimneys there is enough soil and water stored after the rainy season to sustain the trees throughout the year. There are several species, but the Mountain Acacia is the largest and most beautiful. It is not an acacia at all, but closely related to the Msasa, and its scientific name is *Brachystegia glaucescens*. The new season's growth of young leaves of both these Brachystegia species goes through most lovely colour-phases: maroon, orange, terra-cotta and coral pink. The whole veldscape from close by to the horizon is a mosaic of these colours. They are not gaudy but harmonise with each other and particularly with the dry brown grass in which they stand. The trees don these colours before the rains begin, so that the grass has not had time to change from gold to green. Later, when the rain comes in earnest, the pink and orange trees become bright green like the grass.

Also growing out of slim cracks in the granite were the black-stemmed Vellozias seen in the foreground. These plants survive on moisture that they absorb from the air and from their roots after rainstorms. The rock slopes down to a pool of water, which seems to always be full, so that the excess trickles over the edge in a waterfall on the right of the picture. How it maintains its constant level is a mystery, unless the water comes from underground or streams and caverns under the rock.

Of animals, birds, reptiles and insects there is much to describe, but I have run out of space for all that and must needs follow this sketch with a later one. There is so much to see in such a place that a single visit scarcely touches the subject.

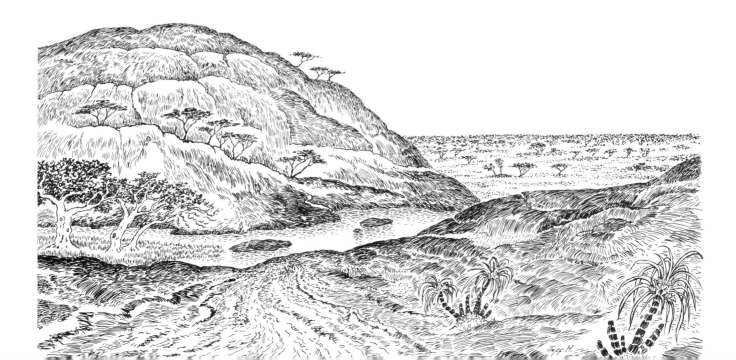

The Two Kudus

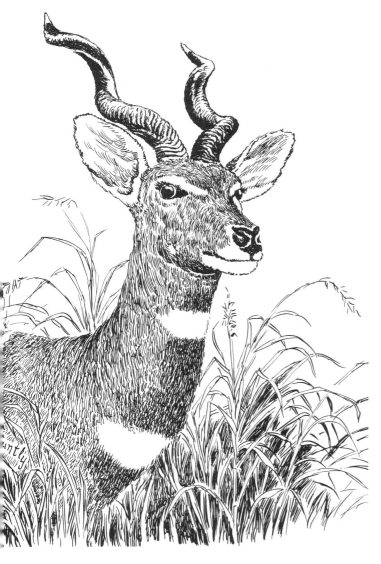

Not many species among the larger mammals have a smaller version of themselves. In the case of the African elephant and the hippopotamus the possibility of that happening could only occur in small areas of equatorial West Africa; Liberia, especially. Zoologists do not consider Pygmy Elephants as a "good species" and tend to regard them as stunted Forest Elephants (*Loxodonta cyclotis*). The Pygmy Hippopotamus, on the other hand, is not only a distinct species but also separated into a genus of its own: *Choeropsis*.

But with the kudus, the large and small versions do occur side by side in quite a number of places in Ethiopia, Somalia, Sudan, Uganda, Kenya and Tanzania. The distribution of Greater and Lesser Kudus overlaps in the Ruana National Park in Tanzania, the Marsabit National Reserve in Northern Kenya, the Debasien Animal Sanctuary in Uganda and possibly in a few places outside of these reserves, always provided that they have not recently been hunted to extinction. One might think of the Lesser Kudu as the kudu of the dry horn of North East Africa and the Greater Kudu as the kudu of the moister central and southern half of Africa. In South Africa itself it survives only in isolated pockets of its former range.

To see the two species properly mounted in a museum display is an easy and inexpensive way to compare the two. In Pietermaritzburg, at the Natal Museum, there is a very comprehensive collection of African antelope, some of them rare and hard to come by now. A male and female Lesser Kudu are displayed next to the pair of Greater Kudu.

The Lesser Kudu has two white flashes on the neck, which replaces the lower neck mane of the Greater Kudu. Apart from its much smaller size, the Lesser Kudu male turns more blue-grey with advancing years, and the white stripes along its sides are more distinct than those of the Greater. Its horn tips are ivory-coloured and the ears are comparatively large, indicating a great dependence upon hearing for its survival.

Both kudu species tend to avoid altogether open spaces and move about only in thicket country or broken veld with dappled light and shade, or areas of thin-stemmed shrubs and trees against which their cryptic colouring and chalk-striped coats provide maximum camouflage. Their ability to freeze and blend with a background of twisted branches is well known but not often observed in modern "drive-through" game reserves, where time-schedules seem as pressing as in the towns.

I relish a small incident in the Kruger National Park in which I observed at very close quarters: a majestic male Greater Kudu sauntering towards a young baboon that was biting into a monkey orange. The kudu bent its head and spiral horns so close to the ape that the latter abandoned its prize and watched with a sort of frowning astonishment as the antelope took possession of the fruit. This observation was made possible by wedging my small car into a thicket and remaining in it for five hours. The spot was frequented by antelope and baboon because of a cluster of fruiting trees.

Footnote: The Lesser Kudu is also recorded from Kenya's Amboseli Masai Game Reserve, Samburu-Isiolo Game Reserve, Meru Game Reserve and Tsavo National Park and the Serengeti National Park in Tanzania.

Community Spiders

Part 1

The Community Spiders (Stegodyphus) are so absorbing to watch, so intriguing in their habits, and such clever web-snare designers, that it is not possible to touch on every aspect in one sketch. A book could be written about them and it would still not cover everything.

This scene by torchlight illustrates the concept of web-snares rather than attempts at literal presentation. The essential idea is much like those great fishing nets used by trawlers, but instead of water currents sifting through the meshes the spiders employ the air.

When we look at the long, thick outer strand of web attached like tent guy-ropes to nearby grass stems or even distant sticks we may wonder how such minute spiders can accomplish this feat. The answer is that they lasso them!

Climbing to a high position near the main nest a tiny spider sends out a long, sticky strand of web into the wind. Presently the line becomes entangled in a grass stem or round the sticks of a nearby bush. The spider then runs along the line, adding to its thickness.

Others do likewise, forming the outer frame of scaffolding, rather like the rounded frame of a tennis racket, in preparation for the criss-cross maze of fine gossamer to fill up the inside.

The nest itself is a frightful tomb riddled with hundreds of crooked *pergolesi* passageways and stuffed with the skeletal remains of a heterogeneous assemblage of insects.

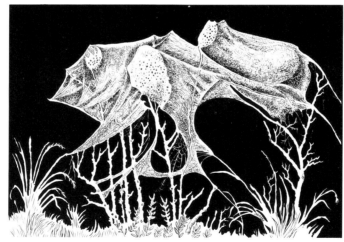

Most of the bodies are dismembered and decapitated.

Beetles and other hard-jacketed insects are all dealt with in the same way. The vulnerable joint between head and body proved to be the fatal chink in the beetle's armour. The spiders simply bite collectively with little mouthfuls into this division until the head is severed. The body juices are then sucked by a swarm of spiders until the beetle is a dry, transparent husk.

Inside the nest many strange bits and pieces make up the substance of its walls. Legs, claws, wings and chitinous wing-covers, brilliant emerald husks of cuckoo-wasp bodies and butterfly wings form an amazing collage that would delight the most fastidious art connoisseur.

The large nest in the middle of the picture remained like this from March to September. Then with the beginning of summer two new, smaller nests were begun. The "colonisation" and expansion programme is eminently logical, for it coincides with and precedes the arrival of the teeming hordes of the season's new generation of insects. Many of them will become enmeshed by day and night in these ghostly silver wind-socks undulating in the wind. This unexpected undulation and puffing suddenly outwards makes the nest even more difficult for flying insects to avoid. Add to that the slight stickiness of the web and we have a monstrous contraption with pale, thin fingers groping in the light of the moon.

Community Spiders

Part 2

Community Spiders overcome the disadvantage of their small size by clubbing together to form communities of many hundreds. This common endeavour results in the construction of large nests in a low shrub or other group of dry stems.

The system of netting their prey is probably the most efficient and deadly in all the spider kingdom. It is indeed fortunate that Baboon Spiders do not adopt this communal lifestyle but live solitary and sedentary lives. If they did use the Community Spiders' methods they could feed regularly upon birds.

Community Spiders are described as nocturnal because that is when they emerge from the nest with its dozens of round portholes. They become active at night and do their web-spinning under cover of darkness. But although they retire under cover during daylight they will instantly emerge if anything should become entangled in their large web-nets. And that often happens, for the dense maze of fine strands is so cleverly constructed.

Crash! A dragonfly blunders into the web. Instantly the midget spiders have emerged from their portholes and are swarming along the webs like pirates clambering up rope ladders to attack a ship.

The dragonfly struggles valiantly to free itself and vibrates its wings. This vibration sends its message along every strand of the web, calling forth even more

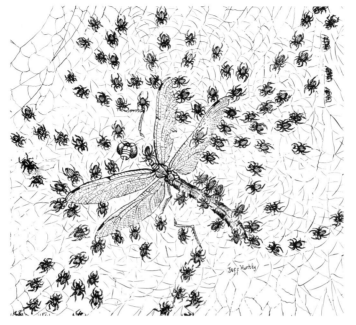

spiders who respond enthusiastically to the dinner gong, rung by the one who will himself provide the dinner!

Soon the dragonfly is covered with spiders so that only a vague outline of its body provides any sign of its whereabouts. It is now only a brown lump hanging in the web.

Having killed the dragonfly with many little bites the spiders begin to move the body towards the nest. Head and legs are severed to facilitate easier passage across the webs.

An amazing procedure now takes place. All the spiders pull the body together in the direction of the nest. Then, as if obeying the military command, "Halt", they pause in their tracks for four seconds – one, two, three, four – then "Heave", they work feverishly for another period. Suddenly they "Halt!" again for another pause.

This alternate work, rest, work, rest technique may be seen at all times when joint efforts are tackled. Every member of the community obeys the order. There are no individualists or private-enterprisers; absolute teamwork is the law.

There is no perceptible issuing of the command to which all individuals respond. But something does pass through the swarm like a wave either to actuate them or bring them to a standstill.

Community Spiders are found in many parts of Africa. Look out for them in the dry thornveld areas.

Farmers and landowners have become the new custodians of rare or endangered species. In the case of the Wattled Crane in particular the fate of these spectacular birds lies in their hands. A growing number of farmers and landowners see themselves taking on this role and are aware of the desperate plight of many of Africa's cranes, storks, bustards and raptors. This awareness is spreading due to the work of Natal Parks Board and National Parks Board, the conservancy concept, the bird clubs, the Wildlife Society, the TV programme 50/50, education programmes in schools and many other pressure groups worldwide referred to as the Greens.

What happens to a species in Africa is no longer only an African affair. The planet earth has become the mutual concern of all earthlings during those moments when they stop fighting among themselves. The worldwide concern for the African Elephant has triggered off the ban on ivory trade and the future does look brighter for this greatest of mammals. The same cannot be said for the Black Rhino due to the intransigence of wealthy Arabs whose idea of manhood is to own a rhino-horn handle dagger. However, world opinion and outrage may yet turn the tide in favour of the various rhino species; the Black Rhino in particular. False beliefs regarding the power of powdered rhino horn are widely held in Far Eastern countries.

Having referred to conservation-orientated farmers as representing the new custodians of endangered species we may consider the challenges facing the Wattled Crane, particularly in South Africa. They are so daunting as to make one wonder if this magnificent bird will in the long term survive as a South African species. These are the factors which contribute most to its decline: invasion of habitat by afforestation; draining of wetlands; damming of wetlands; noise and disturbance by man's activities as he spreads into previously untouched wild areas; raiding of nests by wandering herd-boys; deliberate poisoning of cranes by farmers trying to protect their crops; accidental poisoning when cranes ingest insecticides intended to control insect pests; trapping over the nest by peasant tribesmen; very low reproductive rate of one chick only.

The Wattled Crane has come down to us from a time inconceivably remote. It has survived its own natural enemies in the form of carnivorous animals, reptiles and raptors which have probably attacked the young and eggs of the cranes more than the huge adult birds. It has survived drought and hail – the latter being an irregular catastrophe for big birds – which may wipe out a whole flock in a few moments. Recently newspapers reported the loss of approximately 50 White Storks all killed in one hailstorm! A tragic loss of another hard-pressed species.

Beyond South Africa's borders Wattled Cranes survive in greater numbers simply because there is more solitude, a condition which they need in order to breed. Their breeding instinct is snuffed out by the mere presence of man and they are extremely sensitive to noise. This is why they are so difficult to breed in captivity, although there are a few records of success. The 1984 edition of the Red Data Book (Birds) lists two breeding successes in captivity in the US; one each in Germany and Japan and once in the Pretoria Zoo. Not exactly a captive population to draw from!

The future prospects for the Wattled Crane and all endangered species may best be served by a closer study of the human species – especially its young. When education changes attitudes of young people world-wide the effect is soon felt by the parents. Young people are a powerful influence on their elders who do not want to be seen as lagging behind the times: "Get with it Dad!" says the conservation-conscious farmer's daughter and Dad listens.

Kingfisher

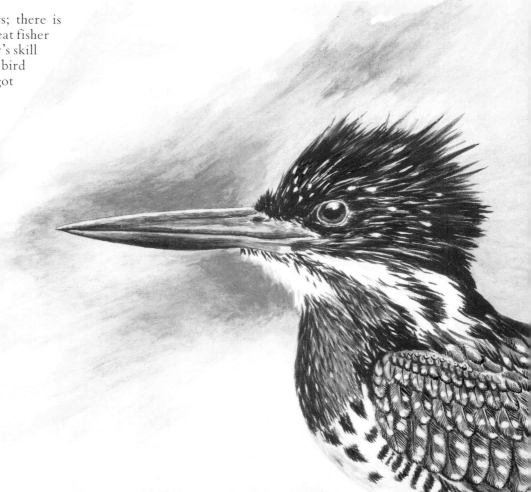

People enjoy watching kingfishers; there is a common bond, since man is a great fisher himself and can admire the kingfisher's skill at the game. Only in the case of the bird there is seldom "the one that got away".

In my experience along an African river, I find the Giant Kingfisher is a constant sentinel at waterfalls. He exploits a fish's temporary disadvantage when it exposes itself going over the fall. Quick as a flash the bird flies headlong into the spray and seizes the fish. He flies back to his rocky perch and manoeuvres the fish in his beak to get it into the best position for swallowing it whole. If the fish is a trifle big it is pounded against a rock to break its bones.

Occupying a somewhat different niche in the scheme of things along the same river, the Pied Kingfisher catches his minnows by hovering high above the water. Among kingfishers he is the most consistent hoverer, and he will hang in mid-air above the water with whirring wings trimmed to remain in one spot. Peering downwards, he will check his wing-beats and come down lower for a better look – then suddenly dive like a javelin into the water, to emerge with a fish.

In Malawi my friend Rupert Gillwald saw a young tribesman walking along with a bizarre brightly-coloured toy, which magically hovered in the air from time to time. It was attached to a fishing line. My friend took a closer look and was horrified to see that the bright toy was a live Malachite Kingfisher. The boy amused himself by letting the pathetic bird go, thinking it was free, and pulling it back again – slowly – as it whirred its blue wings. Rupert offered some money for it and released it on a river bank. Fortunately he had intervened just in time; the tiny jewel of a bird had no broken bones, and it flew off with a little squeak of joy.

Another friend, Richard Bath, was quietly fishing on a reedy bank when one of these same kingfishers flew up-river and alighted on his fishing rod. Its brilliant colours shone in the afternoon sun and he could have caught it in his hand.

The Grey-hooded Kingfisher has given up fishing and can be found far from any stream or pool. Insects, small reptiles and almost any other "small fry" are relished by these species. The Brown-hooded and Striped Kingfishers share this non fishing habit with the Grey-hooded. They nest in holes in dry trees, whereas the fishing kingfishers burrow a long tunnel into a sandy bank for their homes. Their eggs are rounded and pure white and often have small pin-point marks of dirt on the shells. These are made by a small fly that sometimes infests the nest burrows.

Golden Moles

Until a few days ago I had no idea whatsoever of the beauty of these little animals, which are seldom seen. Drawings, paintings and even colour photographs give only a poor idea of the reality; and mounted museum specimens seem dull and lifeless compared with the living animal. Living animal? When can one be seen when they spend their lives literally "swimming" through soft earth beneath our well-shorn lawns or tunnelling beneath cow-pats in cattle folds? To glimpse an African Golden Mole in the open above ground would be a rare event, and it would depend upon a million-to-one chance of being in the right place at the right moment when circumstances forced a mole to surface – perhaps popping out of one of its tunnels to escape the Mole Snake or forced to come up by a sudden artificial inundation of water in its subterranean dwelling.

heaving as he shoved earth from underneath. Jabbing a walking-stick where I calculated would be just behind him I scooped him out in a lucky first shot! Unfortunately my big dog had him in that split second, and although he released him immediately on being told to "drop it" the mole was already dead.

Examining this fresh specimen was a revelation, and I could well appreciate that moleskin was at one time very valuable; for although the British and European moles differ from the African moles in some details, they have in common an exquisite shining pelt. In my specimen the iridescent fur of the back and sides was a lovely shade of mauve-brown like the shining skin of a baobab in evening light, while the chin, throat and forepart of the chest and armpits were covered with dense orange-gold fur. The upper parts of the hind feet were almost black, yet the palms

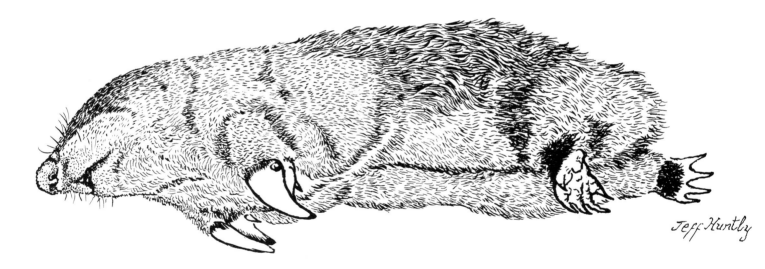

Jeff Huntly

The famous naturalist and writer, W.H. Hudson, enjoyed the rare experience of watching a British mole surface beneath some golden autumn leaves near his boots as he sat on a tree-stump. He witnessed a curious phenomenon: the mole was evidently irritated by the close proximity of crackling leaves, so it scattered them by whirling its body like a sort of horizontal Catherine Wheel, sending leaves flying in all directions.

My only contact with a Golden Mole was over before it began, for my dog had caught and killed it before I could rescue it. This particular animal had been quietly and effectively demolishing our lawn and, quite fortuitously, I spotted his freshest earth-mound

of these hand-like appendages – that is their undersides – were almost white, each claw-like toe being sharply pointed. Perhaps the strangest features are the fore digging claws and the weird face, without eyes or ears but all nose. This consists of a hard, rubbery fender used to push forward through the soil.

A live mole in the hand, apart from giving one a nasty bite, is quite impossible to hold in the way that one would hold any other small live animal. The mole is immensely strong, and the forepaws (which are mostly hard nail-like swimming paddles) push sideways with such vigour that the hand is forced open at once.

The Universal White Eye

The White Eye might be considered the most adaptable and successful bird ever to have evolved. Perhaps it originated in Africa, and over aeons of time it colonised Madagascar, Mauritius (where its existence is now threatened by man), India to Japan, southward again to Malaysia, Australia and on to New Zealand: It uses islands as stepping-stones.

In his vast *History of the Birds of New Zealand*, Sir Walter Lawry Buller speaks of it as having arrived on the north side of Cook Strait for the first time within the memory of the oldest inhabitants in 1856. Indeed, the Maori name *Tauhou* means "new arrival" or "stranger" and points to the recent colonisation of New Zealand by these little birds from the Australian mainland. His description of its nest exactly describes a White Eye's nest in Natal or Kenya. So successful was its colonisation of New Zealand that it is now the most numerous small bird there.

It selects a drooping branch of a mulberry bush on which to sling its cup-shaped nest. The cup is attached by its sides to twigs running parallel to one another and forming supports. Other situations are leafy vines, bushy drooping branches of shrubs or even high tree-tops. I found one nest in a mulberry tree, and it was loosely wound round its exterior with strands of horsehair that had been collected from a nearby barbed-wire fence. The eggs are pale blue, or sometimes white or very pale green.

The name White Eye refers to the dense circle of white feathers round the eye, not to the iris itself, which is brown. Popular names such as *witogie* and the earlier *glasogie*, "glass eye", "silver eye" (Australia and New Zealand), *kersogie*, from the resemblance of the eye rings to white candle wax, all show how well-known these little birds have become. The cheerful call as they search busily in our gardens for aphids, flower nectar and fruit is familiar to people in towns as well as on farms. In summer the male has a pleasing song, often long-sustained, and sometimes imitating the songs of other birds.

They show an endearing companionship to one another, and you may sometimes see a pair huddled up together in bad weather or preening each other's feathers. Sometimes a bird will hang from a twig by one foot and sway from side to side apparently just for the fun of it. I saw a White Eye do that once, and went to its rescue, thinking it was caught in a spider's web; but at my approach it let go and flew off.

They are regular visitors to bird baths, and they make a charming sight in the garden as they fan the water into a spray with their wings.

White Eyes can often be seen in quite a large flock fussily moving through the leaf canopy. At these times they may spontaneously indulge in a mad exhibition of high spirits, chasing one another and twittering excitedly. They can be found in these little bands far out in the bushveld, or in parks and gardens of the largest towns.

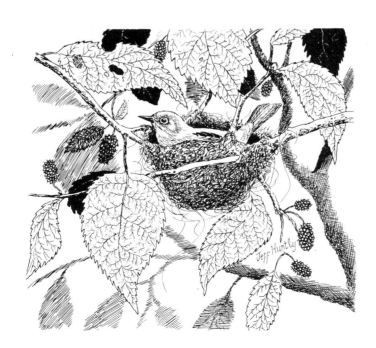

Overlooked

Seldom seen – a rare bird of Africa

It is difficult, if not impossible, to name Africa's most curious rare bird, but if it were possible to do so the Spotted Creeper would be one likely candidate. This fascinating bird has been recorded in various parts of East, West and Central Africa but is less rare than overlooked. Its cryptic colouring, secretive ways and its clever trick of keeping itself on the blind side of a treetrunk when under observation all help to keep it shrouded in mystery.

My own experience of this bird covers a period of five years in its most favoured habitat – the Brachystegia woodlands round the village of Marondera in Zimbabwe. Five consecutive years yielded very few sightings of the creepers. But they

this creeper its habit of joining mixed parties gives the observer a rare opportunity to observe it with some degree of certainty. Its tiny movements as it makes its way upwards on the tree trunks are jerking, twitching and mouselike. When it reaches a point high up the tree it flies off to another one keeping in line with the other members of the bird party. It flies to the bottom of that tree and winds its way upwards again to repeat the process. Its flight is straight and purposeful and is said to resemble that of a woodpecker – which is true – but I think it is even more like the flight of one particular sunbird: the Black Sunbird *Nectarinia amethystina*. Its eggs also remind me of sunbird's eggs; in fact, if I saw them

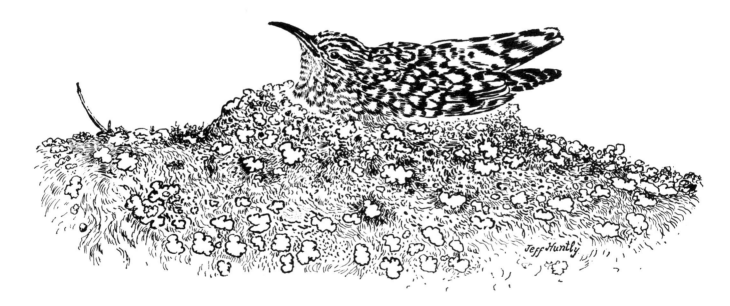

were there all the time, and because they are so easily overlooked one had to make a deliberate effort to find them. If I made a purposeful search for them it would invariably be futile, because they were always members of a mixed party. Bird parties are invariably discovered by chance, and to make things more difficult the Spotted Creeper is silent when with a bird party and plays hide-and-seek with the human observer, often moving round to the far side of the tree trunk. Its colours or markings exactly resemble tree bark, and the bird's movements are all that reveal its position. When it remains still for a moment it virtually vanishes. Mixed bird parties often comprise Eremomelas, Woodpeckers, Crombecs, Tits, Drongoes, Flycatchers and other small fry.

In those parts of Africa and India frequented by

for the first time not knowing they were Spotted Creeper eggs I would take them for the eggs of some small sunbird, perhaps the Olive Sunbird, or Neegaard's Sunbird. They are grey-blue with distinct dark pinpoint markings and some faint cloudy smudges more densely grouped at the blunt end. The resemblance to sunbirds continues in two other respects: the shape of the creeper's beak and the sound of its voice. At nesting time the Spotted Creeper proclaims its presence with a sound not unlike the call of certain young sunbirds when soliciting food from their parents: "tsweepy – tsweepy – sweep – sweep – sweep".

The sound of the brooding creeper is made from time to time throughout the day. I know that because while working for a period of ten hours in one place

I heard the cry of the Spotted Creeper issuing from a certain clump of trees nearby. It came from the same place day after day, so I assumed it was the brooding female informing her mate that she needed to be fed or that she needed to get off the eggs for a break. But I never saw the bird, even after diligent searching among the trees. However stealthily I approached, the bird would simply stop calling and her cryptic colouring kept her completely invisible on her lichen-covered nest. It was hopeless: I knew she was there, but she absolutely eluded me. One day I was looking in the general direction of "her" tree when the male suddenly alighted on a bare horizontal branch, moved quickly to a certain slight lump on the branch and remained there. "That must be the nest!" I said aloud. Using my 13 x 60 binoculars I saw the male briefly pause at the nest but could not see what he was doing. I felt almost certain that he was feeding her and had then flown away – but there may have been a quick change over of shifts to brood while the female went off for a break. Bruce Campbell's *Dictionary of Birds* tells us that the female does all the brooding. If that is so then the male must feed her periodically. I have seen the male Yellow-eyed Canary feeding the brooding female, who calls him to the nest when she is hungry. Its almost certain that the creepers do the same. But I think, as in the case of the canary, the female does go off occasionally. She also rolls the eggs while brooding them.

My nest was in the middle of an horizontal branch of a *Brachystegia spiciformis*. The nest and eggs harmonised with each other; the lichen making up the nest was the same grey-blue colour as the eggs, wonderfully camouflaged. Any rough-barked tree will attract the Spotted Creeper. Considering the difficulties of observing this singular bird even under ideal conditions it is unlikely that ordinary tourists to the game reserves, restricted as they are to their vehicles, would ever see one.

Footnote: An important trick of camouflage employed by the brooding bird is to tilt her head upwards so that her bill resembles a twig or thorn. The drawing shows this, and the nest decorated with lichen.

Black-shouldered Kite

On Trembling Wings

This small, inoffensive hawk, the Black-shouldered Kite, is a common sight along our highways or seen hanging in one spot in the sky on trembling wings as it scans the grass below with ruby eyes.

Its silvery-grey and white appearance at once reminds us of the seagull, as does its buoyant, relaxed flight. But its nest is not so familiar.

Not that there is anything strange about the nest when it is new, or when the four beautiful eggs are still being incubated. It only begins to look odd when the chicks emerge and the parent birds are continually flying to and fro with mice, vlei otomys and other rodents to feed the youngsters.

As time goes on and the chicks grow bigger, so does the accumulation of rodent fur in the nest. Eventually it forms a thick dark grey padding entirely covering the top of the nest, and no doubt providing extra warmth for the birds.

The nest in the illustration was found last June, containing eggs, and the chicks were reared in bitter winter winds in July.

The site of the nest was low down in an untidy wild shrub, quite easy to see and within reach of anyone who might pass that way. But that was the reason for this choice of nest site; no one ever went through that vlei, and it was always deserted; no pathway crossed it, nor was there any destination on the other side. It had solitude and so the chicks were reared successfully.

Four months later that nest still retained its pungent smell. Pieces of hardened rodent flesh hung like biltong on nearby twigs and white guano covered the branches supporting the nest. Fur had blown off to become entangled in twigs like mattress stuffing.

Black-shouldered Kites enjoy a good reputation from other birds, who do not become alarmed at their presence. They are interested only in small rodents, and they must account for great numbers of them. They are therefore friends to farmers.

Since it is a fairly tame and confiding species it is often the victim of small boys with airguns.

I remember with what ease I shot one with an

airgun when I was small. It sat in a tree just above me and flapped its wings pathetically as it hung wounded upside down, its claws still clinging to the branch.

I felt such remorse at what I had done that the sight remained engraved on my mind and can be recalled as though it had happened yesterday.

To one person the killing of other forms of life is deeply distressing. To others it means nothing. Perhaps the world is gradually becoming immune or indifferent to violence.

The entertainment media are almost entirely devoted to the portrayal of violence in some form or other, and children are continually exposed to it. But perhaps there is a ray of hope; one film company at least makes films for young people in which compassion for animals and birds is deliberately inculcated.

Appeals by schools for the conservation of wild life hardly touches the heart of the matter, which is a reverence for life in all its forms, and certain kinds of conservation, such as elephant culling, must be carried out with cold indifference to sentiment or individual lives.

When queleas are aerially sprayed for their sins, other birds die with them if they happen to share the same reed-beds; bitterns, reed warblers, bishops, rails, moorhens, jacanas, coots etc. The good and the bad die together, the wheat is burned with the chaff. As one game ranger put it after a culling operation: "Something inside you goes out."

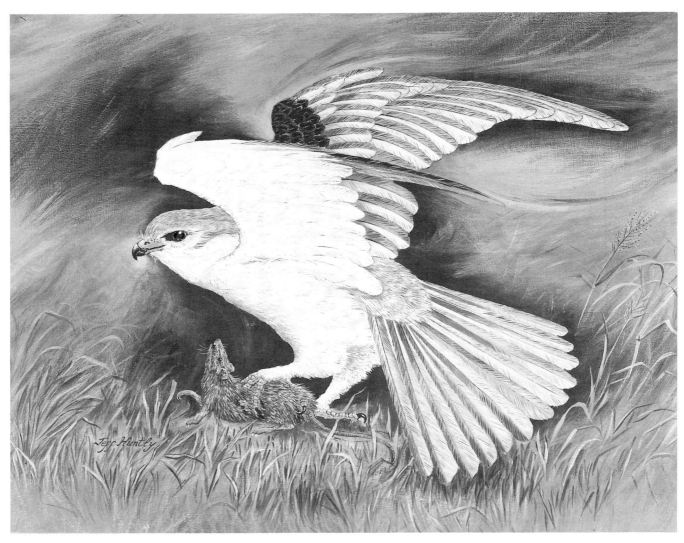

Tree Hotels

Certain trees are like an oasis to all kinds of wild life. They remind one of some popular hotel where coach-parties arrive for refreshment and then depart again on their various journeys.

Of this type of tree the various wild figs are probably the most important. When fruiting they attract antelope, who come and eat the fallen fruits. Likewise baboons and monkeys will knock down more fruit than they can eat, to the benefit of the antelope below. Apart from these animals wild fig trees are the natural home of the Green Fruit Pigeons. These beautiful birds move from one place to another in search of fruiting fig trees.

After dark fruit bats arrive and flap noisily amid the fig leaves as they try to reach the fruit with their doglike jaws. Probably the most prolific of fruits and one of the best known wild figs is the Broom Cluster Fig *Ficus sur* – previously known as *Ficus capensis* or Cape Wild Fig. Its South African National List Number is 50. The Common Wild Fig (No.48) is a typical strangler type fig, while the most famous or unusual tree in South Africa is the Wonderboom Fig – *Ficus salicifolia*, which has been growing for a thousand years near Pretoria.

Many trees attract birds and butterflies when in flower, but two in particular of the veld trees seem best qualified to be called "bird hotels". The Erythrinas in their various species and a strange tree of the Lonchocarpus family, often referred to as the Rain Tree in colonial Rhodesia and as the Appelblaar or Apple Leaf Tree in South Africa (S.A. No.238).

The drawing shows the spectacular scarlet flowers of the Common Erythrina attracting a Black-headed Oriole. Erythrinas in flower become a haven to many disparate species of birds: seedeaters, Red-winged Starlings, finches, weavers, sunbirds of every persuasion, orioles, mousebirds, barbets. I once saw four Pied Crows feeding on the nectar of Erythrina flowers. They were an arresting sight: large black and white birds set amid brilliant scarlet flowers. Their clumsy movements sent showers of red petals spiralling to earth.

A wildlife hotel of a different kind is the Rain Tree, or Appelblaar. When this tree is in flower it is a mass of greyish-violet and is then swarming with small insects, bees and butterflies. Sunbirds also call at the hotel for nectar. Thousands of the little flowers fall beneath the tree and form a thick carpet of petals. This grey-purple carpet in turn attracts many Guinea-Fowl Butterflies, whose chosen manner of life seems to keep them permanently at ground level. Their grey-brown wings are peppered with white spots like commas, and they settle on the carpet to tipple nectar – probably slightly fermented, as it has been lying for days in a spongy damp layer.

Another choice for an hotel tree is the common garden exotic *Grevillia robusta*, or Silky Oak. When in flower, and especially if growing by a farm steading, it attracts great numbers of birds to the honeycomb-shaped golden flowers. On the farm the Silky Oak is a magnet because it is usually the only nectar-bearing tree in a vast expanse of dry veld trees. In towns it is less of a magnet only because there are so many of them all flowering together that the birds become more dispersed. But in Alex Park in Maritzburg, near the tennis courts, there are two huge high Silky Oaks which, when in flower, bring a swarm of various birds, in particular a small flock of Red-backed Mannikins that remain in these high trees as long as there are flowers.

The Garden Inspector

National Park being more richly coloured, glossier and heavier than those round Wankie and Botswana.

Dr William Beebe, the American savant, once found a sleeping butterfly and lifted it from its perch, where it had been hanging upside down. After examining it he replaced it without waking it and its feet gripped the twig as before. He records that some Burmese guides accompanying him on an expedition would not kill a butterfly, and when the party walked through a swarm of golden butterflies, many of which settled upon the men's clothing, they were lifted off gently and made to fly away. These people believed that the golden butterflies were the wandering spirits of men who were asleep!

An interesting fact concerning the Garden Inspector is that the species appears in two forms: a summer form and a more gorgeous winter form, the latter showing a leaf pattern on the undersides of the wings – the only parts visible to the outside world when the butterfly goes into hibernation.

The Gaudy Commodore, *Junonia octavia*, a close relative of our sleeper, exhibits even greater contrasts in seasonal colours and wing patterns, so that for many years the summer and the winter forms were believed to be different species. In the summer form a deep pink is the predominant colour. In the winter form the Gaudy Commodore is a rich mixture of bright blue with a row of red splotches on each side and a lot of black . . . but blue is the predominant colour. In direct sunlight the whole butterfly becomes a lustrous blue as it fans open its wings to absorb the warmth.

One day in June a large butterfly sailed gracefully through my doorway and, after circling round the studio in search of a resting-place, settled upon a bottle of drawing ink. It then went to sleep and stayed there for the next ten days. Another bottle of ink had to be used meanwhile so that nothing disturbed his rest. From the slim shape of his body he was recognisable as a male. All female butterflies, apart from being much scarcer than the males, are fatter bodied.

If a room with an open door and an accommodating human is not available, then the butterfly will seek a shelter in some natural hollow in the veld, perhaps the entrance to a cave or a hollow stump or even an antbear hole. The studio sleeper, *Junonia archesia*, has the common name of Garden Inspector for its habit of cruising languidly among garden walks and settling among flowers, often sunning itself happily on flagstones. It combines three unlikely colours with pleasing effect: rich coffee-brown, some ornate splashes of light blue and a line of brick-red ovals along both wings. Butterflies of this species are more richly coloured in some parts of Africa than in others, although wing markings are identical. A parallel can be found among sable antelope, those of the Kruger

Hornbills

Like India, Africa has a giant among its hornbills: the Ground Hornbill, or as it was once more descriptively called, the Great Ground Hornbill. But whereas the Giant Hornbill of India is very much an arboreal bird, the Ground Hornbill keeps to *terra firma* most of its waking time, only flying up to some dry tree, perhaps over a marsh or over water in the evening to roost.

The Ground Hornbill is famous for its long eyelashes and deep tooting call. This sound issuing from a distant valley and being answered by another bird hidden among the surrounding hills, is unforgettable. The long-distance duet is sometimes carried on by family groups widely separated, although the actual sounds are made by only two birds in each group – one beginning the phrase and the other ending it. A long silence follows, and the other family reciprocates. Perhaps it is a kind of territorial staking of an area. Anyway, an altogether wonderful effect, like African tom-toms, amazingly far-carrying, and likely to bring on a fit of nostalgia for the old Africa now fast disappearing.

The Ground Hornbill is receding in the face of civilisation and encroach-ment by man in his ancient natural habitat. He survives well enough in the big game reserves such as Kruger, Wankie and others, but he is a lover of untouched wilderness, like the Bateleur Eagle.

This hornbill, unlike the arboreal smaller species in the first sketch, does not imprison itself in its nest. The nest may be in a variety of places, such as a large cavity at the base of a secluded tree or in a hole in the side of a gully, sometimes high up a steep hillside in rock fissures.

An unhappy tortoise overtaken by a party of these birds is reduced to a sorry mess within a few minutes as they drive their pick-like bills through its shell and gobble up frag-ments of its body. Although accomplished walkers, they nevertheless manage to look absurd as they waddle along, giving the impression of walking on tip-toe and not flat-footed like other birds. But even these ugly ruf-fians can be transformed into poetic grace when they take to the air. What a change it is! The snow-white wings suddenly appear which had hitherto remained hidden, and the grotesque becomes the beautiful as the sunlight catches them.

In complete contrast to this turkey-sized creature

is the little Grey Hornbill, a great favourite of mine because of its self-effacing ways, its plaintive piping call, which seems to proclaim its regret at not having any bright colours at all, and its characteristic dipping in flight. When passing through an area Grey Hornbills

fly from tree to tree in a series of aerial undulations, pretty to watch and sometimes amusing, as they often seem to misjudge the force of their landing and overbalance. This habit is repeated in many of the hornbill species because of their body and wing structure . . . compounded by a capricious gust of wind.

Four Hornbill Species

The Yellow-billed Hornbill shown in the painting is a species that quickly loses its natural fear of man. In places where these birds had never seen human beings before they soon learned to accept food from a young American couple doing scientific (species study) work in an isolated part of the Kalahari.

In game reserves, where of course they are not molested, they become very tame and often keep company with their near congener, the little Red-billed Hornbill. They learn to accept food from a human hand – this particularly refers to the Yellow-billed in a situation where there has been no previous experience with predatory man. Strange to say, there are still a few places remaining where men have not reached to bring death and trouble. Seen through the eyes of a hornbill or a little buck, men represent everything to be feared. But where men have not reached, the wild things have not learned to fear him. If this sounds like far-fetched idealism, the reader is urged to acquire a copy of Mark and Delia Owen's book *Cry of the Kalahari* (Collins, 1986).

The hornbills are among the most interesting of all the bird families. In at least two widely separated species there exists an unusual habit regarding the care of nestlings. In Africa the Ground Hornbills in a particular group collectively share the onerous job of feeding the nestlings. Unlike the smaller hornbills, who wall up their nest-holes with the brooding female inside, the nest-hole of the turkey-sized Ground Hornbill is left open, and the female can come and go as she wishes. In the case of the Yellow-billed and Red-billed Hornbill the male assiduously feeds the imprisoned brooding female. He does the job alone.

The other hornbill to practise collective feeding of the brooding female is the Bushy-crested Hornbill of Borneo, Sumatra and Malaya. This arrangement of general support from the group helps to sustain the group as a whole and relieve (or rather share) the burden of a single bird having to do the job alone. It would be interesting to find out whether – in the case of Ground Hornbills – the brooding female is fed by males and young males that she once reared in a previous season.

Hornbills' eggs are quite distinctive in that although the shell is hard and compact it is densely and minutely covered with tiny pore-marks and sometimes with small nodules, although these last are very few, sometimes only one to an egg. They are murky white with quite a handsome gloss. Years ago, I was given a collection of eggs of the pioneer Rhodesian birdman Capt. R.H.R. Stevenson, and I have his set of four Red-billed Hornbill eggs which he took on the Matetsi River on 27 November 1933. His nest-record card states in his own hand that the nest was in a Mopane tree. Red-billed Hornbills favour the Mopane country, whether in the northern Kruger Park, the old ranching Mopane country of colonial Rhodesia or other parts of Africa where the Mopane forest spreads itself in the stifling lowveld heat.

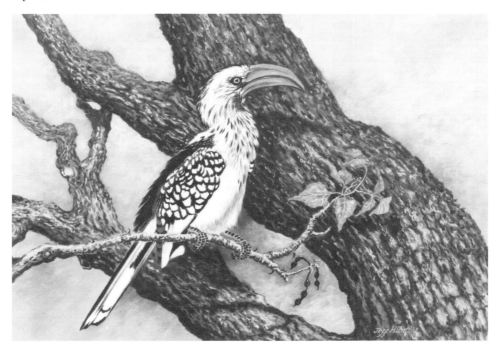

Hole-Nesters

The drawing shows a typical nest of a Black-collared Barbet in the dead wood of a branch sawn from a wild fig tree. Barbets seek out dead wood in treetrunks or branches and use their strong beaks to chisel out the fibrous softer wood, fashioning a short downward-pointing tube leading into a cavity or chamber in which their white eggs are laid. All barbet species nest in this manner, and some of them (e.g. Black-collared, White-eared, and Yellow-fronted) roost communally; the birds enter the nest cavity and cram themselves on top of one another right up the tube until there is scarcely room for late-comers. How they manage to breathe is a mystery. In the morning there is a commotion from those at the bottom and they all erupt out of the entrance hole – pop-pop-pop.

Black-collared Barbets are plagued by some honeyguide species. If the barbets leave the nest for a short break to go off to feed, the lurking honeyguide sneaks into the nest-hole and deposits her egg. If you should one day see the bright red head of the barbet blocking up the entrance hole of their nest, it means that the male barbet has become aware of the honeyguide's presence in the vicinity and he is determined to keep the parasite out. This guarding of the nest-entrance is undertaken by the male, while the female is off duty from egg-brooding and getting a meal. Sometimes an angry Black-collared Barbet may be seen chasing a honeyguide in endless circles from tree to tree near the nest-hole.

Nesters in holes in dead trees are many, and the species vary enormously from the exquisitely-coloured trogons, which use natural holes, and rollers to the cryptic-patterned Pearl-spotted Owl and the curious wryneck. Parrots and lovebirds, some kingfishers, hornbills, wood hoopoes, woodpeckers, starlings, oxpeckers, Grey-headed Sparrow, Yellow-throated Sparrow – all of these nest in holes in trees. The actual drilling of the holes is the work of barbets and woodpeckers. The others either evict the rightful owners or more commonly take over the nests when they are no longer occupied. Hornbills use natural cavities in dead treetrunks (sometimes caused by lightning or veld fires) which are then sealed up leaving a thin slit through which the conscientious cock feeds the imprisoned hen.

With the exception of the two sparrow species mentioned all these hole-nesting birds lay white eggs, there being no need for camouflaged eggs inside a dark hole. The hole-nesting sparrows lay coloured eggs – greyish-blue or greyish-green splotched and streaked with brown, dark grey or often so heavily marked as to appear completely dark brown. This may suggest that these two species of sparrow may have only recently taken to hole-nesting and that the slow process of evolution has not yet resulted in the typical white eggs of all the other hole-nesters.

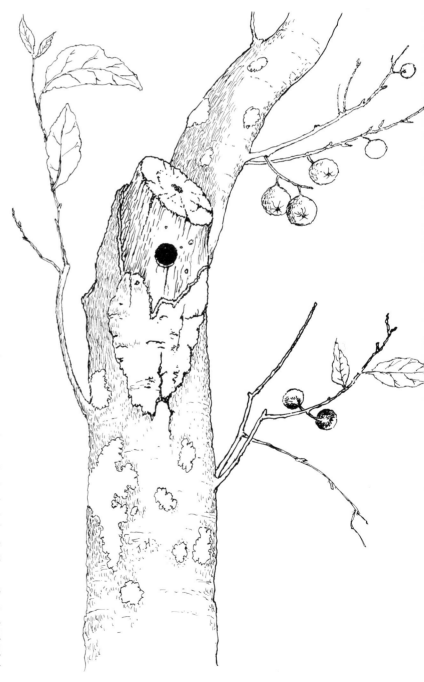

Hammerkop Nest

I once found a hammerkop's nest in a grand old willow tree overhanging a quiet stream far from habitation. With the aid of binoculars and powerfully reflected sunlight from a large mirror held by a friend, we were able to look inside the dark entrance of the nest. We were surprised to see golden honeycombs covered with bees. The bees were inactive because of the cold weather and took no interest in us.

Some short distance downstream, also in a willow, the hammerkops had made two more nests, probably in deference to the bees. We noticed a dead hammerkop wedged in the entrance hole of one of these nests. There seemed to be no explanation for its death in this strange position, except that it had upset the bees at the old nest and had been stung to death trying to enter the second nest. This nest

remained permanently abandoned with its dead doorkeeper blocking the entrance and making an outlandish sight. The surviving bird must have found a new mate, and they had made the third nest.

Hammerkop nests sometimes record a brief history of the immediate neighbourhood, what is going on there and whether there are cattle, sheep or horses near by and so on. Pieces of cement-bag paper decorated the new nest and bore testimony to a visit by a road maintenance squad who had camped by the stream to mend a bridge. Clumps of grass with root clusters pressed into the walls of the nest indicated that a road grader had worked nearby and that the birds had collected this handy material along with pieces of dry cattle-dung. The roof of the nest sported a growing black-jack weed.

A different hammerkop's nest found many years earlier contained several parts of an old gilt-edged Bible. There were loose bunches of pages in different parts of the nest, showing that the birds returned again and again for more of the Great Book.

A striking feature of these huge nests is that the entrance hole is cleverly placed so that it is hard to reach. Any predator trying to get to the entrance would have to climb upside down, only to find that the nest material crumbled away, giving no foothold. Digging through the roof is also forestalled by the birds, they construct a thick barrier of reed stems and clay, which makes an impregnable fortress. A colony of Spotted-backed Weavers is often found adjacent to the big nests, and their nests are shown in the drawing.

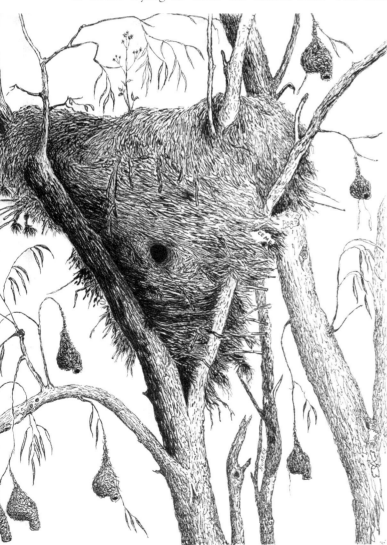

Grey in Nature

At certain times of the year the veld takes on a universal grey colour. It is attractive in a strangely subdued sort of way, as though everything the eye beholds – trees, grass, even the grey sky were waiting for the new season when rain will come and growth will begin again.

I was engrossed in these thoughts about this neutral colour and walking through a patch of dry weeds when a little grey bird flew out from among them. It was a female White-bellied Sunbird; and something about the way she flew off made me think she must have a nest in this unusual place. Unusual, because one expects to find a sunbird's nest higher up in a bush, not hidden in dry weeds just at one's feet.

I looked carefully at the exact spot that she had just left and then I made out the outlines of her nest: an untidy lump of rubbish, or so it seemed to me. But that was the whole point of it. The nest could not be recognised as a nest at all; anyone would have passed it; and so it would remain unharmed.

I made a quick drawing of it and then retired some distance away, hiding in some bushes to watch for her return. I particularly wanted to see if the little male sunbird would put in an appearance, for I wanted to confirm the species.

Suddenly both birds arrived together near the nest, she to disappear into it to brood, he to sit on top of some nearby dry sticks and chirp and chitter in that excitable way typical of sunbirds.

I marvelled at how everything in this domestic scene harmonised. The brooding female was a little grey bird. Her two eggs were grey with streaky markings, her nest was grey and set among grey crackling dead leaves of some wild flower. Everything complimentary to its surroundings and camouflaged to preserve life. Even my painting is grey!

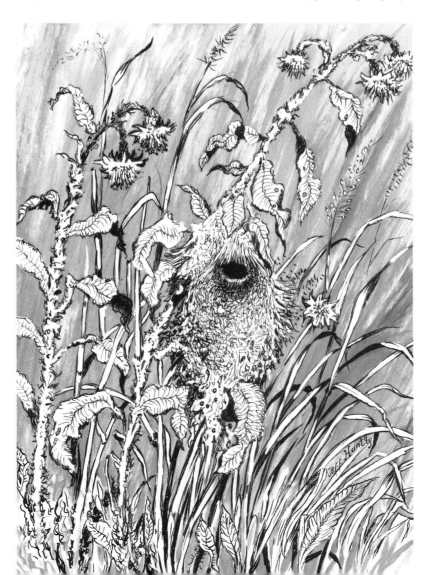

Eagles

The following incident set me wondering about the behaviour of birds in moments of stress or alarm.

I walked along the edge of a wide open stretch of vlei and noticed some bishop birds near a small dam as they sat clinging to various reed stalks. Nothing extraordinary in that, except that they kept looking upwards by tilting their heads first to look at the sky with one eye and then tilting the other way to bring that eye uppermost and look again, as though to confirm what they had seen the first time! They were watching a large brown eagle as it slowly descended in a series of steep aerial steps with pauses to hover momentarily at each new level. At the last of its hovering pauses, hanging there in mid-air like a huge kite, it brought down its legs, opening and closing the fearsome talons. I was reminded of someone sharpening a sword in preparation for some grim encounter.

At no point had I been able to see the object of his interest, but I knew that some creature lay hidden in the vlei grass and that presently the eagle would have it. One last swoop and the eagle had landed clumsily next to a Rufous-naped Lark which, instead of flying rapidly away, merely hopped feebly to one side. The eagle lunged at it again, and the lark flew up in a short loop only to land in front of the eagle. This time the eagle had it in his talons and flew off with it to some nearby trees where he devoured it with gusto.

What interested me was the lark's feeble inability to get out of reach, which it could have done easily, after the eagle's first bungling attempt. But in all probability the lark's fear was too great and made it partly paralysed and incapable.

Eagles may sometimes be seen cooling themselves in shallow water in a river bed. I once saw a large gathering of eagles and vultures where the Salitjie Road overlooks the Sabi River in the Kruger National Park. There were present Tawny and Wahlberg's Eagles, about half a dozen Bateleur Eagles and Lappet-faced and White-backed Vultures. They remained there for a considerable time with their legs and undercarriages submerged, making a memorable sight. Apart from these there were buffalo, waterbuck, kudu, impala, baboon and giraffe, all in the vicinity. This was in November 1963, and it would be interesting to know whether there are many Bateleurs now. The habit of cooling their legs in shallow water is in strong contrast to their dislike of flying in the rain. I've seen a Wahlberg's Eagle dash for cover from pelting rain. He dived under the shelter of a dense leafy tree, settling on a branch and shaking himself like a dog, giving the impression of extreme annoyance.

The Wild Strelitzia

In certain mountainous regions, where these wild strelitzias abound, they make a wonderful sight when their shiny leaves glitter in the sunlight. This is often mistaken for water glistening on the steep rock faces, and it is easy enough to make the mistake, for, after heavy rains, a great deal of water spills down the mountainsides in falls and rivulets. This may be observed often enough in the east-facing foothills of the jagged Chimanimani Range in Zimbabwe. The same banana-like tree is found along the Natal coast, but not in such a spectacular setting. Wild strelitzia flowers are pollinated by the two sugarbirds, and if you are fortunate enough to own both Keith Coates Palgrave's *Trees of Southern Africa* and Gordon Maclean's *Roberts' Birds of Southern Africa* you will observe an interesting link between the two sugarbirds and the two strelitzias. The species-distribution maps of these two volumes show that the Cape Sugarbird and the Cape Strelitzia overlap and the same is true of the Natal Strelitzia and the Gurney's or Natal Sugarbird. In the case of the latter both books show Gurney's Sugarbird and the Natal Strelitzia with almost identical map references on the eastern Zimbabwe highlands crossing into western Mozambique along the same mountain range.

The dry seed-holder of the wild strelitzia is a bizarre creation which would arrest the attention of anyone seeing it in a dry arrangement. The seeds are held in place by nut-shaped pods until these become dry and brittle, when suddenly they

snap open and the round black seeds shoot out. When freshly opened, the insides of the pods are beautifully coloured, for the ebony-black seeds nestle on cushions of red velvet, which in turn are held in place by the hard sides of the white inner pod lining, with an added interior layer of yellow ochre-coloured casements or shells.

During the life of the tree its leaves grow from stems that spring out from the main stem alternately, first to the right and then to the left. Old leaf stems gradually bend towards the ground and are left behind, as it were, by the new growth, which displays its greatest vigour in the centre leaf thrusting skyward.

Wild strelitzias and sugarbirds seem to have a certain amount of natural protection from man, and therefore from extinction: the tree cannot be used for firewood and so it remains unmolested. Some of these trees grew near our house and we could watch Gurney's Sugarbirds sitting astride the creamy white flowers and shaded by the banana-like leaves. In such a setting the sugarbirds kept up their "rusty-gate" call by the hour – a very distinctive twang, not unlike a certain guitar note mixed with other odd effects, a bright, pleasing sound.

The flowers are more beautiful than their close relation the Crane Flower, which, to my eye, seems a bit gaudy. The wild one is a subtle creamy white springing from a silvery blue sheath that looks like a crane's beak. It is full of nectar and attracts other birds besides the sugarbirds.

Woolly Legs

The huge assemblage of butterflies known as the family Lycaenidae includes some strange little fellows called woolly-legs, or scientifically, *Lachnocnema bibulus*, which roughly translated, means "with hairy legs and fond of drink". The name is apt and easily understood if one has the good fortune to watch the butterflies for a while. The woolly coverings to the legs remind me of the Mexican cowboy leggings called chaparajos, worn as a protection against thorns.

A certain bush was discovered to contain this species. When the bush was given a shake, out they came and danced erratically about before settling again; small butterflies they were, not much bigger than a ten-cent piece. When one of them was chosen for close attention it vanished the moment it settled among the leaves. Another was selected and this time very carefully watched, and the secret of the disappearing trick was revealed.

The colours of the wings exactly resemble dried or damaged leaves, of which every bush has a few. Furthermore, when the butterfly has settled it remains perfectly still for some time and only then begins very slowly to turn along the plant stem in search of the waxy scale insects upon which it feeds. So slow are its movements that few predators would detect them, let alone the puzzled observer trying to mark the spot in the bush where he last saw the butterfly. To make matters worse for him and better for Woolly-Legs, the butterfly moves under the twig and its shape becomes even more difficult to see.

Having located the scale insects, Woolly-Legs finds one that is "sweating" or exuding its tasty juices. This sweating is caused by numbers of small black ants stroking the scale insect. The butterfly takes advantage of the ants' efforts and moves forward until its legs straddle the scale insect. It then lets down its sucking instrument, or proboscis, like a tiny drinking straw, and proceeds to siphon the juice. The ants cannot get at the scale insect because of the hairy barrier of its legs and so move off to tickle a different one, perhaps with more success. The butterflies often feed upside down as shown – so they "siphon down", not up!

The butterfly sits with its abdomen raised away from the twig. This action keeps the abdominal parts out of reach of the ants, whose only contact with the butterfly is the hairy legs, from which they recoil. The markings on the undersides of the wings also resemble the colours of the scale insects: red-brown with some silver flecks or lines. A characteristic of the species is the great amount of time spent sitting in the bush and drinking. Like most drinkers, Woolly-Legs prefers company, and wherever the species is found it will be in companies of five or six in each bush, never showing themselves until the bush is shaken.

The scale insects (Ceroplastes sp.) are frequently found on a shrub known as the Blue Bush or Monkey Plum *Diospyros lycioides* (S.A. No.605).

An Old Farm Gate

Rural scenes, such as the one depicted, have always touched some chord in my imagination or brought back some vague memory of a childhood spent in wide open spaces in a variety of African settings.

The familiar farm gates often included several different notices in their immediate vicinity, and on windy days these objects would squeak and rattle as though tired of holding up their messages . . . a rusty chain on the gate would clink in sympathy.

I invite my reader to walk through the gate to the low hills beyond and survey the prospect from their slight elevation. Being of no great height they are undemanding of physical effort, allowing time and opportunity to hear some Rock Buntings, often to be found on bare desolate ridges in many parts of Africa. Their bright chittering snatches of song emphasize the solitary feeling of the place. Consider too the trees and grasslands just below the Rock Buntings, and the other veld dwellers that stay in that cover.

Among those trees I find a pair of duiker feeding on some hard dry berries. The wind disturbs the trees and grass, muffling my footsteps; and I have made a detour to keep the wind always coming from their direction to me. Soon I am near them and can watch them at my leisure, partly screened by some dry khaki weeds behind which I crouch. The buck are unaware of my proximity, and I can hear the crunch of their teeth on the hard fruit. These animals are extremely wary of human beings, but here for a brief time are brought together – by the chance action of the wind – two buck and a strange human being who has no

wish to kill them. I marvel at my good fortune!

But reader, I must do this alone. If you had come with me we should not have got so near to those duiker; or, you must go alone – don't have me with you – more than one is a crowd in the veld. The wind changes and the duiker catch the dreaded human scent and are gone. They will not return to this spot for the rest of the day, so I make my way to the open ground shown on the left of the drawing.

This is a paddock that has been grazed and trampled by cattle, and the bare ground attracts many birds. Some pipits fly up at my approach and are blown away by the wind. They settle awkwardly on the barbed-wire fence at a good distance awaiting my departure. They have a nest somewhere near my feet in the dry grass clumps bordering the paddock. Other birds include plovers, Namaqua Doves, Turtle Doves, waxbills and Swempi Francolin. The collective effect of cattle hooves churning up soil and dry dung creates excellent conditions for birds by day and a variety of animals by night, especially if these conditions cover a large area with cattle present.

Aardvarks, spring hares, porcupines, wild cats, servals and polecats have all been encountered at various times in well-used cattle paddocks. The two felines were probably after the large burrowing crickets that frequent such places, also gerbils and sleeping birds. Nightjars and bats are particularly drawn to the sleeping cattle, attracted by the swarms of small insects hovering over them.

At dawn the nocturnal animals have gone, leaving their spoor and the old gate to clink in the wind.

Black Flycatcher

There is a curious relationship between the Black Flycatcher and the Fork-tailed Drongo. Whether it qualifies as anything approaching symbiosis is doubtful, but it does seem that the Flycatcher-Drongo association persists over long periods of time, and in vast areas of Africa separated by equally vast distances. Birds in the southernmost extremity of their common range have this same habit as those in the northernmost extremity.

The association is simply a casual affair in which the Black Flycatcher seems to follow the Fork-tailed Drongo about on its insect-hunting forays. This sentence should really be in the plural, for it is usually a pair of Drongos joined by a pair of Black Flycatchers, and quite often young sub-adults of the season are also present. These black birds of both species can then become a party of five or even seven individuals. It seems that the main beneficiary of this casual association is the Black Flycatcher, which enjoys a certain amount of protection from proximity to the Drongos – for Drongos are the avian policemen of the veld, warning all other birds of danger, chasing off hawks, owls and other predators.

In the matter of nesting there seems to be no association. Black Flycatchers nest near the ground in cunningly chosen sites, whereas Drongos nest quite high up in trees far out of reach of human nest-robbers.

The Black Flycatcher often chooses a broken stump of a tree that has been blackened by veld fires. If there is a hollow about shoulder height there, the nest is placed so that it is easy enough to look into it and see the eggs, if one ever finds the nest! Sometimes the nest is placed among aloe leaves, as shown in the illustration. Although one may think it is foolish of these birds to nest within reach of human beings, the nests are so cleverly concealed that they nearly always escape notice. Those nests situated within charcoal-blackened hollows in burnt tree trunks completely hide the brooding bird, which is black to match the charcoal. When the chicks hatch their fluffy bodies are also impossible to see in the dark shaded hollow. Their plumage grows rapidly and becomes vermiculated with wavy lines, giving a mottled, streaked appearance, like the nest-lining of fine rootlets and pine-needles.

I watched the nest in the aloe, and when an African gardener brought his lawn-mower directly beneath the nest and the noisy machine worked round the base of the aloe, that nest was never discovered, although the man was almost breathing on it!

The big aloe leaves also proved excellent protection against storms. One day hail battered down, and I wondered whether the chicks had survived, for many trees in the vicinity had their leaves shredded by the hail, and two of them had collapsed during the night and lay spreadeagled on the ground. The chicks were fine, and their nest was completely protected and dry among the fleshy aloe leaves. Very soon after the hailstorm the fledgelings were gone – grown sufficiently to fly off and to be cared for by the parents a bit longer in the surrounding trees, after which they could fend for themselves.

The Saddlebill

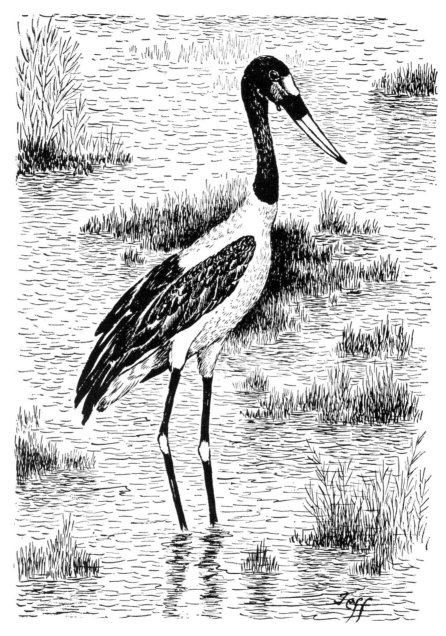

This magnificent stork is an excellent example of bright colour contrasts creating an impression of greater size. Seen against its drab background, the dazzling white and black colour scheme with scarlet bill is an unforgettable sight. But even more beautiful is the sight of a saddlebill in flight as it slowly circles in a thermal current, lifted upwards in great spirals as the warm air buoys it up.

These great birds are threatened with extinction as "civilisation" spreads its tarmac and concrete tentacles into the last remaining wilderness. If it were not for the rigorous protection given by the various wildlife organisations, the saddlebill would long ago have joined that unhappy club whose qualifications for membership bears the inscription "extinct species".

I was once the privileged spectator of a pair of saddlebills wading across a shallow pan in a Lowveld game reserve. They marched in step together side by side, every now and then striking with their scarlet bills to transfix some careless frog. I tried to record the scene on the canvas of memory rather than with the crude materials of the artist.

People with even a casual interest in our birds will be familiar with that common and abundant little bird: the Bronze Mannikin or Fret. Not so familiar, and in fact seldom seen, is its nearest relation the Red-backed Mannikin. This latter species is more richly coloured than the former, its back is a pretty chestnut and the black head is more distinctive, with the jet-black extending farther down the chest. The white spotting and barring is also more distinct that in the Bronze.

Environmentalists, ornithologists, scientists in every field of research, people from every walk of life with any interest in South Africa's wild life and last remaining wilderness are once again saddened or angered to learn that more of the coastal dune forest area along the Natal coast is to be reduced to a pulverised wreck as mining operations are planned and put into effect in the quest for money, foreign-exchange earnings and the urgent need to pay off some of the national debt. Always in the affairs of men there will be the justification to destroy the riches of the earth in exchange for money. When the last of the unspoilt glories of Nature are gone the debts will still be there, the greed for money will still be there, but the things that money cannot buy will not be there any more.

What has all this to do with the Red-backed Mannikin, littlest of little birds, the size of your thumb? What has it all got to do with the rare Black Coucal? These two species – one quite common, the other rare – as well as other more spectacular birds, animals, and most important of all, indigenous coastal trees and plant life, the fragile balance in the distribution of species and entire webs of interdependent life-forms will have gone for ever.

The accelerating speed which technology has given to man's destructive capacity means that within the next decade or two our natural world will scarcely be recognisable and those species now listed as "vulnerable" and "threatened" will inevitably have become extinct – if not entirely then in vast areas of their former range – a fate that is already overtaking the Bateleur Eagle, the Wattled Crane and the Bearded Vulture among birds.

In the South African Red Data Book (Birds) there is a puzzling reference to the Black Coucal. It reads "full legal protection is afforded by provincial and homeland conservation ordinances. If the occasional modern records from the Lake St Lucia Complex represent breeding birds, they are thus protected".(!) The exclamation mark is mine. How can "full legal protection" be taken seriously in the face of the expansion of the human population, the replacement of natural habitats by sugar-cane estates, mining operations, the draining of wetlands etc., etc? "Full legal protection" was supposed to protect the Bateleur Eagle, yet that magnificent bird has been wiped out in the Cape, Natal and the O.F.S., because it picks up poison baits put out for jackal. "Full legal protection" sounds very grand; but if it is impossible to enforce then it is just empty verbiage.

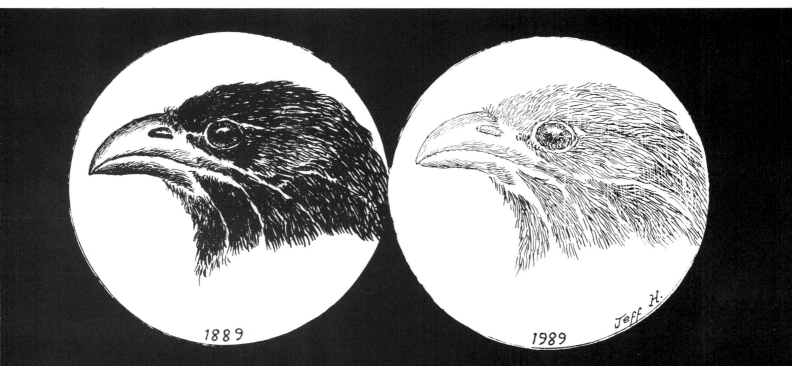

1889 1989 Jeff H.

The Twig Snake

When thinking about the Shona name for this snake I am reminded of the Apostle Paul's experience with a snake while gathering firewood and putting it on the flames: "And when Paul had gathered a bundle of sticks and laid them on the fire, there came a viper out of the heat and fastened on his hand..." (Acts 28:3)

African tribeswomen all over the continent have always had the job of collecting firewood and the smaller children the kindling. While so engaged they have since time immemorial inadvertently picked up a bunch of sticks in which lurks a thin grey snake, so like a stick itself and so motionless as to be impossible to see. A girl may hoist the bundle and carry it on her head, snake and all, and only discover the snake if the bundle goes straight into the fire and the snake tries to escape, suddenly revealing itself by its movements. Of course this is a rare occurrence; the snake is usually detected a lot sooner. The bundle is then thrown down amid squeals of mirth from her friends and shrieks of fear from the bearer herself. A former Rhodesian District Commissioner tells me that finding the snake in your faggots was an omen of good luck! The Shona names of *Kangamiti* and *Garakuni* alludes to its remaining still in trees (*miti*) or firewood (*kuni*). An alternative spelling is *Gara-huni*, *huni* being the general name for dry faggots.

There is a beautiful painting of this snake in Frank Oates's *Matabeleland and the Victoria Falls*, and the snake was named *Dryiophis oatesii* in his honour in 1881. The name underwent a change later when it became known as *Thelotornis capensis capensis* with *Thelotornis capensis oatesii* as the representative of the species in the Mopane tree country of Matabeleland, eastern Zambia, northwards to Tanzania and Malawi.

Although considered harmless for many years, it was found to be lethal to human beings if a large specimen got its venom into a person. I once put my face very near to one of these snakes, not realising what it was. My African companion was an amused spectator of my fright when I detected a cold pair of slit-shaped eyes staring at me from one end of what I had thought was a grey stick. It was lying in the middle of a sandy path, simulating a stick to escape our notice as we walked towards it. I had bent over to examine it closely.

My African friend gently pushed the snake's body with his boot and it merely continued its imitation of a dead stick - adopting the "U" shaped outline of the toe of the boot. This amazing simulation of death or a twig went on long after our patience was exhausted.

The twig snake feeds mainly on arboreal chameleons, geckoes and fledgelings, and it has the habit of imitating a rigid stick swaying in harmony with other real sticks blown by the wind. This position is held for long periods at a time, as though the snake had frozen into an inanimate stick. In the many thousands of years of the snake's existence as a species it seems not too far-fetched to think that birds have occasionally perched on one believing it to be a twig!

The remarkable part of the stick act, which completely fooled me, was that the kink in the snake's body was sharp, almost at right angles, like a real break in a stick. The natural "S" shape of a snake was deemed not to be realistic enough. How do they know?

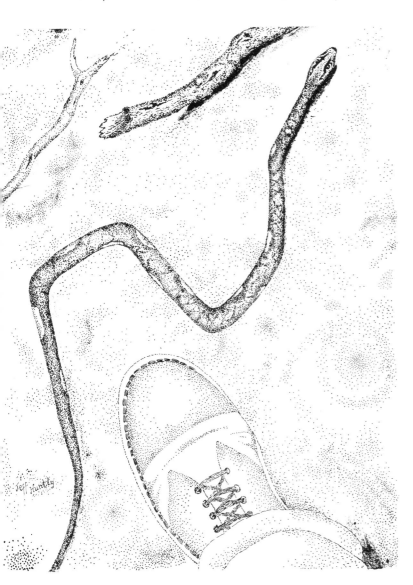

Fieldmouse

Part 2

Kestrel and Fieldmouse

In a previous article concerning a wildcat mention was made of fieldmice being active towards sunset. This would appear to be the case, for a few days later the wildcat was observed in the same place at the same time, almost certainly awaiting his opportunity to take another mouse.

As if to confirm that I could expect to find fieldmice active at this time I saw a greater kestrel on the same road at the same time feeding on one, and next day I saw the kestrel again – although this time he was merely sitting on top of his favourite perch. He was watching the ground below him.

I was determined to wait and watch with him, for I hoped that if I could be patient enough I might see him dive down upon a mouse, allowing me to photograph the whole sequence. But alas! the golden rays of the setting sun began to fade and the kestrel's patience, as well as mine, gave out and he flew away.

An inspection of the area beneath his perch revealed that the grass was criss-crossed with fieldmice tunnels, as had been the case with the wildcat's hunting ground described in Part 1. These tunnels are winding pathways thickly overhung with grass under which the mice can scamper about in comparative safety from the sight of their many enemies.

The fieldmice were the common four-striped fieldmice (now known as the Four-striped Mouse) which are diurnal creatures conducting their business by day, which offers diurnal predators, such as the kestrel, the chance of a meal.

It seemed reasonable that they would become active just before sunset, as they would want their last meal of the day, and in the case of the wildcat, which is normally a nocturnal animal, the two crossed paths, the mouse scurrying home after being out in the mealie field and the cat alert for his first meal of the evening.

An interesting point about the wildcat and the kestrel is that they returned expectantly to the same place at the same time, as though the memory of earlier success lured them back for more.

After maize has been harvested there is always some of it lying about, and this attracts fieldmice and other rodents; predators can therefore often be found in old mealie fields, which gives a rare chance to see a wildcat, a greater kestrel and many other shy hunters.

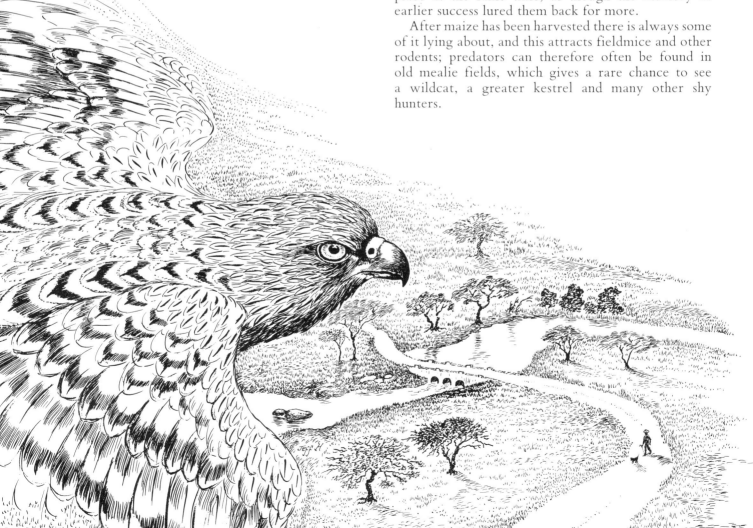

Leopard

The character of animals, their mental make-up and how they react to other animals are always a rich field for conjecture and interest. Leopards seem to be able to read the thought-patterns of their prey – or so it appears to someone watching a leopard who in turn is observing its prey. The following incident may illustrate that.

I visited a game farm with an artist friend and my daughter. Near the farm homestead there was a very large wire enclosure containing a pair of leopards. Outside that, in the garden and surrounding park-like grounds, various animals and birds, most of them tame, were free to wander about. Among them were a number of vervet monkeys, which had become quite insufferable. They were a general nuisance, pestering visitors, acting aggressively towards children, who sometimes teased them, and taunting the leopards from the safety of their position outside the wire mesh.

Our visit apparently coincided with the moment when a leopard decided to rid himself of one particular imp of a monkey, which, bolder than the others, clung to the wire and made faces at him. The big feline gave the impression of bored indifference as it paced slowly along the wire. Its yellow eyes regarded the posturing clown impassively; yet one could sense that it knew the monkey would make the inevitable mistake of all monkeys and become too cocksure of itself. Which it did.

For some reason, the monkey put its hand just too near the leopard; perhaps its concentration wandered for a split second. It seemed as though the leopard had actually been anticipating this mistake, for its paw seized the monkey's hand in a movement so sudden that the monkey was being held in a deadly embrace before it had time to scream. Because of the size of the wire mesh, the leopard could grip only part of the monkey's head, but the razor claws sank deeper while the frenzied cries of the simian grew weaker. Soon it hung limp against the wire, with the leopard continuing to grip the lifeless form in that savage unrelenting manner of the big cats.

What morbid curiosity caused the monkey to pester the leopards day after day? It had the whole farm to enjoy along with all its kind, for there was quite a band of them. Yet it chose to play a game of dare with leopards. After a week or two some other monkey, short of memory and wisdom, would no doubt take up the same nonsense with the leopards.

It is interesting to compare the life-style of the leopard in India and that of his counterpart in Africa with that of the jaguar in the New World, where

it extends from the Rio Grande to Argentina. The original name of our leopard was *Felis leopardus*, later changed to *Panthera pardus melanotica*, whilst the name of the jaguar, *Felis onca onca*, given to it by Linnaeus himself, is still retained. In India leopards live near peasant villages, where they know they can get domestic or semi-domesticated animals: a careless goat or calf, a fowl or two, dogs, anything wandering too near the jungle where the leopard finds cover.

In Africa, in places where peasant villages offer less cover being in more open country, leopards depend less upon domestic animals. Like the jaguar they find a quiet retreat in broken country with plenty of cover. This becomes their hunting territory for a long period, as long as conditions suit them: enough prey and water to drink. Leopards understand the habits of their human enemy so well that they survive right under his nose in the most unlikely places, such as the suburbs of Nairobi. Both leopard and jaguar have an extremely catholic diet, which contributes so greatly to their continuance.

The Sky-Leopard

It's good to see that so regal a bird as the Crowned Eagle was named originally by Linnaeus in 1766 from the type specimen obtained in "Coast of Guinea, West Africa". The scientific name Stephanoaetus coronatus (linnaeus) indicates that the name underwent an alteration at a later date. This is indicated by the name Linnaeus being shown in brackets. Linnaeus himself named it Falco coronatus but this more dashing and poetic name has been altered and only "coronatus" remains of it.

Linnaeus' name likens the eagle to a Crowned Falcon. The name Falco now refers to the family of true falcons - Falconidae – which embraces the Peregrine, the Lanner, the Hobby Falcons, the Saker and the Kestrels.

Striking similarities: To the monkey tribes of Africa the Crowned Eagle is an ogre, the terrible flying tiger which may suddenly appear in their midst to carry off some hapless member of the clan in its huge talons. Tigers, leopards and crowned eagles have some striking similarities in their hunting techniques and markings: the same lurking in shadows, the same thunderbolt attack. All three of them face a bleak future as more and more of their wild habitat is cleared for agriculture and resettlement.

This regal eagle takes time off from hunting twixt shadowy forest trees to ascend into the heavens and demonstrate his powers over the force of gravity. Wheeling and plunging, alternating brisk wing-flapping with gliding in huge circles, he gives his mate an awe-inspiring display when he dives, curves upwards like an old World War 1 biplane when it reached its highest point and "hung on its propeller" before falling back and sideways again. The eagle does this steep dive and upward climb again and again whilst calling "kewee-kewe-kewe".

I once witnessed a remarkable incident when a Crowned Eagle landed in a large wild fig tree with a rush of wing beats. It had seen a domestic cat hiding in the tree intent on stalking a small bird. The terrified cat bounded along a wide branch and did a spiral descent down the stem with the eagle in hot pursuit. The eagle spread its huge wings and came around the trunk in his own spiral before reaching the ground just behind the cat. Before touching ground, Garfield's legs were already blurred in a running motion and his hair was all on end in fear. He shot across the lawn with the eagle bounding and flapping close behind. He managed to whisk beneath a dense bushy hedge and escape.

More recently I saw a Forktailed Drongo fly upwards, almost vertically, to attack a Crowned Eagle. The little drongo's wings beat feverishly as he launched two attacks on the eagle which, despite its size and strength, quickly took avoiding action and flew away. Drongos actually dive onto the backs of eagles and owls to give them a swift peck, knowing the big birds cannot turn fast enough to retaliate against this furious plucky midget.

Apart from monkeys, Crowned Eagles also partake of the Blue Duiker found in the same forest habitat, game birds such as the Crested Guinea Fowl, a briefly careless Hyrax and mongoose, among other animals depending upon locality. Monitor lizards and even the occasional goat are also authentically recorded as its prey.

Colossal Structure: The nest is a colossal structure of sticks in a high tree and, when in use, is lined with new fresh leaves. It is used for many years in succession if not interfered with by man. The late David Reid-Henry, doyen of bird artists, once owned a female Crowned Eagle appropriately named Tiara. David's admiration for Tiara was not reciprocated and she twice sent him to hospital for stitches. He carried her perched on his arm in the manner of a falconer but he was never sure when she would turn on him again. Having known David, I think he enjoyed the uncertainty of the relationship and the element of risk.

The Telephone Bird

This fine robin can imitate the sound of a telephone so well that a person may rush to answer it only to find that the sound is being made from a nearby tree! The phone has a duplicate among the branches outside the window. At other times the real telephone will ring and if the Chorister Robin is singing in the vicinity it will immediately mimic the rings as though mocking the instrument.

A pair of Chorister Robins will live in a garden permanently if unmolested and breed there year after year. At least this has been my experience when observing them over an extended period. They will brood twice in a summer season, as I recently discovered. The first nest was made in November 1989 and the second in January 1990 by the same pair. Both nests were in a wall creeper.

The most interesting characteristic of these ever-vocal birds is the secrecy and cunning they employ when nest-building. Although I am constantly observing birds in our garden I have never seen these birds carrying nest material to a nest site. Yet they made a nest in a dense creeper growing against the walls of our house; furthermore, on that side of the house where people come and go the most. I found the nest accidentally when I was on a stepladder clearing a gutter of leaves. The nest contained three chocolate-coloured eggs which were very glossy, like dark brown glass marbles.

Even when the eggs hatched I never saw the parent birds flying to the nest with food, unless I made a special effort to watch the nest site. Then the parent birds would fly briefly into the leafy creeper and quickly pop the food into the little gaping mouths and fly out again. All in a matter of seconds. No lingering about advertising the nest's whereabouts. Once I saw the parent bird gathering earthworms and flying straight to the nest – so I knew at least one food item. Another was soft green katydids, those long-legged grasshopper-like insects.

Strangely enough the brooding female would take a protracted and lengthy bath late in the evening.

She would be thoroughly soaked after these sessions and, in the semi-darkness of late evenings, would fly to her nest to brood the eggs and also the chicks after they had hatched. It was difficult to understand why a bird would choose to spend her nights sleeping in wet pajamas but there it is; she did it regularly! Chorister Robins must be among the cleanest of birds for I saw them bathe daily throughout the year and often both of them bathed late – sometimes so late in the evening that one could hardly see them.

When the female was egg-brooding the male kept up his loud and vigorous serenade from various locations in the garden. It seemed that he was reassuring her of his constancy and companionship and that all was well. I am convinced that he had a special refrain inviting her to come and dine. He may have even done this to swop places with her, relieving her of brooding duties so that she could have a meal, stretch her wings and preen her feathers. This practice is common among birds generally.

When the chicks are fledged they suddenly fly out from the nest in rather a haphazard manner. I mean by that their initial flight is an alarming exhibition of inexperience, bad steering and poor timing. One youngster fluttered straight into a bush, misjudged his wing brakes, collided with a branch and landed wrong way up on the lawn. He sat there hunched up for a long time but his parents coaxed him to fly again into cover, thereby guiding him to safety. To sit exposed on the lawn was dangerous and he could have been taken by a passing hawk. It was obvious that the parent birds understood the situation and called him with urgency to safety.

When closely attending to a fledgeling the parents use a special kind of sound for the occasion, a sound not heard at any other time. It goes "Worraworraworraworra – worraworra" and if you were brought up on The House at Pooh Corner, you will recall that the same sound was made by Tigger when he jumped on Pooh's tablecloth.

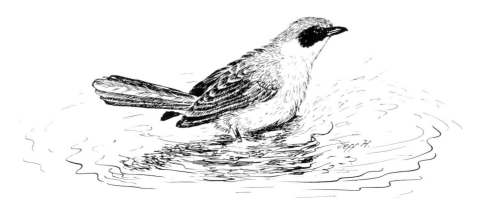

Elephants and Butterflies

The interaction between animals, birds and insects is complex and to the sympathetic human observer always fascinating. Even the dung of big animals plays an important part in the chain of cause and effect in the ramifications of Nature.

In the cycles of Nature elephant dung is part of the food chain of certain animals, birds and insects. By night one may observe scrub-hares feeding on seeds and partly digested vegetable matter in elephant dung; hornbills do likewise and all kinds of insects find nourishment, from beetles to butterflies. By grubbing about in the dung these creatures break it up and the seeds in it are dispersed. Some tree seeds need to pass through an animal to stimulate germination.

The drawing depicts a strange sight that I saw in the Kruger National Park: elephant dung completely covered by small bright yellow butterflies known as Grass Yellows. When disturbed they rose in the air in a yellow cloud before settling again. Nearby were some birds called Little Bee-eaters . . . which catch and eat butterflies on the wing, while other birds eat butterfly larvae . . . the unending chain.

Man interacts with his environment, but he conducts himself as though he did not. The wholesale destruction of tree cover all over the world, the ignorance of peasant communities of the proper conservation of topsoil, continues.

Example: Malawi as a country is washing away to the Indian Ocean. Although the population is hard-working and possessed of a national characteristic of honesty, they have managed to farm up and down steep hillsides and virtually strip the country of its tree cover. The Shire River is an instrument that records the situation. Old inhabitants remember the days when the country was densely covered with indigenous trees and the great river sparkled with clear water. Now the Shire is the colour of chocolate, full of rich topsoil that once fed the people – all flowing into the Indian Ocean.

Example: The burning of the Amazon jungle to make way for beef cattle.

Example: The destruction of the Redwoods of California, giant trees two thousand years a-growing, cut down in minutes.

Although elephants are so destructive to trees their function in the dispersal of tree-seeds was once balanced to some extent by the number of trees that they destroyed. The prodigious increase of man has upset the fragile balances of Nature, so that we now have a situation where conservationists are devising ingenious schemes to save the last remaining stands of rain forest. The Earthlife Foundations project to save the rain forest of Cameroon is an example of such attempts at conservation. The British Broadcasting Corporation's magazine *Wildlife* has an amazing advertisement on its back cover. It is a full-colour map of Korup Rain Forest and Cameroon, as though seen through the eyes of a computer, made up of tiny squares. Each square represents a thousand trees. By sending the organisation £10 the donor will secure the future of one of these squares of forest. Earthlife, working in cooperation with the government of Cameroon hopes to save the ancient Korup Forest. The text of the advertisement reads: "Rainforest: Life on earth depends on it – to regulate our climate, to shelter millions of species of plants and animals, and to provide sustenance for more than a billion people. Without it, life as we know it cannot survive. Yet within thirty years most of it will have gone."

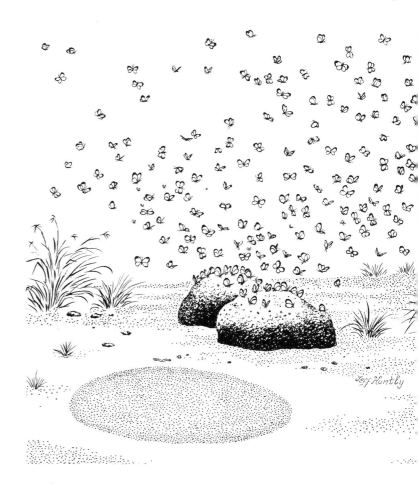

Saving the African Elephant

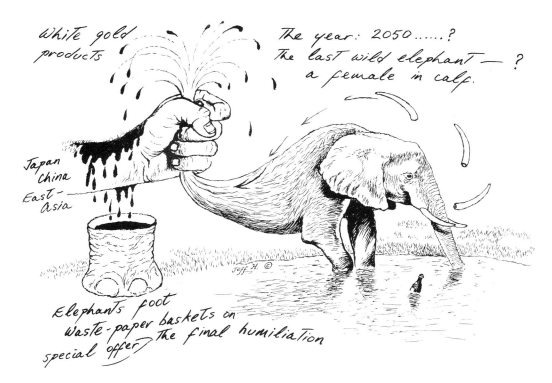

In a comparatively short time this once abundant animal has been reduced in some parts of its range by as much as 90 per cent. Because the bulls carry the finest tusks, they have been so relentlessly hunted that poachers shoot mother elephants with calves in their ruthless quest for whatever ivory they can get. Africa has become, once again, the stage for a new and special kind of tragedy in which baby elephants are left to their fate: ending always in prolonged suffering of one kind or another.

The response of the Western world has been a proposed total prohibition of the import and sale of ivory – the so-called "white gold" of antiquity. Some African states such as Kenya, have been the leaders in calling for this prohibition, while others are reluctant to lose revenue from ivory products and do not accept it. Far Eastern countries, take part in a huge trade in ivory with a vast infrastructure of skilled craftsmen creating ivory bric-a-brac and particularly tourist mementoes of infinite variety. These objects are their stock-in-trade: pot boiler junk bought by thoughtless tourists at airport kiosks all over the world.

Passing resolutions and prohibitions that cannot be enforced is regarded by some authorities as a mixed blessing and by others as impracticable. The threat of a ban could push up the price of ivory and intensify the rush to get more of it. The people who have proved that elephants can be farmed and profitably harvested have hardly been consulted, and the prohibition could hurt those countries that control and manage their elephants properly. South Africa leads the world in its management of elephants in the Kruger National Park. The Endangered Wildlife Trust likewise is a world leader in conceiving ways and means to save many threatened species from extinction.

It would seem that the aesthetic feelings of the Western world cannot stomach the idea of elephant farming in which these symbols of the ancient world become so many domestic animals like cows, sheep, pigs and champion bulls, with all that that implies, in the way of total human control of every facet of the elephant's life: its food, its movement within prescribed areas, its health, its rate of reproduction: everything about it regulated and reduced to a commercial product – this job-lot on special offer to a friendly government, that other lot to be turned into hide, meat products, etc. That big tusker to be used at a fee of two million dollars for hire to an American film company proposing to shoot Hemingway's *Green Hills of Africa*.

Overnight the word "wild" will virtually become obsolete. The great majestic elephant, once capable of fending for himself and going where he pleased, has suddenly been transformed into a commercial commodity with no greater or less value than a fast-selling plastic toy. His only salvation from extinction

at the hands of poachers is to become homogenised, homosapienised.

Like the Black Rhino, the African Elephant has reached a fork in the road: to the left, total extinction; to the right, total domestication. The road has no third fork that we humans admired and loved so much in our idealism – the one we called "wild".

What we humans do outwardly and how we feel inwardly are two different things. Is idealism in the world of technology obsolete? Like morality it has no commercial value. Where are we heading?

The Elephant Bull

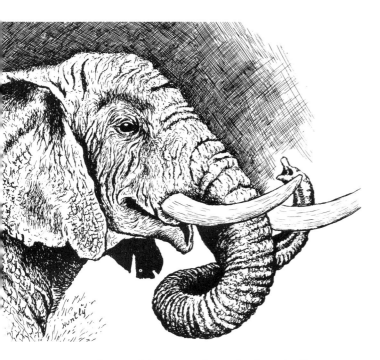

On a loop of dusty road an elephant bull was seen making his way down to a muddy pool where his interesting ablutions were noted from start to finish.

The back of a stationary Landrover has afforded me some glimpses of wildlife that could perhaps never have been obtained in any other way. The elephant bathing himself at the little mud-hole provided such an occasion, and I soon laid aside my half-completed painting to watch him.

Having drunk his fill from a part of the pan where the water was least muddy, he then siphoned up a great deal of mud with his trunk and sprayed his entire body. It was at this point in the proceedings that the strange phenomenon of the elephant trunk in action could be observed.

You may watch elephants scores of times in a game reserve, and unless you focus your attention and binoculars specially on the trunk you will miss the most interesting and expressive thing about the animal.

Its sensitivity to the slightest and most subtle whim of the elephant is perhaps best observed when the animal is enjoying a mud-bath. Then the trunk moves restlessly about the body, bringing mud and water to every part that feels in need of it. Now it gracefully curls up tight between the tusks like a sleeping python, now it uncoils and expands like a wet rubber concertina to plunge its tip into the muddy water.

Perhaps the extraordinary impression of "having a mind of its own" is caused by the impassive and immobile attitude of the elephant itself. The great pachyderm stands there as if in a daydream with eyes half shut, its body quite still, while the restless trunk goes about its own occasions.

The subtleties of the movement are so absorbing to watch that it is easy to understand the helplessness of birds and rodents fascinated by a snake's flickering tongue. Only by concentrating attention on the trunk rather than upon the whole animal can one appreciate what a marvellous creation it is.

Now entirely covered with mud, he moved to a dusty place and began to blow clouds of dust over his back to dry off his body. Soon he was the pale colour of Kalahari sand as more dust and clods of earth were flung up, mostly over his head and behind his ears. One of these missiles – a clod with a clump of grass attached – fell on the ridge of his forehead and rested there for the rest of his *toilette*.

He then marched over to a twiggy bush and stood astride it so that his belly pressed against all the prickles. Swaying backwards and forwards he scratched his belly with obvious satisfaction, while the grass tiara balanced upon his brow.

Knob-billed Duck

The interrelations between bird species, animals and human beings is interesting and sometimes even amusing.

On a small dam or lake for that matter, you may see a party of Knob-billed Duck busy feeding in the shallows, dipping head-first beneath floating vegetation and waterlily pads for their food. There is something comical in the sight of the blimpish goose bodies up-ending from time to time, the rear half sticking up from the water while the head, neck and foreparts are submerged, foraging beneath the surface. They pop up for air, blinking water out of their eyes, giving a sharp flick of the head to shake off the drops. Sometimes the beak is covered with strands of green waterweed like a moustache.

This stirring up of the water by the ducks attracts a group of jacanas, which form a ring round the birds. They dart about catching insects and small water-creatures disturbed by the activities of the birds. One may see Cattle Egrets doing the same thing round a group of oxen feeding in the grass.

Cattle sometimes enter the water to feed on lush grass growing in the shallows. This also attracts the jacanas. The birds collect in a group round a beast's head, where the action is – like chicks round a mother hen. By pulling up the grass from its roots the ox uncovers a host of aquatic insect life, and the Jacanas have a feast.

Where buffalo, lechwe and sitatunga still survive, jacanas come and feed round them, and instead of cattle churning up the water-grass one may picture in the mind's eye a group of jacanas in attendance upon game animals wallowing among the waterlilies.

To return to the Knob-billed Ducks: after finishing their underwater meal they climb with heavy flapping on to a dead tree standing half-submerged in the dam. There they remain in the hot sun, preening and oiling their feathers, later dozing off and sleeping with head tucked over the shoulder.

Wild geese are crafty and intelligent birds, never allowing a near approach by their arch-enemy, man. However, they are quick to sum up a situation if people are engaged in some absorbing activity nearby. The "Knobbies" in this story went about their daily occasions near some African fishermen. These people were deemed by the birds to be temporarily harmless, but the geese would not permit any human approach nearer than three times that distance if carrying a gun or moving furtively.

Knob-bills are beautiful seen in flight, especially if one is slightly above them as from the vantage point of a dam wall or jetty. Then one may see the coloured patches on their wings shooting off rays of green and violet light, rather like a piece of glass moved in the sunlight.

Tailpiece: The Knob-billed Goose is also found in India, where it is known as the Nukta, and there is an authentic record from there of forty eggs being found in a nest – but that was probably the work of two females. Two jacana species, rather different from the two African species, are also found in that sweltering land.

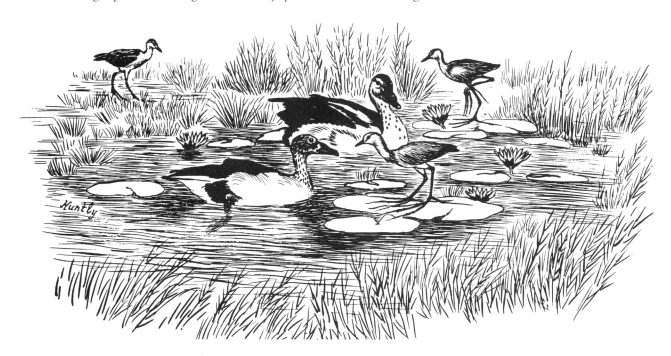

Wild Dog

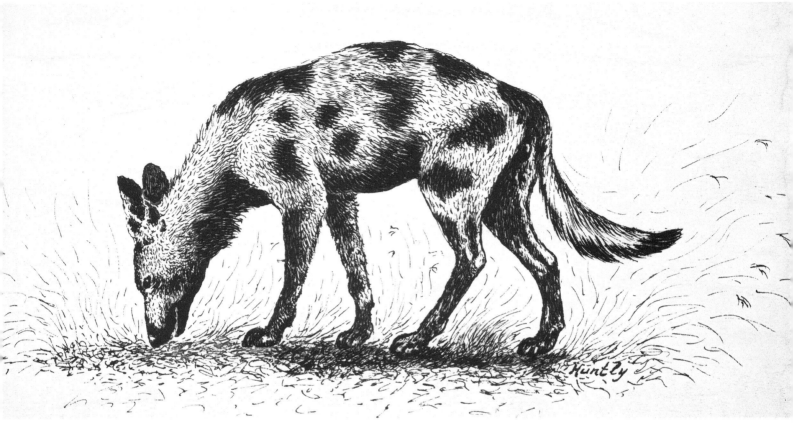

Of the interludes provided for me by the veld none compares with a chance encounter with wild dogs in 1967. It seemed to epitomise for one brilliant moment the essence of wilderness and imprint upon memory a vivid picture that I can see and relive in the smallest detail.

My good fortune was due to the fact that the wild dogs were unaware of my presence. To add to my luck, no other vehicle arrived on the scene for four hours – an unusual experience these days. I had been concentrating steadily on a painting inside the car and was oblivious of all except the scene in hand. Then they arrived, four dogs, very near to my car and quite preoccupied with their own affairs, one of which was to slake their thirst at the water's edge.

They stood relaxing after their drink, occasionally looking about, particularly towards the grey universal thicket that extended towards the north and west and from which they had emerged. They appeared to be waiting for other members of their pack.

My delight increased the longer they remained, for never had such wild spirits as these come so near. The sun shone from a clear sky, highlighting their markings, emphasising the snowy-white fringes along the undersides of their tails. Their earliest scientific name, *Lycaon tricolor* Brookes, 1827, seemed eminently suited to them with their three-colour scheme of black, ochre and white, like dry leaves in sunlight and shadow mixed.

One of the dogs moved slowly along with his mouth to the ground in the typical attitude of a dog retching. His stomach muscles expanded and contracted with the effort, and I was surprised to realise that he was giving out the peculiar bell-like call almost identical to the single mournful note of the Namaqua Dove. It was strangely ventriloquial and no doubt travelled far, despite its haunting softness.

The note was not difficult to imitate, and soon I began an extraordinary duet with the dog, which presently ceased on his part, when he became aware of the new sound. I persisted, carefully holding the exact note and the same pauses. The dog's ears pricked up, then he trotted over to me, in all respects behaving exactly as any puzzled alsation might. I ceased my effort for, quite frankly, my little car with its open windows felt even smaller with *Lycaon tricolor* looking straight into my eyes. He returned to the others to loaf and laze with them all afternoon in the most enviable manner.

Water Dikkop

Some years ago I was sketching in the Kruger National Park, sitting in my car near the banks of the Faai River. Having to remain still and confined to the car for long periods has often brought unexpected rewards in the form of observations of wildlife.

Although preoccupied, I became aware of a quiet mewing sound that seemed to come from the ground just outside the car door. It was not unlike the mewing of a kitten, although it came at very irregular intervals with long gaps of silence in between. I peered carefully into the grass nearby.

A very long wait followed, as it inevitably does when one gives one's attention to something. Haven't you sometimes said: "Listen everyone! that sound . . ." and everyone stops to listen . . . and so does the sound!

Anyway, I was about to become impatient with the silence, when a brown mottled bird seemed to materialise out of its background without moving. The effect was rather like focusing a camera on some leaves or grass until some feature becomes clearly outlined. The bird was standing near to the car in some clumps of grass when I saw its shape for the first time. Its beige, brown, sepia and white mottlings and vermiculated patterns caused it to vanish into its surroundings which were also beige, brown and sepia with bits of white light shining off polished river stones and grass stems. Soon I could plainly see its mate crouched among the grass blades.

My introduction to the Water Dikkop, with its distinctive white bar on its wings.

I fumbled about for a pencil and made a life sketch of the two of them just as they were. I value these life portraits above all other forms of drawing, because one gets the chance to capture their characteristic attitudes, and something of their mood gets into the picture. The "mewing" sound seems to be reserved for these occasions when the birds are sleeping during the daytime. At night, when they become active, their cries are loud and exciting to hear – a plaintive and penetrating whistle often heard above the distant roar of a river in the moonlight, for they love the moonlight and call more often at such times, as do plovers and night-jars.

The drawing shows them with their eyelids half shut, giving an impression of sleepiness. When I kept very still their eyes gradually closed completely and they were asleep. But I had to move about some time later, and they mewed like kittens again.

I could find no reference to this sound in any of my bird books, so I assumed that it may be heard only by someone near two sleepy dikkops for a long time.

If you should disturb a pair of dikkops while walking in the veld you may observe their curious flight as they take off ahead of you. The wing beats are not even, as in other birds, but alternate in bouts of slow flaps interspersed with quick ones; a novel effect. In some parts of Africa, where crocodiles abound along tropical river sandbanks, these Water Dikkops actually breed among the huge sinister reptiles.

The Bent Egg

The Three-banded Sandplover, and its congener Kittlitz's Sandplover, lays creamy eggs covered with thick dark lines or short strokes. This dense freckling blends the egg with its sandy background, for the eggs are laid on the bare sand of a riverbed or among pebbles not far from the water's edge. Nothing very interesting about that, really, except that the little Kittlitz's Plover kicks sand over the eggs when she leaves them, thus temporarily making them impossible to find. But if she should be surprised while sitting on her eggs she may not have time to cover them with sand, and the eggs may be exposed too long to the sun's rays.

Looking carefully one day at two eggs of the Three-banded, I noticed that one of them seemed to be an odd shape – like a stone, quite irregular, bent in fact. By moving away and looking at the egg from a different angle it seemed to change its shape and look more like an egg again. The dense peppering of marks formed two vague rings round the egg and caused the optical illusion of an irregular shape. This not only broke up the symmetrical egg-shape but the colours blended with speckly sand grains. So the little plover eggs are doubly protected and, if one also takes into account the glare of the sun on the sand, making the search more difficult, then the eggs have three things in their favour. But there are yet two more, and these concern the parent birds. When the brooding bird squats on her eggs, the dull upper part of her body blends with the colour of the ground. Her brighter underparts are hidden. Some black marks about her head break up her outline. Then as a final protection to her eggs or tiny chicks, she may run off the nest dragging one wing in the dust, or pretending to have an injured leg. This will induce the predator to follow her, and thus she will lead it away from her young ones. This trick is played to lure away humans, dogs and many other creatures that might harm the eggs or chicks. Near "civilisation" it might include dogs, bird-nesting boys, perhaps a cat, certainly mongooses, etc. Out in the wilds baboons will take eggs or chicks. You may see a troop of baboons foraging about on the dry banks of rivers or along sandy riverbeds where plovers nest. Blacksmith Plovers dive-bomb human beings, dogs and large storks, and they would not do that unless they felt threatened.

Overheating of birds' eggs by the fierce African sun is a danger that the parent birds are fully aware of. In the sizzling swamps of Zambia and north through Uganda and the Sudan in the Great Sudd one amazing stork keeps her eggs and chicks cool by carrying water to them in her huge boat-shaped bill. While standing over the eggs she allows the water to dribble on them, like some surrealistic watering-can. She and her mate don't know it, but they have been named Shoebill informally and formally *Balaeniceps rex* by Gould since 1852: King Whalehead.

Some Observations

on the De-Humanisation of Animals

Modern scientific writers in such fields as zoology avoid as much as possible the use of anthropomorphic analogies in their description of animal behaviour. Recently a reader took me to task for saying that butterflies play and gambol at the tops of kopjies. He said that recent research had revealed that "hilltopping" by butterflies was in fact an exhausting activity practised by rival male butterflies to attract females. In the law of Darwin's survival of the fittest the more robust and energetic males would tend to supplant the slightly less energetic and robust, thus ensuring a greater likelihood of the best and strongest males to achieve mating. They are not amusing themselves, insisted my correspondent. Fair enough, one lives and learns.

However, although the de-humanisation policy has great merit, it can be taken too far, like all excess of zeal. In the case of bird-books, to go "totally scientific", only scientific names should be used, as they are in some books on butterflies and others on wild flowers. This approach adversely dulls the interest of the very people for whom the book was written: those who want to take a less than professional interest in butterflies and wild flowers because they wish to conserve them on their farms. Nothing can be as off-putting as colour plates showing familiar butterflies with only scientific names beneath them . . . the instant "Wall of Partition" between scientists and the rest of humanity. Imagine *Roberts' Birds of Southern Africa* devoid of all non-scientific names. How many people other than ornithologists would buy it? Familiar names such as Laughing Dove – an extreme case of anthropomorphism, for only people laugh – would be known only as *Streptopelia senegalensis.*

Bird names are filled with these anthropomorphisms: Trumpeter Hornbill (strictly speaking, the domain of Louis Armstrong), Crowned Hornbill (only kings and queens are crowned), Bradfield's Hornbill (after an *anthropos* called Bradfield, surely), Giant Kingfisher, Goliath Heron and Pygmy Kingfisher – all images of huge brutish men or small jungle-dwelling ebony ones. Widow finches seem to have lost their husbands.

Animal names fare no better in the struggle to avoid the human connection. What about Peters's Epauletted Fruit Bat, named in honour of Dr Peters a scientist who probably never wore epaulettes (which appendages are most often worn by men in uniform). Dwarf Shrew; Dwarf Mongoose; Spectacled Dormouse; Pilot Whale; Bushbaby. All these names have human connotations: uniformed epauletted generals or commissionaires, Snow White's little men, spectacled sleepers, pilots and babies.

Nor does the problem end with popular vernacular names. The scientific names themselves are riddled with anthropomorphisms. Many life-forms: birds, animals, butterflies are named after the scientists (all human, naturally) who first described them and some are even named after the gods and goddesses of mythology who never existed, far less described them.

Then there is the impossible task of describing animal behaviour without resorting to anthropomorphic simile: Lions are usually "majestic" (kingly). Foxes and jackals are "sly" and the Sable Antelope has a "proud" and "haughty" bearing and, when wounded, will fight "courageously" to the death. All these qualities that we find in the sable are those of brave *people*. To avoid words such as "proud", "majestic" and "courageous" would flatten or deaden any truthful representation of the sable. For this antelope really does possess these qualities. So to use such words is scientific. For whatever is scientific is supposed to be true.

The Goliath Heron in the illustration has just speared an unhappy Vlei Rat. Having just been stabbed by a lightning jab by the huge heron beak, its last few seconds of life would scientifically, truthfully, be unhappy ones. The consequences of the rat's not appreciating the true identity of the immobile, stump-like object that suddenly came to life. For this great heron, like the smaller members of the family, can stand immobile either in the water or on the grassy bank for so long that fishes, frogs, Vlei Rats or the ubiquitous multimammate mouse become careless and move about unaware that the motionless object is waiting for one of them to get near enough to spear.

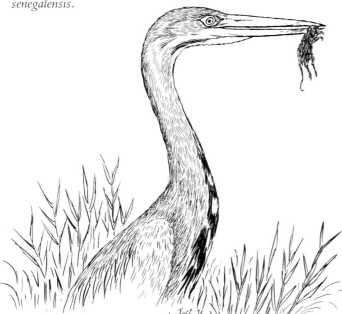

A Case of Deception

The scene: near a pan in a lowveld game reserve. Time of day: 1 p.m. in the heat of October. Heat-waves make dark treetrunks appear to undulate and flicker. Harsh contrasts of light and shade are caused by the white glare of a cloudless sky and black shadows along branches and trunks. A group of zebras moves across the lattice-work of thin stems and for some time zig-zag stripes and shadows mingle – some of wood, some of hide, some of shadow. The animals appear and disappear by turns as the eyes are allowed to focus on this picture and then unfocus alternately.

late; they scatter too quickly for her to choose an alternative.

Did the gaudy stripes make a contribution in that split second before impact? Especially with so many other zebras near the intended victim, causing a visual confusion factor.

Zebras have been observed by moonlight asleep among the trees, and the camouflage effect is astounding. Careful observers insist that this is probably the main function of the stripes, for the preservation of the species.

The brilliant stripes adorning zebras may not be connected only with this factor of confusing silhouette. On the Serengeti Plain and at Gorongoza zebras congregate in large numbers in the open, far from light and dark tree trunks. They could hardly be more conspicuous against their drab background.

The hungry lioness making her final assault on a herd of zebra not infrequently misses the mark, because of some last-moment bungling, as though a dexterous move by her intended victim causes her to graze its hide instead of bringing it down.

Instantly she lashes into the others, but it is too

In the case of our common scrub hare the bright white underside of the tail has its obvious use. In the dim light of sunset when hares come out to feed after a day's fasting, they keep in touch visually with their mate (when the latter runs away) by following the bobbing white tail.

I recently watched a pair of hares doing this when they were surprised feeding on young cabbage plants in the half-light at sunset. The white tail of the leader was like a pale light that the second animal followed. It was impossible to see the rest of the body.

Crab Spiders as Pretty as Flowers

Crab Spiders represent a side of Nature that one may occasionally observe with some sorrow. They epitomise in miniature the deception and evil intent that gives the lie to the idea that Nature must be a manifestation of a kind and benevolent Creator. When Eugene Marais first observed the cold, calculating and ruthless world of the termites he found himself locked in an inward battle with his feelings about God and his own relation to his Maker. How to reconcile what he saw with his religion?

Towards midday, when the sun is at its hottest, we see the Dotted Border Butterflies (*Mylothris sp*) take wing in large numbers; and it is at this time that the Crab Spiders take up their positions. Crab Spiders appear to be fully capable of appreciating the strength and robustness of their prey. The comparatively large Dotted Borders are slow and weakly built.

An unwary butterfly settles on the vernonia flowers, near a Crab Spider sitting among the lilac blossoms looking just like one of the buds both in shape and colour. The butterfly moves to another flower, still nearer to the "bud", and becomes preoccupied with feeding. With its proboscis deep in the flower the butterfly is too busy to notice the stealthy sideways motion of the spider. Besides, a little breeze jiggles all the flowers and buds together and conveniently helps to conceal the spider's movements.

A scarcely perceptible hook of the crooked legs and immediately the spider has the butterfly gripped in its venomous embrace. The prey is bitten in the "neck" between head and thorax and the insect is held until the injection of poison causes the wings to beat no more. They curve unnaturally downwards, yielding their protection to the body, and the spider begins its repast of body juices siphoned out of a sucking hole made by the fangs when they first struck.

Crab Spiders are as pretty as the flowers that they imitate. They are usually rather small, and they have a sinister sideways movement as well as the other crab-like features of the wide-spaced, hooked legs. They slip under the flower petals but move into the centre of the flower when hungry and very successfully imitate a bud or a petal. They let out a gossamer Tarzan-rope if they have to descend to the ground in a hurry or swing away in a breeze.

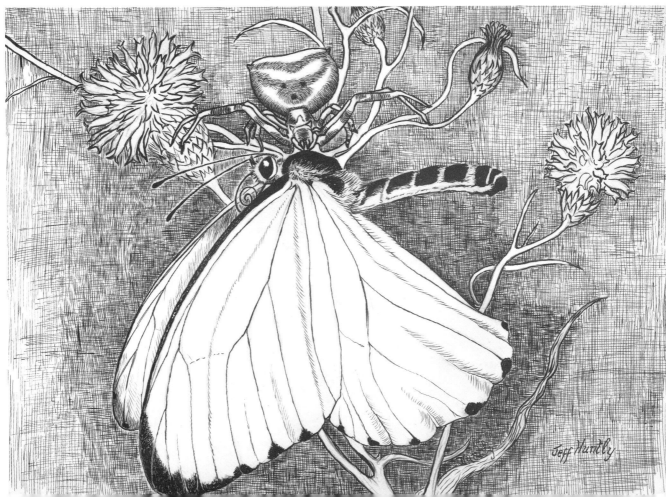

Jeff Huntly

The African Darter

Wen swimming under water the African Darter uses stealth to approach unsuspecting fish from behind the cover of suspended water plants. When it is near enough to the day-dreaming fish it suddenly lunges with its dagger-like beak. The darter's kinked neck is "unkinked" with lightning speed and the beak thrust forward like an arrow from a bow. The bird surfaces with its prey and deftly moves it into a position suitable for swallowing – that is, head first. The inner margins of its beak, towards the tip, are serrated with sharp spines that prevent the fish from slipping back into the water.

The African Darter, when seen from a distance, seems a drab bird; but when seen through good binoculars it is a handsome creature of rich velvety black, chestnut and brown with a white stripe along the neck. After his underwater hunting forays, during which the feathers become saturated the darter surfaces and dries his wings in the sun, after the manner of a cormorant. He may sometimes be seen swimming with only the spear-shaped head cleaving the water's surface. This makes him look rather like a snake, so the early colonists called him the "snake-bird". The snake-like effect is heightened as the neck undulates sinuously in rhythmic harmony with the paddling movements of the feet. There is an authentic record of a black child killed by one of these birds. The boy tried to seize the bird alive when he found it caught in his nylon fish trap. The bird struck at him with all its force and the deadly beak pierced his temple, killing him instantly. A trapped darter should therefore be approached with great caution; it will go for your eyes with that beak.

Many waterbirds get caught up in nylon fishing nets and are either drowned or left struggling pitifully with their legs or beaks hopelessly entangled. Cormorants, darters and grebes are instinctively drawn to the nets if they contain trapped and struggling fish.

Nestling darters are quite unlike their parents; they are covered with pale creamy down. They keep up an incessant wheezy chatter, begging their parents for food. These noisy performances begin the moment the chicks observe the approach of a parent bird and they are so loud that they draw attention to the nesting site – often near cormorants' nests.

This species has the wise practice of slipping unobserved into the water when it senses the approach of danger. It observes you long before you observe it, and thus it has acquired the reputation of being rarer than it is. In this respect it has much in common with the Peter's Finfoot, another sly fisherman; and the crocodile, with its remarkable ability to slip quietly into the depths at your approach.

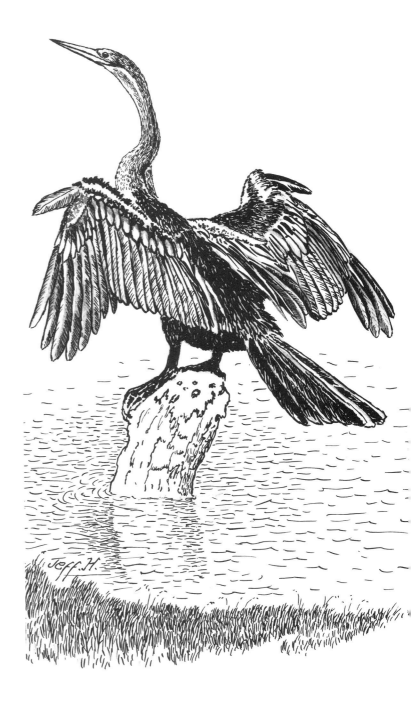

Mind of a Crocodile

We observe animal or reptile behaviour and sometimes attempt to interpret it. Thoughts present themselves that sometimes tempt us to jump to wrong conclusions; and at other times we are stumped and relegate our speculations to the unknowable.

A tribeswoman was seized by a crocodile while she was washing clothes in a pool. Apparently she had her back to some deep water, and, being preoccupied, did not notice the stealthy approach of the beast. She was never seen again, and I determined to put an end to the crocodile, which in the event was easier said than done.

Week after week I walked stealthily along that river bank, or waited, hidden in a place overlooking his favourite basking rock some distance downstream. Always he eluded me, seeming to foresee my arrival at the river, for I would sometimes catch a glimpse of him quietly disappearing beneath the water just a shade too quickly for me to get a sight on him. My working hours prevented me from planning some more elaborate scheme to get him, and in the end I gave up.

About a month after that decision I happened to be passing his basking rock on some urgent business, walking normally, quite preoccupied and making no attempt at stealth, when I saw him on his rock apparently asleep! I could have shot him with ease, but of course I had no gun. But was he asleep? I think he had been watching me all the time, for when I tried to edge away from the bank – foolishly thinking I could run home for the gun – I averted my eyes for a moment and then glanced back only to see an empty space on the rock where he had been a few seconds before.

A very similar experience is recorded in *Jock of the Bushveld*, where the hunter was stalking a buck along a river bank. So preoccupied was he that he stepped on a crocodile, thinking that it was a dry log. I kept thinking about that incident after my frustrating experience, trying to find a common factor. It seemed that in both cases the people concerned were preoccupied, and perhaps the crocodiles had no sense of danger. Surely something as cunning as a hunted crocodile would hardly allow a man so near as to step on him! What to think? Both stories are true, but impossible to prove by experiment. The mental state of genuine preoccupation cannot be simulated without being immediately falsified.

To confuse the matter, one may recall the many cases in which hunters get their crocodile with comparative ease.

My father had a narrow escape when drinking from a deep pool. He saw a hideous face gliding up from the depths towards him and he leapt backwards just in time. Returning later with his rifle he waited at the same place, leaning forward over the water as before. Up loomed the grinning image just beneath the surface and he shot it. "Most theories about crocs are just guesswork" he used to say dryly. Still. . .

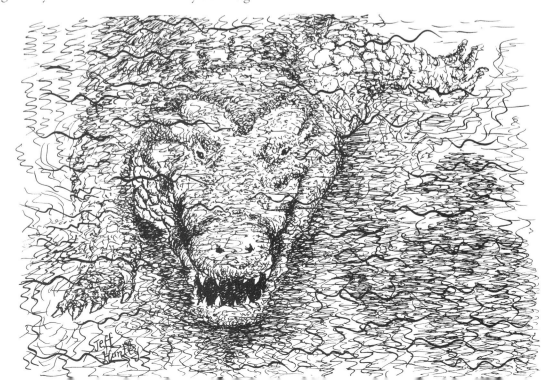

The Yellow-eyed Canary

Certain bird species return year after year to nest in the same trees as though to confirm that they like a familiar routine, and having brought off one brood successfully in a particular tree they wish to repeat the success again.

Our Yellow-eyed Canaries nest every March in some apricot trees when there are hardly any leaves remaining on the branches.

No attempt is made to conceal the nest, which is sufficiently low to be examined by anyone passing by. In fact there is a path near the tree, and people continually use it. One suspects that the canaries choose the place because the presence of human beings deters predators. The birds could nest anywhere out in the surrounding veld if they wanted to, but no, they choose to be in the busiest part of the establishment.

The nest itself is very small, so small that anyone seeing it for the first time would surmise that a tiny flycatcher had made it. It is composed of furry twigs bound neatly into a shallow cup with cobwebs. On March 5th the hen bird was sitting on three pale blue-white eggs, which had a few minute marks here and there. Typically the eggs are white, but occasionally a set of the blue-tinted eggs turns up. When the sitting female is approached she remains on the eggs, bravely watching the human intruder, until the last possible moment, when she can no longer bear the tension and flies off to wait in some nearby trees.

The only other time she leaves the nest during the day is in response to the distant calling of her mate. He is quite obviously calling her to join him to feed. However, she eats quickly and is soon back again settled on her eggs. When the eggs are in an advanced stage of incubation she is more reluctant to leave the nest. This is when the cock bird feeds the female himself, quite evidently aware that he must not call her away from her duty. It is fascinating to watch their routine at this time. The cock suddenly arrives in the apricot tree with a cheerful greeting song. The female responds with a few notes and looks upwards at him. He hops down to her through the twigs and promptly regurgitates some food from his throat and feeds her. He repeats the act – a brisk nodding of the head and an up and down motion of the chest or crop – more food comes up and he feeds her again. Then he is off and does not return for several hours.

The little brooding hen does not keep still on her nest all day, though. She is restless and moves about on the nest frequently as though trying to find the most comfortable position. She also shuffles with her feet and thus keeps turning the eggs. At other times

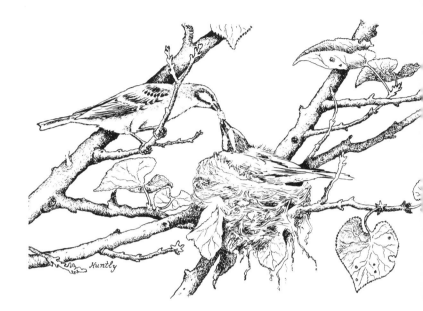

she industriously preens her feathers, but she never moves off the eggs. She also remains at her post in pouring rain, keeping those precious orbs dry and warm although her top half is soaked through. When the days are hot the sun blazes down on her for hours and only one leaf remains to shade her – and soon even that falls off, yellow with age.

When the chicks hatch they are covered with hair-like strands that conceal them in the nest. They are like three hairy caterpillars, and the female can often be seen sitting over them, protecting them from the sun. She feeds them just as she herself had been fed by the cock, and they grow up astonishingly quickly. At this period birds go through their most vulnerable period and seem to know that they must develop quickly and fly away to a safer maturity.

The Yellow-eyed Canary is common over the entire eastern half of southern Africa in habitat suited to it.

Fieldmice Build Grass Dormitories

The Four-striped Fieldmice are reported as living in holes and nesting underground. However, they evidently make dry-season surface nests as well, possibly as a kind of dormitory for many individuals to sleep in.

These nests are abandoned at the onset of the rains for dry places under rocks or in holes vacated by other creatures. Nests containing young have been found in haystacks and hidden beneath mounds of dry mealie-cobs for cattle fodder. The nest is about the same size as the dry-season nests made high up in leafless trees by bronze mannikins, roughly the size of a pint jug. The purpose of this grass dormitory is the same in principle as that made by the little birds. As in the case of the mannikins, which live in bands of half-a-dozen to twenty individuals, so the Four-striped Fieldmice tend to be gregarious; particularly so in the dry winter months, when they gravitate to flower and vegetable gardens that form islands of green in the surrounding dry veld.

A party of about a dozen has been observed to feed regularly on the buds of mesembryanthemum flowers. These flowers are on one side of a large granite boulder. On the other side grows a tangle of prickly vines of a youngberry bush. Beneath this thorny canopy and snug against the black granite is the large nest of the mouse colony.

It is presumed that the structure is a communal sleeping nest. Its most interesting features are two smooth paths leading to and from it.

Four-striped Fieldmice tend to live on greens more than other mice, taking green peas whenever available and gooseberries when they ripen and fall to the ground. The berries are picked up by the forepaws and munched. Dry mealie seeds, birdseed, both green and dry, and sunflower seeds are all included in the menu. Among birds the Streaky-headed Seedeater is a counterpart of these fieldmice, with a similar feeding niche. It also relishes buds of the mesembryanthemum, feeding just above the mice at times.

Observations of other species of mice show that the Single-striped Fieldmouse is more solitary in its ways, larger and less interested in green foods than its nearest relative already discussed. Both these mice are veld-dwellers, hence their name, and not often found in houses, if at all.

A reference to the nesting habits of mice should not omit the ingenious grass-climbing mice. They may be found using the vacated nests of Fire-Finches in low bushes. The birds' nests are round, with a side entrance, and made of grass warmly lined with Guinea-Fowl feathers.

The mice bring their own shredded grass and stuff the birds' nests full of it. They also adopt the vacated nests of prinias, bishop birds, or weavers if these are within easy reach. Another habit of theirs is to make what appear to be false nests. These are about the size and shape of a tennis ball and placed in dry khaki-weed stems. If opened they are found to be grass all through and apparently made to no purpose or possibly made to mislead predators. Some of these solid grass balls are quite near to the "real" nests inside the Fire-Finch structures.

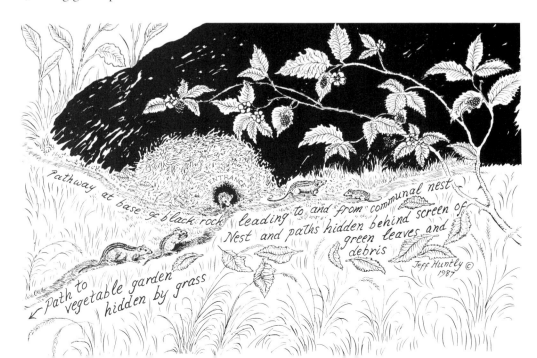

Streakyheaded Canary

A few species conceal their nests in the dry dead leaves of aloes. On 20 October 1988 I found the nest of a Streakyheaded Canary by noting the spot among dead aloe leaves where the bird flew out at my approach. The aloe was one of an avenue planted at regular intervals along a country road. They were large specimens, and over many years they had grown much taller than a man, and all had aprons of grey dead leaves – shrivelled, twisted things hanging below the living green leaves above them.

The nest with its contents of four eggs was a most pleasing picture in itself: pale blue eggs nestled among soft orange-coloured fluff that formed the snug lining. Pale blue set in orange or rust-coloured velvet fluff. The birds collected this stuff from dry flower-pods or seed-containers. The twisted, grey dead leaves formed a curious support for the nest, and they seemed to be like the leathery skins of prehistoric reptiles, especially as they were edged with spikes like the teeth of the small pterodactyl *Rhamphorhynchus*.

I made a regular visit to the nest on my daily walk to collect my newspaper – always being careful not to peer into the aloe when anyone was about for fear of nest-robbers. I was also careful not to touch the nest or the aloe and merely to take a quick glance to see if all was well.

When the chicks were newly hatched they could hardly be seen in the nest at all. They appeared to be so much dark grey fluff, very much like hairy caterpillars. In fact I could not see anything resembling chicks, and at first glance I thought that some mishap had occurred. But this resemblance to inanimate hair nest-lining must all be part of the camouflage to protect the young. One egg never hatched, then two chicks vanished and the surviving chick grew rapidly.

Just before this fledgeling's departure I noticed that the distinctive eye-stripe had preceded the development of all other parts of the body so far as plumage was concerned. In other words the head and crown of the fledgeling seemed more complete, more like the adult bird than the rest of the body, with its bare patches and hair-like juvenile covering. At this stage the eyes are like beady black buttons, and presumably the brown colour of the adult iris develops later. I saw the chick for the last time a few days later when I passed that way. It was calling to its parents from inside the canopy of a nearby tree (the tree nearest to the nest-site aloe) and one of the parent birds fed it while I watched. I never saw it again after that.

An interesting characteristic of the nest in its final stages was the mess that it was in. The entire periphery of the nest was covered with dung from the fledgeling.

It would seem that the canary family, like doves and pigeons, is not so concerned with cleanliness as many other species that keep their nests spotlessly clean. Prinias and Cisticolas in particular are fastidious about the state of their nests and remove chick droppings as soon as they are deposited.

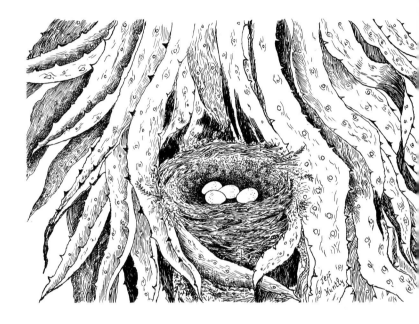

In C.J. Skead's classic monograph on the *Canaries, Seed-eaters and Buntings of Southern Africa* he refers to the alternative English name of "music bird" for this species. Although the name is seldom heard nowadays it is quite appropriate, as the male is capable of pouring forth a pretty refrain somewhat reminiscent of the Yellowhammer of England. This he does in the breeding season while clinging to a dry stalk or perched on a dry twig sticking out of the top of a bush. He is sombrely attired in grey, with the eye-stripe the only prominent feature. But for all his dull plumage he is an interesting little fowl.

Strange Butterflies

The great pine and gum plantations growing mostly in those parts of Africa with high rainfall make ideal places to find butterflies.

This may seem surprising, since man-made forests are so often thought of as silent, rather sterile places, devoid of wild things. But because the forests are planted in blocks, with open spaces between them for the control of fires and for roads, they offer micro-habitats and, in a small way, even micro-climates; small areas of shelter from wind.

for butterfly larvae that in certain seasons abound there. Of course these plants are not allowed to grow unchecked, as they would soon cover the roads and become a fire hazard. However, during those brief periods when a temporary truce reigns between man and nature and the wild plants are not considered too great a threat we may observe *Acraea* butterflies in their hundreds along these forest roads. Conditions are perfect for them; they sail lazily about enjoying the artificially created hothouses between the forest blocks. Some years are more suited to them than others, and in a season where all conditions are just right we may see them in great numbers. The various *Acraea* species are found in many other parts of the continent as well.

They go about confidently, their flight is leisurely as though they are aware that they have no need to be furtive; as though they are under a secret magic spell to keep them safe. In a sense they have! Their slim bodies contain a yellow fluid distasteful to birds, monkeys and other butterfly-catchers. Their orange, pink, red and rusty hues combined with black proclaim this fact to the world at large, for these are nature's warning colours. A combination of black and red denotes a poisonous creature among many diverse forms of life.

In some mysterious way other butterfly species, in no way related to the *Acraeas*, have become close mimics of the toxic *Acraeas*, thereby enjoying the same immunity to predators as the true *Acraeas*. One such is the appropriately named *Pseudacraea boisduvalii trimenii*, alias Trimen's False Acraea. If the predators but knew it, this gorgeous fraud is probably a tasty mouth- or beakful! They are deceived by his mimicry and leave him alone. But his rapid wingbeats and furtive manner distinguish him at once from the languid, carefree true *Acraea*. It's as though he is never quite convinced that his deception will not be seen through. The drawing shows true *Acraeas* mating.

These open spaces let in the sunlight, while the dense barriers of trees stop the wind, particularly at ground level. An interlaced mosaic of small plants, weeds, flowers and creepers springs to life in these sheltered sunny roadsides and provides the food plants

The Christmas Butterfly

The Christmas Butterfly, the most ubiquitous of the swallowtails, with a distribution over vast areas of Africa, arrests the attention of even a casual observer. Its beautiful green and black-green ground colour dappled with yellow exactly matches the shifting splashes of sunlight on the citrus tree leaves where it delights to dwell. On sunny days it can be seen circling restlessly about the orange orchards, occasionally settling with quivering wings, a characteristic that it shares with all the swallowtails.

It may be the most successful of the breed, the hardiest and best adapted to survival, with a great number of food plants suited to it and ranging even into the Cape Peninsula – the only African swallowtail to do so, as Roland Trimen was the first to observe.

The caterpillar, which can readily be found on citrus leaves, is an interesting creature. If it is disturbed or feels threatened by a predator, it erects a tiny two-barrelled gun from behind its head-shield and pop! it fires off a little stink-bomb. The smell seems to be a concentrate of the leaf upon which the caterpillar is feeding. The predator, whether wasp or bird, is repelled and abandons the plump bonne-bouche. The popgun is retracted when the caterpillar thinks that all is safe again. This device is called an osmaterium. The caterpillar is camouflaged as green as the leaves upon which it feeds. It has a pair of false eyes painted on its back, and it can look quite threatening when it rears up half its body like a miniature cobra.

Watch a Christmas Butterfly circling among the orange trees on a bright sunny day. Here and there it passes, sometimes giving chase to another of its kind as they gyrate happily in the light. Then a cloud obscures the sun, and immediately the butterflies come to rest on some convenient place among the leaves. Away moves the gloomy cloud, revealing sparkling sunbeams – the signal for butterflies to come out and play again. Their love of sunlight and bright colours may have been the reason for their popular name of Christmas Butterfly, the wing patterns resembling Christmas wrapping paper. Some say that the name was bestowed upon it because of its seeming abundance at Christmas time. Other names are Citrus Swallowtail and Orange Dog.

D.A. Swanepoel, that indefatigable observer, tells us of the kopje-climbing proclivities of *Papilio demodocus*. On any hot bright day the Christmas Butterfly may be seen sailing up the side of a kopje, to remain for some hours at the summit circling about for the sheer joy of flying in the company of other butterfly species that enjoy the sport.

Since writing this piece I was rebuked for thinking butterflies are enjoying themselves when they go "hill-topping". Apparently the real reason for hill-topping is in order for the males to attract females for mating. Only the most aggressive males achieve mating, thus ensuring the survival of the fittest.

Jeff Huntly

The Bushman's Art

If you should walk alone into a deserted art gallery and stand awhile in the silent, empty hall, you may experience the paintings more intensely because of your solitude. Perhaps, like me, you may feel you are not alone, especially if the paintings are eloquent of meaning. They seem to speak to you quite loudly sometimes, as though not made of paint but of sound – the voice of the artist's mind.

A certain rock face on a granite kopje always gave me this feeling, for despite my solitude I felt I was not alone when I reached the place after a long climb. The wide rock panel at the entrance to a cave was adorned with Bushman paintings. Resting in the cool shade of the mighty granite overhang I would study the works of artists of ancient times and speculate as to their meanings.

After some time a certain bird species, sometimes found in such places, would command my attention and I would temporarily forget the paintings. The bird concerned was a boulder chat, whose notes were like tiny silver bells swaying in the wind and striking one another. But when the bird was gone the Bushman's art would obtrude on the mind again and I felt beckoned by those pictures to return to the rock face.

One sequence, painted by a master of his craft, was of three kudu antelope, two males and a female. The males, with their spiral twisting horns, fed on some leaves of a bush. Perhaps the great charm of Bushman paintings is that the animals are always *doing* something. The two kudu bulls were feeding on leaves and the hornless female appeared to be walking slowly. So apt! So accurate and true to life, for kudu bulls will often consort together and one may see a kudu cow on her own walking in no particular hurry.

By sitting on a branch I could just comfortably reach the kudu cow to carefully trace the painting. The two bulls were out of reach and I guessed that either the ground was much higher hundreds of years ago and had since been eroded, or that the artist had sat on a branch to paint. It seems unlikely that they made platforms to reach higher up. Perhaps a great rock fig-tree once grew against this rock face, forming a convenient natural scaffolding. But I preferred the first theory that the artist stood on the ground when he worked.

Bushmen artists were good naturalists and captured the alert, wary attitudes of antelopes. These creatures appear as they do in life, ready to leap into action. One scene depicts hunters converging on a buck at bay. Its tail is up, showing its alarm. The kudu cow, walking with two bulls, has its tail down, being more relaxed. The lines of the legs dip into grooves on the granite surface, but the artist has compensated for that so that the legs still appear visually correct.

I returned again and again to this art gallery and to my private viewing, with only a silver-throated bird for company.

Black in Nature

A fact: hawks have hi-fi vision. A question: can hawks see the colour black? If so, why do they ignore conspicuous black birds and hunt brown ones? Among bird species one finds a consistent thread of conspicuousness running through almost all black or pied species, right across the board. Crows, rooks, ravens, Blacksmith Plover, oystercatcher, drongoes, Black Flycatcher, Longtailed Shrike, Redwinged Starling, Black Sunbird, Buffalo Weaver, *Sakabula*, Red-Shouldered Widow, the Widow Finches and the Paradise Whydahs. In all these black (or mostly black) species one sees them sitting out in the open, feeding or displaying conspicuously without making any attempt to conceal themselves.

In the case of the various widows and Paradise Whydahs the conspicuous black males become as shy and furtive as their brown wives in the off-breeding season. The very conspicuous male *Sakabula* who, at the height of the breeding season, displays his all-black plumage in the most spectacular manner, goes through a psychological transformation at the approach of the winter, when he loses his long tail and black breeding dress. His feathers, are then mostly brown, and he behaves more like his wives – keeping a low profile.

This is also true of the Paradise Whydahs and the pied Pin-tailed Whydah, and of the Red-throated Widow and the other widows and bishop birds.

Perhaps the most striking contrast of this kind is seen in the Widow Finch group. The all-black male sits exposed for hours singing from a telephone or H.T. line or from a twig sticking out above the surrounding foliage of a tree. If he can find a dead leafless tree so much the better, as he prefers an unobstructed view of his surroundings. His retinue of wives is nowhere to be seen. They are somewhere in the vicinity, nesting and feeding in the grass well out of sight. Why do the brown females of Widow Finches not join their conspicuous male on his conspicuous display perch? Is it because, being the brown of most brown prey-species, they fear being caught by hawks?

Why do the brown females of the *Sakabula* also not expose themselves in full view alongside their ostentatious lord? And all those wives of all those other widow and bishop species? With them too, it is the same story.

Pied birds seem to enjoy a similar immunity from hawks. The most provocative of the crows and plovers are the Pied Crow and the pied Blacksmith Plover. In both cases these birds make no attempt to hide themselves, and I have seen a Pied Crow chase a hawk

and drive it off for a considerable distance. Blacksmith Plovers are by far the boldest of all plover species.

The all-brown counterparts of Blacksmith Plovers in size are the dikkops and rails and francolins. In all these brown birds one finds inconspicuous behaviour as though, being brown, they know that they are "hawk-prone", having colours of prey species. Dikkops are masters of camouflage and conceal themselves by day (for they are nocturnal birds) by lying or sitting motionless, blending with their surroundings like nightjars. Rails and francolins likewise keep out of sight and, although diurnal birds, always keep to grass or bush cover.

The colour combination of black and white, black and red, green, yellow or blue or just black by itself is an advertisement to predators that the owner or wearer of these bright contrasts is distasteful or poisonous. Animals such as the skunk, snake weasel, frogs in black and red, snakes and various insects banded with black and red or spotted black, white and brown, denote inedibility or, in the case of the skunk, a foul or repelling smell. Perhaps hawks associate the black or pied crows with this general rule of distastefulness, and although able to see them better than a human can, leave them alone, and all other black birds as well.

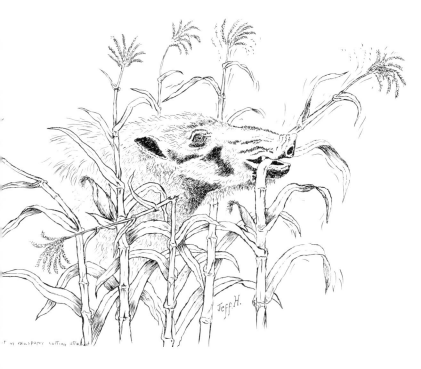

The Bush Pig, or Wild Pig, has the distinction of being very seldom seen yet, at the same time, the evidence of their presence in a district is very easily seen: devastation in the mealie fields with green mealie stalks, leaves and half-eaten cobs strewn over a wide area. In forest areas even in close proximity to suburbia you may see where they have been rooting up tubers, churning up soft loamy soil for roots or ploughing up furrows in muddy places to wallow in.

They are perfect examples of wild animals, which, because extensively sensitive sense of smell and almost equally sharp sense of hearing they are able to give the hunter the slip and the frustrations of hunting them are legendary.

Highly intelligent: Being highly intelligent and cunning they can usually overcome measures taken by farmers to keep them out of crops. Having raided a maize field by night they can then vanish into the surrounding forest or bush leaving absolutely no clues to follow up nor any indication as to their final destination.

The Giant Forest Hog, from its comparatively restricted range in the very middle of Africa, is a huge and fearsome pig. Some idea of its size can be gained by comparing the weight of an exceptionally big one with the common Bush Pig: 500 lb for the Forest Hog and up to 190 lb for the Bush Pig, while the Warthog can go up to 300 lb.

The distribution of this monster hog in Africa is small and patchy compared with that of the Bush Pig and Warthog: the West African coastal and interior jungles and into the equatorial forests of Northern Zaire across to Kenya, Southern Ethiopia and Northern Tanzania. It has relatively long legs and strange swellings – called excrescences – below the eyes. It hides up by day in heavy grass or impenetrable dense masses of bush, shrubs, weeds and wild cane. In such places a sort of hollow is made and in that a group takes rest, awaiting dusk when they emerge to feed, rooting about like other wild pigs.

Adults join forces in protecting the young and, where they are living temporarily, they create large middens. Unlike the Warthog they carry their tails down, as in the case of the common Bush Pig. Although they are now nocturnal creatures because of being hunted, they return to their old diurnal timetable in game reserves: thus proving that, like many other persecuted animals, they would like to revert to a daylight lifestyle if they had the choice. Although the giant Forest Hog possesses an ugly set of tusks these weapons are not nearly as large as those of an old Warthog.

The Warthogs' unsecretive ways make it a familiar object to tourists in the lowveld game reserves. They are comical and high spirited. I saw one rooting in some dense masses of ground creepers. These creepers became entangled in his tusks and had even got caught up behind one ear. The pig tried to pull backwards to dislodge the creepers but that did not help.

High pitched squeals: He then shook his head vigorously and let out a few high-pitched squeals, kicking up his hind legs then suddenly dashing off in a semi-circle, again shaking his head. The creepers looked like a veil dropping from the hat of a little old lady. He got rid of the veil and hurried off with his ridiculous tail held straight up with its tassel flapping up and down like a hand waving goodbye.

In ancient Egypt pigs were driven over fields where grain was about to be planted. Their trotters made holes in the soft muddy silt of the Nile flood plains. The hoof-holes were just the correct depth for the seed and the Egyptian farmers would simply follow after the pigs and plant in the holes.

Aerial Antics

Jeff Huntly

The roller family are famous for their aerial displays, whence their name.

Watch them on these occasions and they will delight you by demonstrating how they enjoy diving, then swinging upwards with closed wings to feel the exhilarating sensation of temporarily hanging motionless before gravity tilts the body forward again to go plunging headfirst towards the earth.

As they plunge the wings are brought out and tilted from side to side, as if some gleeful pilot were determined to tear the wings off his machine.

But these glorious blue wings don't tear off and the birds chuckle harshly with reckless abandon, revelling in their ability to excel human beings with all their contraptions.

The broad-billed rollers will perform these aerobatics as a team, sometimes up to five of them displaying together. Other rollers prefer to show off singly.

But all the species are noisy.

The monarch of aerial display is the Crowned Eagle.

The male circles with blue sky and white clouds as an overhead backdrop. He goes "kewee-kewee-kewee", a loud musical sound that fades as he turns away, then grows louder as his circling brings him nearer. Then he plunges to a lower altitude and turns upwards again, the velocity of the dive giving him free impetus to shoot upwards. Reaching the apex of this climb, he tilts forward for another dive, and so on, describing huge Ws or wave patterns in the sky. The performance is accompanied by the "kewee-kewee-kewee" calls, which are far-reaching and can be heard even when the eagle is so high as to be a dot against the clouds.

Another aerial wizard is the White-necked Raven. They make spectacular dives, plunging earthward at high velocity and pulling up at the last possible moment to go skimming over the close-cropped grass in cattle and sheep paddocks. They do this in their non-breeding season in the winter, when they form flocks.

The Gymnogene, that curious double-jointed hawk, may sometimes be seen flying in wide circles while dipping up and down. During this performance it calls in a querulous way. The cry seems a feeble sound from such a large bird, but it is nevertheless far-reaching. Sometimes a Gymnogene will fly in a straight line, high up while flying with undulating dipping motions like an extended W with endless U shapes.

Parasitic Birds

A surprising number of birds besides cuckoos induce others to bring up their young. They include such disparate families as Honeyguides, Whydahs, Indigo Birds and the Parasitic Weaver.

Most of the cuckoos lay eggs vaguely imitative of those of their hosts. The Great-spotted Cuckoo copies the egg of the Pied Crow: pale blue-green with brownish spots but smaller than the crow's eggs. The Red-chested Cuckoo lays a brown egg not unlike some of its robin hosts. Klaas's Cuckoo lays in a sunbird's nest and the egg is plainly an attempted sunbird's egg. Perhaps the best imitations are found in the nests of Bishop Birds, shrikes and weavers.

The cuckoo anomaly is the Jacobin Crested Cuckoo whose pure white egg is placed with nonchalance in the nest of a Bulbul, along with the very distinctive brilliantly mottled eggs. The Jacobin even dares to lay in the nest of the fierce Fiscal Shrike. Both hosts appear incapable of knowing what to do with the alien egg and so do nothing but continue hatching their own eggs and the cuckoo egg as well.

The Diederik Cuckoo lays eggs of a variety of shades and markings and imitates the eggs of the weavers. But since the weaver eggs lie in total darkness it would seem that a white egg would suffice. Instead the pure white egg of the Jacobin is reserved for the wide open nests of bulbuls and fiscals, where its differences are obvious.

But the strangest parasitic bird must be the Cuckoo Finch or Parasitic Weaver. It does not parasitise weavers or finches, as might be expected. Rather it has an extraordinary association with some of the warbler family known as Prinias and Cisticolas. The Parasitic Weaver is given its start in life by these shy little brown birds. At that stage of its development it is in some respects just another Prinia or Cisticola, eating what they eat, and even looking like one of them with the brown and mottled plumage of a younger warbler.

Then it becomes an adult and leaves its Prinia-Cisticola mask behind! Now it is the common yellow of the teeming weaver family, its beak is deep and strong for cracking seeds, and it henceforth conducts its affairs after the manner of all weavers.

But when breeding time comes round again its fraudulence is exposed: it cannot weave a nest and must needs assume its Prinia-Cisticola mask once more.

Baines's Tree Aloe

The tree aloe or *Aloe bainesii* flowers in June in South Africa. It is confined to the high-rainfall eastern part of the country. If you love aloes then this singular species will satisfy your aesthetic sense as it transforms itself from a curious-looking tree with green leathery leaves into a tree with masses of reddish-pink flower-clusters pointing like spikes above the strap-like leaves. Calling an aloe a "tree" sounds odd enough, but *Aloe bainesii* is a genuine tree. One of them grows near the house where we live, and it towers over the roof.

One needs to live near these tree-aloes to become familiar with them. Their flowering period is quite brief, and therefore the tree tends to be overlooked in its wild setting, usually some rocky mountainside or kloof where its drab grey-green colouring blends well with its background. The flowers are typical aloe flowers but more densely clustered and the flower-spikes consequently are "fatter". The whole appearance is chubbier, and these flowers are so full of nectar that one may see drops of the stuff glinting like diamonds when the flowers are back-lit. Each branch carries its load of fleshy aloe-leaves in a typical cluster at its extremity, and the weight of this load must increase during flowering time. The weight of a spike of tree-aloe flowers exceeds that of the more typical ground or rock aloes.

A most interesting characteristic of this Baines's Aloe is that after it has finished flowering it begins to throw off its old leaves. Towards the end of July one may see old leaves lying scattered on the ground beneath the tree. They present a curious appearance, very much like kudu horns, curved and twisted like antelope's horns. At one end is a white flat appendage where the leaf was once attached to the branch and sheared off when its life was over. The mystery is how the branch manages to "throw off" these dead leaves. If the old leaves remained clinging to the branches (as they remain clinging to the main stem of ordinary aloes) their weight would break the branch. So the tree aloe has evolved an adaptation to overcome this problem and simply chucks off its old leaves!

The name *Aloe bainesii* happily has not been altered, as it commemorates the famous artist-explorer Thomas Baines (1820-1875) after whom it was named. Apart from his valuable historical oil paintings he made botanical and entomological discoveries of great value. He made the first paintings of the Victoria Falls and accompanied David Livingstone on an epic trip up the Zambesi River (1858-59). Baines first discovered the tree aloe in 1873 near Greytown, Natal.

When in flower the tree aloe attracts a great variety of nectar-seeking birds. Bulbuls, Orioles, Sunbirds, Red-winged Starlings, Cape Weavers and, depending upon the particular district in which it is growing, other nectar-seeking species as well: White-eyes, Barbets, Streaky-headed Canaries and probably Mousebirds.

The leaf-clusters are a favourite nesting site for Bronze Mannikins, and these little birds also make their "sleeping" nest in the tree aloe. The sleeping nest may be used throughout the year as a dormitory for a crowd of these little birds - all on top of one another!

Fruit Bat

The small fast-moving insectivorous bats fly nimbly between obstacles using a complex sonar bouncing system that guides them with great precision.

Compared with these, the fruit bats are large and clumsy. You may sometimes hear them carelessly flapping against twigs and leaves as they grab at fruit in the treetops. This carelessness can sometimes lead to an untimely death, as the illustration shows.

I noticed a strange-looking object caught up in the thorns of a shrub growing near a copse of wild fruit trees. It looked like a nylon stocking, but it turned out to be the dried body of a fruit bat. These bats eat the fruit of the trees in question, and I imagine that in its attempts to reach the fruit this one brushed against the hooked thorns of the shrub and became entangled.

The wings were spreadeagled and pinioned, and the animal eventually died of starvation or exposure to the fierce rays of the sun next day. Since they are nocturnal creatures, they probably succumb quickly in a situation like that.

The sound made by fruit bats intrigues many a person hearing it for the first time. They hear it at night issuing from shadowy depths of trees. It is described as "pinging", but it sounds even more like a bicycle pump being used rhythmically: "Tsink-tsink-tsink. . ." monotonous yet haunting when it blends with the hoot of an owl. This sound of bikes being everlastingly pumped - and other weird sounds - can be heard from Cape to Cairo, as fruit bats in their various forms have an immense range, some migrating vast distances to find fruit trees in season, both domestic and wild.

My father told an interesting story about a blundering fruit bat. He was on guard duty one night beneath some electric power-lines when the bat tried to settle by hanging on one of the wires. Being such a large creature, its ears touched the wire below it, causing a great shock to pass through its body. The bat fell dead at his feet.

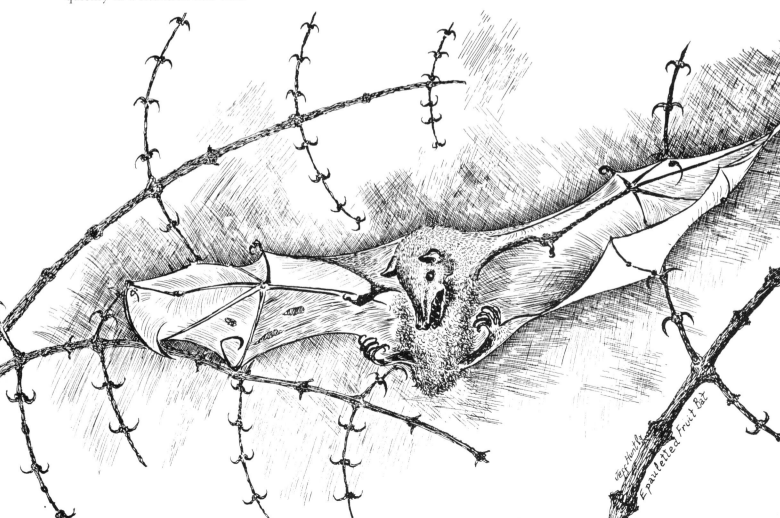

Epauletted Fruit Bat

The Bat

The powerful lights of a certain African airport attract a great number of flying moths which, in turn, act as a magnet for the local bats. As the bats fly out of the black night towards the lights their outlines become clearly defined, briefly coming into focus as a white shape, then vanishing again as they recede.

The effect is strange and somewhat analogous to a far-off sound increasing in volume the nearer we approach it and then rapidly fading away as we pass beyond it. When the bat moves away into the night again it sheds its luminous mantle and vanishes. Even in such unnatural surroundings as an airport, with its noise and metallic glitter, the bats still preserve their air of the weird and the otherworldly. The practical business of catching their food near electric lights is turned into a display of visual magic. Even their names evoke mental images in reading them: Egyptian Slit-Faced Bat, Egyptian Tomb Bat, Natal Wrinkle-lipped Bat, Welwitsch's Hairy Bat, the South American Vampire and the Black Clinging Bat.

Bats in the veld hide by day in all manner of unlikely places. Some sleep in holes bored into dead wood by nesting birds, others in disused nests of Weaver Birds and Hammerkops. They have been found in old disused bark beehives placed in the branches of trees by African tribesmen. Hollow trees, holes in banks and most often holes and clefts in rock faces and caves, mineshafts and hollow baobab stems are typical places of refuge by day. Some years ago I was peering through binoculars and making a close examination of a leafy branch directly overhead. As the glasses reached a junction of twigs and leaves a face appeared, looking straight down the binocular tubes. Without the glasses I could just make out a ball of grey-white fur with a face in the middle of it. Seen from directly below it was a sleeping bat, and it hung there among the leaves swaying from time to time in harmony with the wind. From my position it was like a furry tennis ball. That was my introduction to Commerson's Leaf-Nosed Bat, a species given to roosting in trees by day. The drawing was made entirely by the use of binoculars, the only means of seeing the features clearly. I lay flat on my back with the drawing-board on my chest.

Towards evening slight movements could be perceived, and the animal became restless. He sensed the approaching night. He gave a toothy yawn, licked his lips as though in anticipation of the coming feast and bent his head forward to nibble his belly as a dog does with its teeth when it itches. He was now wide awake, and as the great bulk of the earth tilted farther into its own shadow his wings began to droop into the open flight position. He positioned his wings and let go of his hanging stick at 6.50 p.m., dropped downwards, then curved up into the clear night sky. The last calls of the bushveld birds were still echoing as the bat flew off, getting his world right way up again after his sleep upside down.

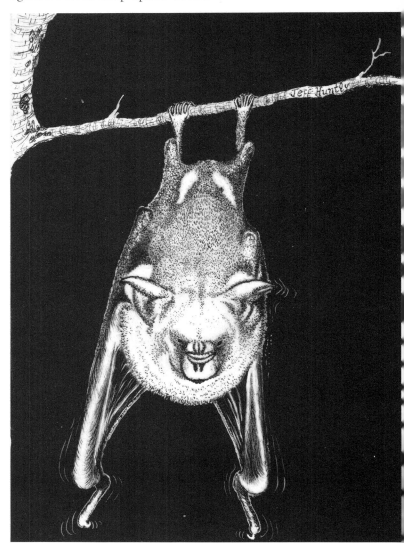

Scrub Hare

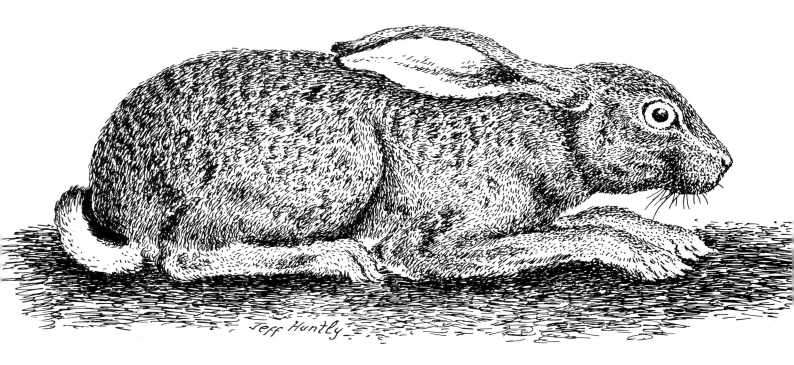

Jeff Huntly

Confining myself to strictly personal observations in these sketches I revive these memories of Scrub Hares: first, an early-morning walk near a maize field with my two dogs. A large hare was having his last feed of the night in the first rays of the morning sun. We had come upon him suddenly, and he made a split-second decision to "freeze" slowly lowering himself and flattening down his ears. His great orange eyes stared fixedly and the dogs were quite unaware of him. He looked like a mound of earth. Suddenly one of the dogs caught his scent and rushed past him, very close, with excited yaps, and went tearing off in the wrong direction. The second dog followed the first, and they went crashing off through the mealie plants. When all was quiet the hare got to his feet and went on his way unhurriedly, skirting round another maize field. I thought of wily Brer Rabbit.

The second is of young hares and how vulnerable they are. A group of Banded Mongooses passed quite near to where I was resting beneath a tree and suddenly they came upon a young Scrub Hare sleeping in its form under some tufts of grass. It squealed pitifully as they ripped at it, and although I tried to save it I was not quick enough. Young hares are also easily caught by dogs kept for the purpose by tribesmen, as they are less fleet of foot than adults.

Hares love vegetable gardens if these are near open veld where they live. Some hares always visited our young cabbage plants, and in the dim light of evening all that I could see of them was the white powder-puff tail. When he was alarmed the big male would run off, and his white tail bobbed away into the distance, acting as a guiding light to his mate who followed that white blob unerringly. The same white flash principle is used by the reedbuck, the Greater Honeyguide, the gallinules, the moorhens and other creatures. In the case of gallinules and moorhens the white flash under the tail guides the chicks through dense reeds and grass. The honeyguides' tail-flash guides ratels and human beings to beehives.

Bullfrog

A strange and authentic story was sent to me by a reader of this series, Mrs Phoebe Stanley. It concerned her son who, when out duck-shooting, waded into a shallow pan. So preoccupied was the young man with the waterfowl overhead that he did not notice that he had waded into an area covered with the floating bodies of many bullfrogs. Apparently this spot was their breeding-place, and they closed in on him from all sides, mouths agape, snapping and jumping over each other in a frenzied effort to get at him.

"The waterhole was a seething mass of them all trying to bite me," he wrote. He staggered backwards, beating them off and kicking ineffectually through the water.

The drawing tries to convey Mr Stanley's impressions and also the two protuberances in the lower jaw known as "mandibular spikes", which can inflict a nasty bite.

Some years ago I placed a wire enclosure over a large bullfrog with the object of temporarily keeping it confined for observation. After an absence of two hours I returned to find that the giant had almost vanished beneath the earth and that only the top of his head was visible. He made shuffling actions with his hind feet, slowly burrowing and moving the whole body with its partial covering of earth in a circular motion – *in one place* – like someone treading water.

I watched, fascinated, until half an hour later he had completely disappeared. This action was undertaken either as protection from the fierce rays of the sun or to get out of sight of hawks, eagles and other predators.

The scientific name is *Pyxiecephalus adspersus* or Giant Pyxie, and its colours are green above and yellow beneath. Only the colours are attractive, however, for the face of an enraged bullfrog is reminiscent of the frightful creatures invented by the 15th century artist, Hieronymus Bosch.

This far-ranging African species may occasionally be seen abroad during the rains, when it comes out of hiding underground in response to termites swarming on their nuptial flights.

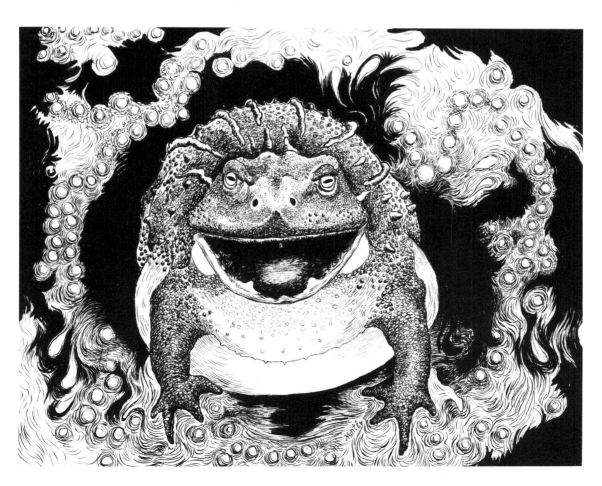

Termite-funnel Spiders

A termite mound with a long open funnel protruded like a ship's smokestack from a sea of grass in open savannah veld.

Round the lip of the clay chimney were three spiders. They were grey-black, striped, and in size somewhat larger than a peanut. Moving slowly forward to peer down the funnel, I found twelve more of them in a semicircle round a mass of working termites. From time to time one of the spiders moved forward and with swift precision seized a termite on the edge of the mass and bore it away to eat.

That the industrious termites were aware of these marauders there was no doubt. Some large-headed soldier termites stood on guard with heads and pincers raised to protect the soft-bodied workers. The spiders deliberately avoided these soldiers and sprang to one side of them to seize a worker. Once having caught a worker, the spider left the banquet table to dine in the sunlight near the top of the funnel.

One spider jumped over a soldier and landed right

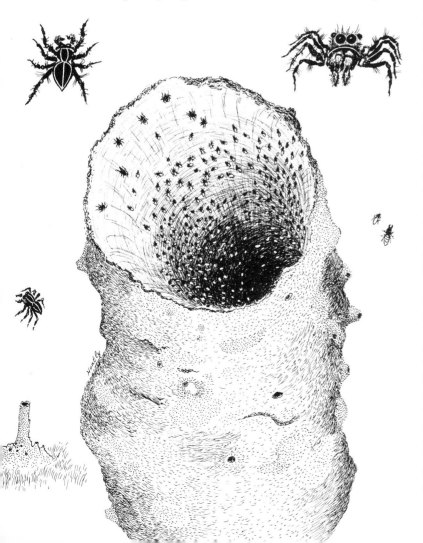

in the middle of the teeming workers. He continued jumping until clear of them, for if he had remained to select, one of the others would have closed in on him. Even the soft white workers can inflict a bite on the spiders if given time. The same spider attacked again, and this time succeeded in catching a worker from behind.

Close observation with a magnifying glass was possible when he came up to the sunlit rim to feed. Sunlight and glass combined to reveal with intense clarity a diabolical visage. The spider sucks the juices from the worker's body and having satisfied himself drops its head into the funnel. He then returns to the living banquet table for another sacful of juice . . . for to him that is all that a termite represents.

I watched this curious battle in miniature betwixt termites and spiders over the next month or so. Other clay chimneys of termite mounds in that district each had their quota of Termite-Funnel Jumpers. Taken on the whole the effect of the little marauders was to slow down the work of the termites. In the marvellous scheme of Nature the termites were prevented from making clay smoke-stacks too fast. The spiders kept the clay chimneys at a certain stage of development. The termites were in a sense retarded in their building. They could neither get any higher with their clay chimney because of the spiders, nor could they abandon the building because of their imperative urge to build, build, build.

A most interesting experiment could be carried out. If all the spiders were removed from a termite mound and the clay chimney kept permanently clear of them, then we should see how high the termites would build their chimney. Would they build it so high that it would fall over? Are termites really such clever creatures, or have they blind spots in their mental make-up or instincts? Are the spiders filling a gap in a blind spot?

One blind spot in termite intelligence is this: because they are "aware" of the spiders they have soldier termites at the ready to guard the toiling workers. Yet these soldiers are totally ineffectual against the nimble spiders. They might just as well leave the workers to their fate. Their presence as guardians is worthless, futile. Yet they go on forming what they "believe" to be a protective shield round the workers. The spiders simply jump over or sidestep them and help themselves to as many juicy workers as they want. Are the spiders in fact the termites' "friends" by preventing these blind, stupid builders from building chimneys that would eventually fall over?

Termites and Kestrels

A host of birds is soon in attendance when termites come out of their stronghold and take to the sky. I watched a flock of about a hundred kestrels wheeling above a certain spot in the veld. They made a wonderful show as they circled round a low termite mound, criss-crossing one another's flight paths continually, sometimes avoiding high-speed collisions by a hair's breadth. I was fortunate enough to be in a car at the time and was able to stop right in their midst without disturbing them. I switched off the engine and was then able to hear the perpetual swishing and rushing sounds made by their wings. Apart from the sound of wind passing through their wing feathers nothing else could be heard, emphasising the birds' grim efficiency of purpose.

The sight of these swiftly circling kestrels had attracted other birds, which remained poised and perched on various trees and bushes on the periphery. From time to time one of these smaller birds would fly into the melee and quickly snatch a flying termite. Then it would dash back again into the safety of a bush or tree. It was interesting to watch a pair of Paradise Flycatchers doing this. The male particularly was very dashing and brave for such a small fellow; he looked like a bright reddish-brown arrow flying among the kestrels.

Other birds to arrive on the scene were some Fork-tailed Drongoes. These birds were quite nonchalant about flying among the hawks, although they were always quick about settling again to eat their prize. In surrounding trees I picked up weavers, doves, bulbuls, thrushes and babblers with the binoculars, while in the grass there were about a dozen queleas and Red Bishop Birds. After that I heard the quiet conversational grating talk of some guinea-fowl that had stalked up to the exit holes of the termites and were now busily engaged in devouring succulent insects even before some of them had had time to open their wings.

At one point in these happy and industrious proceedings there was a loud cry of alarm from the drongoes and bulbuls, and all the small birds dashed for cover, as did also the guinea-fowl. The fright was occasioned by the arrival among the kestrels of a larger hawk, possibly a Lanner, although poor light made it uncertain what it was. (Typical situation when it comes to the birds of prey!) At all events this larger bird flew rapidly about among the kestrels, which seemed to ignore it. It continued for several minutes, while I tried to identify it. It appeared to be hawking termites as well, but I had the impression that it was on the look-out for some careless bird in an exposed position. After a while it could no longer be seen among the kestrels, so it must have departed.

While all this was going on I noticed that a Steppe Eagle (or possibly some other migrant eagle) was busy picking up termites from a different exit hole to the one attended by the guinea-fowl. Then the most interesting avian personalities arrived in the form of some twenty Abdim's Storks. They settled laboriously some distance away and then marched over to the spot already occupied by the guinea-fowl. They ignored the rights of the latter and began picking and pecking at the termites. Their feeding methods and manners were amusing, for in their haste to gobble up the food their large beaks constantly clashed, giving the impression of clumsy swordsmen in an amateurish attempt at fencing.

Hobby-Falcons and Nightjars

Dusk is a good time to look for birds, animals and insects if these things interest you. You may think it surprising that such diverse creatures as Hobby Falcons, jackals, genets, bullfrogs and nightjars should find a common interest; but this does happen when termites take to the air in swarms at sunset.

Of the two species of Hobby Falcons (the European and the African) found in Africa, both will hunt at dusk and take early bats attracted to flying termites, and both will gorge themselves on termites. I have seen side-striped jackals feasting on flying termites and experienced a wonderful event watching these animals through binoculars as they caught the insects. They gave every indication of enjoying themselves as they jumped to snap at a flying termite or picked them off the tarmac of a remote farm road.

I have watched nightjars at these termite feasts, particularly the enchanting Pennant-winged Nightjar. In the half-light of dusk the long streamers issuing from its wings make a weird and memorable sight, as does the insect-like twitter by which it informs its mate of its presence, in case she has not noticed his spectacular trailing streamers.

In West Africa a very strange nightjar also catches termites in the gloaming. This bird is "strange" because it sports a feathery tassel at the end of a long bare primary feather. This is the ninth wing feather, and it grows very long at the beginning of the breeding season. One "flag" from each wing, a long bare quill with a tassel. When in flight the shafts holding the tassels are invisible, but the tassels themselves can be clearly seen. The result is a visual impression of three birds flying along, the big one being followed everywhere by two smaller ones that undulate up and down! It is known as the Standard-wing. This bird has a nuptial display flight for its mate in which the wings are softly fluttered, like a moth fluttering against a window-pane. This has the effect of raising the tassels above the bird so that they too seem to hover.

Nightjars have the curious habit of rolling their eggs to a different place if they believe the eggs have been found by a human. I found a female brooding her usual clutch of two and returned next day to find that she had moved them, perhaps during the night so as not to draw attention to herself by her movements. They were in a new place about two metres from the first site. It is not clear how she had moved them, perhaps in her bill or by rolling them. I prefer the latter guess, because the new site was so near.

Nightjar droppings are another oddity among birds – they are coiled like a tiny spring, and they were the only means by which I could find the site of the first "nest" – actually no nest at all, just the tell-tale coils.

Hadeda

Jeff H.

The typical form of this bird was introduced to science, as long ago as 1790, from the Cape of Good Hope and was given the engaging name of *Hagedashia hagedash*. The late Leslie Brown – doyen of ornithologists – lamented the later name bestowed upon the bird: *Bostrychia hagedash*. He considered that the original name was so suited to this comical mixture of avian solemnity with the braying voice of an ass. He found it a most lovable bird, and would perhaps have been at a loss to learn that some city-dwellers in South Africa greatly dislike it.

I can only think that the dislike is occasioned by the extraordinary loud cries emitted by a flock of hadedas as they pass overhead at dawn when people are rudely awakened by the shattering noise. Apart from this glaring (or blaring!) fault they are highly beneficial to man; a flock will rid his gardens and sports fields of all manner of obnoxious pests. They add beauty to the landscape as they march along, sometimes five abreast, the sunlight gleaming on their wings and shoulders, giving off first lilac and then emerald reflections, depending upon how the bird moves and catches the light. When they take to the air one may glimpse the deep purple shade of the flight feathers. Purple? Yes – again, depending upon the angle of the sunlight catching those wings you will see that what you always imagined were dark grey, almost black wings are in fact deep purple.

Michael Stuart Irwin, in his recent *Birds of Zimbabwe* makes the interesting observation that along the Middle Zambezi Valley and west of the Victoria Falls (Botswana-Zambia border) the hadeda is extremely wild and quite unapproachable. My own conclusion as to the reason for this fear of man in central Africa and the extreme tameness and tolerance of man in Johannesburg and Pietermaritzburg is that this species is hunted ruthlessly as food in one place and has been protected in the other. In the towns it has become almost semi-domesticated, rather like the Feral Pigeon and the Indian Mynah. It has lost much of its fear of man, particularly in Maritzburg, where numbers of them may land in a garden and give the lawn the once-over, pulling earthworms out of the ground by the yard.

I like David Bannerman's apt remark on the preferred habitat of the hadeda in West Africa, because it applies to the rest of Africa too. He says it is typically found in the sort of "places beloved of the hammerkop", that is wet, flooded or marshy plains, rice-fields, streams and near big towns at sewerage works. The hadeda's and the hammerkop's menu includes many items of common taste: frogs, certain snails, insects of all kinds, worms, tadpoles and just about anything that wriggles, hops or bounces.

Although hadeda, hammerkop and Sacred Ibis share common interests and habitat, of these three the hadeda breaks with tradition and often leaves its two friends to their damp domains and will seek out a burnt stretch of veld far away from water. Here it will wander in small bands seeking and finding burnt rats, singed lizards, baked frogs and sizzled grasshoppers. It will also be found in bushveld and "foresty" places where neither hammerkop nor Sacred Ibis will go.

Hadedas are in complete contrast to their friends the hammerkops in nest-building. Hammerkops provide their young with superb accommodation. Hadedas are sloppy nest-builders, and their young often fall out of these disgracefully jerry-built platforms, ready to fall apart in any storm. They nest singly and in quite tall trees, so that if the chick falls it is often killed or injured.

Antbear by Torchlight

an antbear emerged into the path not more than four yards from me. The brilliant light evidently baffled him. His ears were held backwards in alarm, and he continually sniffed deeply; long sniffs such as one might expect from anything with a nose like his.

A brisk breeze was blowing all the time from him to me, so that he could not catch my scent or hear my unshod feet on the sand. Then his extraordinary wet tongue shot from his pursed lips, glittering in the light and covered with the sticky substance that draws thousands of termites into his mouth. I stared at him, trying to memorise every detail for a drawing, trying to get a visual imprint on memory to work from.

Something startled him, and he bounded off into the grass, a humped grey thing moving surprisingly fast in a very characteristic loping movement.

I inspected the place where he had been so noisily crashing about and found many small termite earthworks over a wide area. At dawn I examined the spot more carefully and found several places where he had scratched with his mighty forepaw and licked up the termites.

The powerful torch and "stockings only" approach has brought me very close to wild animals, particularly on tilled ground where there are no leaves to crackle underfoot. A windy night is good, and early evening seems to be the best time since the animals are out looking for their first meal after their day-long fast.

Seeing nocturnal animals alive and free in their wild state is difficult and often considered too troublesome. But one method is sometimes quite rewarding and reveals small aspects of their lives, something about their thought patterns - their mental attitudes - their way of doing things, their innate intelligence.

Recently a long-held wish of mine was fulfilled when I watched an antbear by torchlight, though for only a short time. A number of factors combined in my favour and provided what was probably a hundred-to-one chance of seeing one of these animals close up.

I had stopped for a "listening break" on a veld road where a sandy footpath crossed it, when I heard some heavy-footed creature rustling in the grass nearby.

Slipping off my shoes I stole towards whatever it was along the sandy footpath, shining a powerful torch at the sound. I was careful to move forward only during the periods of rustling, and froze every time the animal stopped for *its* listening break. Presently

The Cabbage Tree

Ten species comprise the weird-looking trees named Cussonia, after the French botanist Cusson. In the days of the ox-wagon they were called *wabome*, because their light, soft, grainy wood made excellent brake-blocks for wagons. This old name has unfortunately gone out of use except among older generations of farming communities, and the less felicitous name of Cabbage Tree has been bestowed upon them all.

If you are fortunate enough to own a copy of the original *Trees of Central Africa* by the Coates Palgrave family, with its huge collection of paintings by Olive Coates Palgrave, you will read how the musicians of Malawi made xylophone keys from the wood of the Octopus Cabbage Tree, *Cussonia arborea*. This coffee-table book, incidentally, contains some of the finest botanical paintings of African trees ever published. The leaves, flowers and fruits depicted in water-colour have a feeling of the veld about them and seem to breathe the atmosphere of wild Africa.

By comparison, modern glossy photographs, however well done, seem artificial, glitzy and with the atmosphere of the electronic age about them. This is probably the result of flashlight photography rather than natural sunlight.

The flowers and fruits, and in fact everything about the Cabbage Tree, is strange and singular. One is reminded of the terrible head of Medusa, with its grey, writhing serpents instead of hair. Some species have the fruit and flower part looking like grotesque stumpy hands reaching skyward as though pleading for rain. Others are like octopus tentacles, with round sucking discs. All the species, when flowering and fruiting, attract swarms of flies, wasps and beetles. These insects can sometimes be seen etched against the clouds when you look up through the branches of Cabbage Trees.

A curious characteristic of *Cussonia* is its ability to survive hard times and to grow in unusual places, taking advantage of protection afforded by other trees and rocks. For example, one species will grow beneath the canopy of other established trees. The Cussonia grows rapidly and emerges above the canopy of the older trees to reach the sunlight. Presumably it had protection against frost beneath the canopy during its youth and also against veld fires, there being little or no grass beneath the trees.

In the Drakensberg one may see species of *Cussonia* growing between rocks and split boulders. Here they are protected from veld fires because of the rocky ground, which supports little or no grass. Rocks and Cabbage Trees cooperate to create a fortress against fire, and the trees survive and give a distinctive look to the landscape.

I have seen one species of *Cussonia* completely burnt up in a veld fire; all that was left was a charred burned out wreck. Or so I thought. But at the onset of the next rainy season it sprouted new leaves and completely recovered, like a sort of arboreal Phoenix! The explanation of this miracle is that the inner life of the tree is protected by the thick, corky bark, which refuses to burn properly. Only a thin layer of the outer bark catches fire briefly and chars black. The tree seems to be all aflame temporarily, but its inner life is protected by the cork jacket.

The Grey-rumped Swallow

This curious little swallow was first described from Port Natal in 1850 by Sundevall, but it is more typically a bird of northern Natal, Swaziland, the north-eastern Transvaal and northwards to the Sudan. Its claim to fame is that it is the most easily overlooked of birds, because of its similarity to the European Swallow and also because of its small size and self-effacing ways.

To observe these birds requires a deliberate effort, and once one has become acquainted with them they are easy enough to identify. But finding their nests demands harder concentration, and the only way to discover a nest in actual use is to keep the birds in view continually as they flit aimlessly about over their particular vlei ground "airspace". Sooner or later one of them will dive and vanish into a hole in the ground. Mark the spot where you saw it disappear and walk straight towards it. Reach the place and you will find an ordinary rat hole. And that is what the nest in fact is – an abandoned rat hole or gerbil's tunnel. At the end of the hole the swallow has hollowed out a small chamber and lined it with wispy grass blades to form a soft padding for the delicate, thin-shelled white eggs.

Although this habit of flying apparently aimlessly over vleis or bare open ground appears pointless, it is an important part of the swallow's life. They are feeding on tiny insects, and they are nearly always in small parties, even in the breeding season. They keep low down when in flight; which may be a protective device to maintain a low profile and draw less attention to the location of the nest hole. When the bird enters its nest it shuts its wings and dives in. Rather like a golf ball in a "hole in one". Now you see it – now you don't!

Every species of bird has some niche particularly suited to it, and the Grey-rumped Swallow seems to like open vlei ground, especially if it has been closely grazed by cattle or burnt bare by a veld fire. This exposure of the ground also reveals the rodent holes, and whenever I have found the Grey-rumped Swallow it was always in places where gerbils (a nimble night rat) had their burrows. These conditions allowed the swallows to skim close to the ground, always flying into the wind, and suddenly diving into a gerbil hole. When the grass grew long at a different time or season and covered the holes, the swallows would leave the district, no doubt in search of other bare ground. This type of local migration in search of a preferred habitat is practised by a vast number of species all over the world.

Rhino and Irony

The great irony about the insatiable greed for rhinoceros horn is that the magical aphrodisiac and medicinal value attributed to it is purely imaginary. These beliefs, widely held throughout the Near and Far East, have been the cause of a huge demand that continues and grows.

Another factor is that newly-rich young North Yemenis with wealth from Saudi oil fields can afford daggers with rhino-horn handles. Possession of one of these weapons seems to confer some magical advantage over all other mortals. The sale of these daggers is an irresistible motive for poachers to hunt for rhino horns wherever and whenever they can.

Of the five existing species the White Rhino is probably the most familiar to people in the western hemisphere and Africa in particular because of the ease with which it can be photographed or observed in sanctuaries, particularly in Natal, Swaziland, the Kruger Park, Zimbabwe and Botswana. Its comparatively mild disposition, sedentary unruffled manner and habit of resting and wallowing in mudholes in the open all combine to make the White Rhino a familiar object to tourists. Perhaps not so well known is that the rare White Rhino of The Upper Nile and adjacent territories is considered to be slightly different from the Natal animal. Zoologists observe some minor differences in the skull and teeth, and therefore name the Upper Nile Rhino *Ceratotherium simum cottoni*, whereas the Natal or southern African White Rhino is *Ceratotherium simum simum.*

The Great Indian Rhinoceros (*Rhinoceros unicornis*) is the famous Rhinoceros of antiquity and legend. Like all rhino species it is continually threatened by poachers, and since earliest times it has been hunted extensively by kings and princes of the Orient. It has also been used for a horrible and disgusting "religious" rite in which the initiate wallows in rhino blood in the cavity of its huge body. This practice is the culmination of many absurd beliefs concerning rhinos in the Near and Far East. It is considered even by some well-educated people to be a magical animal, and parts of its body are used for all kinds of medicinal uses or as good luck charms and so on. Powdered rhino horn is regarded in some areas as being a aphrodisiac, and wealthy clients pay vast sums to get their hands on the stuff.

Another ancient belief among Oriental kings and princes was that a goblet or drinking bowl made of rhino horn would "split in twain" if poison were added to its contents. In some parts of Africa a paste containing powdered rhino horn is smeared on the eyebrows. This is believed by the young man wearing it to attract beautiful women without fail.

The Javan Rhino is the rarest large animal in the world. Relentless hunting brought this species to near extinction in 1970, when only 35 animals remained in the world in the Ujung Kulon Nature Reserve in Java. This sanctuary was proclaimed in 1921 for the express purpose of saving the Javan Rhino. By 1983 the population had made some recovery, with about 65 animals in the Ujung Kulon. Perhaps still the second rarest large animal, the Sumatran Rhino is the smallest of surviving rhinos. It is distinctive in being hairy, and its range includes small isolated pockets in Sumatra, North Borneo, Malaysia, Thailand and perhaps a few relict groups in Burma. But the position can change overnight and whole populations be wiped out for one reason or another, and nearly always connected with the human factor: wars, changes of policy, movement of peasants, pressures of human population and demand for more land. The familiar scenario of Africa and South America.

Useful Associations

Nature often reveals loose associations between species of one kind or another, and zebras frequently associate with wildebeest and other animals with the idea of gaining extra protection from predators. Some quality of superior vigilance – eyesight, sense of smell, hearing or greater intelligence - may be exploited by various species associating whilst feeding. When zebra associate with giraffe, the zebra benefit from the giraffe's eyes placed at such great height as to see over bush cover any approaching hunter or predator. When the giraffe becomes alarmed and starts to move away so do the zebras; thus one animal's advantage of great height is not only to his own benefit, but to other animals associating with him.

The sheer cunning and intelligence of baboons likewise aids the zebras, for it is extremely difficult to approach a troop of baboons without being detected, whether you are a lion, leopard or poacher. Baboon sentries will climb a tree for a quick look around from time to time and always one or other member of a troop will peer intently into the surrounding veld for danger. They may give an impression of preoccupation with feeding but they nevertheless maintain constant vigilance. All this of course greatly benefits the zebra herd.

In the case of zebra associating with kudu it would be an instance of zebra benefiting from the keen hearing ability of kudu. Kudu and bushbuck look towards suspected danger as though relying heavily on their eyesight, but observe those huge ears! These funnel-shaped absorbers of sound pivot silently as though on oiled ball-bearings to catch the slightest sound which could quite conceivably be missed by zebra with their smaller ears. Imagine what a man will miss hearing with his relatively flat appendages stuck on the sides of his head! If you cup your hands behind your ears and concentrate your mind on a distant bird-call you will appreciate what a difference big ears must make to such animals as the kudu and the bat-eared fox. Your cupped hands scoop out of the air and into your ear-hole a considerable amount of sound which your ears normally miss. Try it, especially at night, the next time you go camping or are up in the mountains beneath the stars.

Along the Chobe River in northern Botswana one may see with comparative ease a long-standing association between baboons and the Chobe bushbuck. I once sat in a Land Rover overlooking the Chobe flood-plain and had been watching a distant herd of Lechwe feeding in shallow water. My vehicle was parked in some shady trees and dense bush. Suddenly I became aware of shadowy forms all around me, silently making their way down to the water's edge. They were baboons and Chobe bushbuck walking together in a loose aggregation and being extremely stealthy and alert, stopping from time to time to listen before proceeding to the water's edge. Here was a blending of senses to one another's advantage: the keen hearing of the bushbuck, superior to that of the baboon and the keen eyesight and intelligence of the baboon, superior to that of the bushbuck. When united the two species formed an aggregation extremely difficult to surprise.

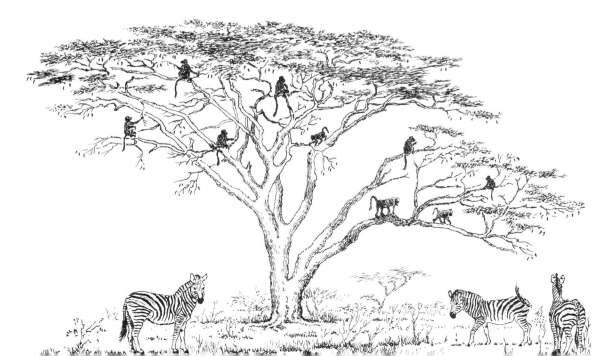

Bishops, Widows and Whydahs

This interesting group of birds lives and moves and has its being in areas of rank grass, tall weeds and lush riverine vegetation. Beds of bulrushes and river reeds are favoured, as are termite mounds covered with broad-leaved grass, khaki-weed and thistle. All this in the rainy season when the birds are nesting. In the dry winter months the same birds resort to open grasslands, maize and wheat fields and fallow land where crops have been grown, such as sorghum and millet. In this off-season period they move about in flocks, sometimes of mixed species: bishops, widows, whydahs and weavers consorting together, probably for mutual protection. At that time of the year males and females look alike in their dull stripy brown eclipse plumage.

and the birds pull surrounding grass over the nest, completely concealing it. If the female remained sitting on her eggs at your approach the nest would never be found. But alas, her nerve fails her at the last moment and she flies out of the grass, revealing the nest.

When the White-winged Widow lays her first egg her nest is so flimsy and transparent that the blue egg may be seen lying within. But as time goes on she adds more strands of green grass to the structure until the desired thickness of walls is attained. It is not certain whether the male goes on adding to the nest, although he begins the basic structure in the first place. By the time the chicks are ready to hatch the nest is sufficiently thick.

When the rank vegetation has well established itself at the height of the wet season, they begin their domestic programme with the males doing the nest-building. As a rule Red Bishops attach their thin grassy nests to reed or bulrush stalks standing in water. White-winged Widows choose a site often on a river bank or by a water drain and attach their nests to grass or weed stalks or in prickly thistle stalks, over dry ground. The Red-shouldered Widows can be found in grassy fields and vleis quite far from water, and their nests are cleverly concealed in short grass. The nest often rests on the ground or just above it,

An interesting characteristic of the Red-shouldered Widow is the cock's nuptial display ritual performed to impress and excite the various females that comprise his harem. He chases a hen round a grassy field until she settles on a stalk of grass or weed. The cock lands near her, often slightly below her, and opens his wings. The wings are held in the manner shown in the drawing, sometimes for quite a while, as though making the maximum impression on the female. This fanning out of the wing feathers displays the red shoulder patches, which are edged with a narrow band of golden ochre colour.

Strange Beetles

The great assemblage of African Longhorn Beetles includes some very strange creations: one of which simulates a wasp (A1 and 2) and the other displaying a bizarre pair of antennae with pompoms and flat spatulae that jiggle and quiver as the insect walks. (B) Their respective sizes are roughly shown in relation to a man's hand.

The wasp simulator is *Dirphya similis*, and it is perhaps the most extraordinary of the Longhorn family. It has a swift flight, reminiscent of a wasp's, and when aloft has quite a threatening appearance. It is brilliantly coloured in bright orange and black, the warning colours of Nature proclaiming its wearer to be toxic or in possession of a dangerous sting.

But *Dirphya similis* flies under false colours, gaining protection by looking like a bright hornet. The amazing simulation of a wasp is not only by colours but also in the shape of the abdominal region – an imitation of the slim wasp "waist" and the poisonous "sting". A side view of *Dirphya similis* shows this feature (A1). A dorsal view shows how the harmless beetle's wing-covers are also shaped like the narrow wasp's wings (A2). The Solitary Wasp (C) or the Mason Wasp (D) could be the models which the Designer of *Dirphya similis* had in mind for this extraordinary mimicry.

On the three separate occasions when I saw this orange and black beetle in the wild I noticed how alert it was and how keen its eyesight. Unlike other members of the Longhorn family it would not allow a close inspection, but when sitting on a low shrub it seemed to see me from a long way off. It snapped to attention and its movements were also twitching, abrupt and threatening – very much like a wasp when it feels threatened. On each occasion *Dirphya similis* took off like some weird helicopter and swiftly departed over the trees before I could get near enough to photograph it. The eyes are shaped rather like doughnuts (E) and half encircle the bases of the antennae. The antennae are shaped like black fishing-rods made of bamboo and even have bamboo-like joints. They are very long for the size of the beetle, and when the creature flies they are held wide apart and curling backwards in the wind. This greatly increases its threatening appearance. . . (see also A2).

The Pompom Longhorn (B) is *Cloniocerus kraussi*. It is shown at rest with antennae held together pointing forward, in contrast to the wasp simulator, whose antennae sweep backwards over its body when at rest (A1). When *Cloniocerus kraussi* walks hurriedly along the antennae with their pompoms and decorations jiggle up and down. The effect is ridiculous to the observer, reminding him of a strutting tin-pot dictator, but to a predator of beetles it must be quite off-putting. One may see a similar device on some caterpillars: when they feel threatened they erect black spines or flat spatulate projections that create an alarming appearance.

Cape Vulture

Tarzan of the Apes once dreamed that he was carried aloft by a gigantic primeval vulture and that he stabbed upwards at it with his famous sheath-knife. Edgar Rice Burroughs was not entirely fanciful in his tales, since vultures of great size once patrolled the skies peering down in search of dead bodies of huge creatures now long extinct.

The Cape Vulture or Griffon stands, or rather soars, perilously near to the vortex that sucks many a life-form into extinction as the interests of Man conflict inevitably with those of Nature. These great birds once performed the task of cleaning up the veld. They were like flying rubbish-bins clearing up the remains of animals killed by predators and on a big scale, when vast herds of springbok, quagga, wildebeest and zebra once roamed the wide open spaces. But, unlike rubbish-bins, they exhibited grace when soaring aloft with magnificent mastery of the air currents and thermals.

The great herds of game animals are now gone, replaced by domestic cattle; dead cattle are speedily removed and buried by farmers to keep the country from disease. The vulture has farther to travel in search of food. Add to sheer starvation other hazards to these obsolete relics of the old order: power lines, concrete water-storage tanks, lack of bones to feed their chicks, shotguns in the hands of people who love killing for its own sake or from idiotic superstition. With their natural food source almost gone, it is inevitable that they should sometimes attack sheep.

Dr Peter Mundy and his colleagues in their vulture projects could create a situation in which the Cape Vulture can still be snatched back from extinction, but it will be a race against time, against ignorant prejudice or – more difficult still – justifiable prejudice, a battle against a civilisation that is extremely uncivil to other forms of life with which it shares this planet.

Jeff Huntly

Leguaans

Part 2

The Water Leguaan is appropriately named. The dry-land leguaan is called the Savanna or Tree Leguaan. Both can climb trees when the occasion demands.

My dog indicated that some creature was in a tree just out of his reach. He stood on his hind legs with his forepaws resting against the treetrunk and peered up in great excitement. I looked up too, but could see nothing at all, and was puzzled at his behaviour. I imagined he had treed a slender mongoose which had concealed itself behind a branch. After trying unsuccessfully to persuade him to "come along . . . let's go . . ." I decided to search the branches systematically to find the creature, whatever it was. Looking straight upwards with binoculars I saw what I had previously thought to be a bulge in a branch. It was in fact the belly of a Tree Leguaan. The underside was wonderfully patterned or marked with transverse black bars of camouflage against a yellowish ground. When looking up at this design seen against the glare of clouds and sunlight the leguaan seemed to be transparent with dark shapes of back-lighted sticks and thin branches passing through it at right angles. The Tree Leguaan! a master of camouflage magic, completely invisible from below by this design of stripes.

I must have walked beneath many a Tree Leguaan in the past, quite unaware of its presence in the branches above. Only the fact that the dog had treed this one gave me the chance to see the vanishing trick.

Leguaans have been hunted through the ages by tribesmen, and the cryptic patterns on the leguaan's underbelly has evolved specially to conceal it from its two-legged enemy. . . that's my belief anyway. But think of it: what other predator looks upwards at leguaans from under trees? I mean predators of leguaans? Eagles?. . . the ratel? They catch the leguaan by seeing him from above, in the case of the eagle, and diving down upon him when he exposes himself on the ground. The ratel digs him out of the earth in certain parts of the country. No, the black stripes on his belly are of no use to him in these situations, but come into marvellous effect to protect him from man, his most dangerous predator.

That leguaans spend long periods of time in trees in certain circumstances is vividly illustrated by Bradfield, quoted in Walter Rose's *Reptiles and Amphibians of Southern Africa* (Maskew Miller 1950). Bradfield observed leguaans in Damaraland stationed in trees containing the flowering parasitic mistletoe. They remained dead still, with infinite patience, awaiting the arrival of nectar-seeking birds which were caught and devoured if and when they got within the range of the leguaan. Once again, the camouflage on the belly would help the reptiles in this exercise. To the leguaan time means nothing, and it will lie concealed in the mistletoe for hours on end awaiting the inevitable arrival of some careless bird.

Footnote: One often thinks of animals and birds as using camouflage against other animals and birds, but many of these protective devices have evolved as a protection against the king of predators, man.

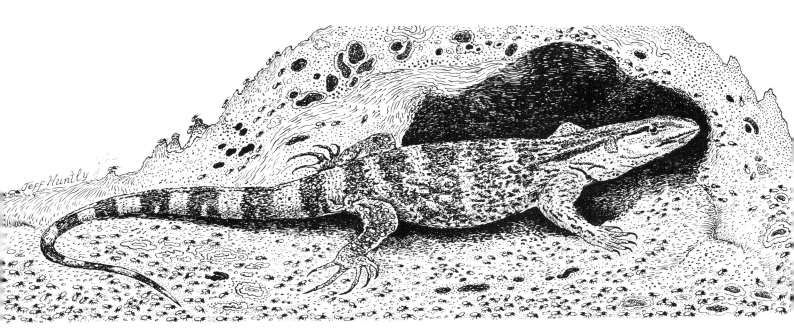

Jeff Huntly

Musk Shrew

Musk Shrews are minute creatures possessed of dental weaponry seemingly out of proportion to their needs, yet this is obviously not so when we consider the nature of their prey: hard-shelled insects, beetles encased in chitinous armour, other insects with stinging or biting defense tactics of their own requiring a swift attack from the shrew and a piercing bite to render then inert. They also take carrion and incapacitated small animals and birds.

The hunting of insects goes on at night, mainly, when these tiny assassins creep along grass runways, insect burrows and beneath slabs of rock – the favourite resort of a heterogenous assemblage of insects. Other beetles living behind pieces of peeling bark, or in holes bored into rotten wood, are sought out and devoured. To the insect hordes the Musk Shrew represents the Sabre-toothed Tiger of their miniature grass jungles.

Like all life forms the shrew's body is marvellously adapted to its activities, its intelligence directed towards the fulfilling of its desires and welfare and the continuation of its kind. The ears can be likened to instruments especially designed to register faint scufflings of insect feet, the dry rustling of wing membranes and the distant "cri-cri-cri" of crickets - fatally advertising their whereabouts. The sound of the toktokkie beetle may call up a musk shrew instead of a mate, the erstwhile lover proclaiming his presence scarcely finishes his sentence of "tok-tok-tok" before he is snatched in ivory jaws and reduced to crumbling pieces like a rusk.

A few days ago I was very surprised to see a Musk Shrew in the middle of a swimming pool. The little fellow had clambered up a floating plastic basket containing chlorine pills. There he sat like a man on a raft in the middle of the Atlantic with no hope of reaching land. When I tried to push the little raft towards the edge of the pool the shrew dived into the water and swam rapidly away. My surprise was at the speed with which he swam. Perhaps the fur on a shrew's body contains minute bubbles of air to help buoy it up, or some other factor may be involved, but the little creature fairly sped across that pool. His triumph was short-lived, however, as he could not climb up the overhanging sides. I draped a twiggy branch into the water just in front of the little speedboat and he climbed on to it, allowing me time to place him on the lawn and off he scurried into the geraniums.

In North America the Water Shrew *Sorex palustris* skims over the surface of still waters employing minute bubbles of air caught between stiff hairs on its hind feet. Its velvety fur also aids the buoyancy, being extremely waterproof. Observing my shrew (genus: Crocidura) swimming so expertly it seemed that they shared some common factor though far more developed in the American shrew.

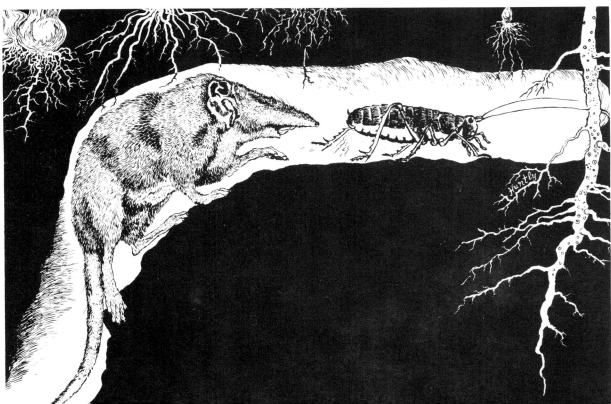

The Edible Dress

Imagine a farmhouse vacated for three months. The owners have gone abroad perhaps. When they return they discover termites working up the side of a doorframe. Until that moment they had believed the house was safe from these insects, as special precautions had been taken when the foundations were

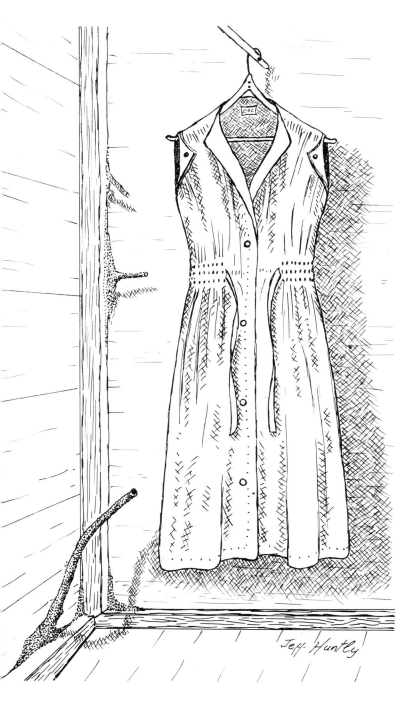

Jeff Huntly

laid. Perhaps the long period of silence in the building had encouraged the termites to be bold and begin attacking doorframes and other woodwork.

A cupboard door is opened to reveal a strange-looking clay pipe, shaped like a snake and pointing at a dress hanging inside. Two smaller brown fingers also point at the dress. These clay tunnels would have been joined to the dress if the house had been vacated for another week. Termites would have passed through the clay pipes to reach the dress and would have begun to eat it. I saw this happen, and I can only speculate on how these toilers in total darkness can sense the presence of an edible dress. It is almost as if the clay pipe itself contained some sense of direction, like a tentacle reaching out for its victim. Eugene Marais got an odd feeling, when observing termites, that the whole termitarium was presided over by an unseen intelligent force and that the little termites were its life-blood, answerable to this intelligence, totally obedient to it. The termitary seemed to be "a separate composite animal".

Of all the thousands of termites working under this building why do a few of them detach themselves one day from the main group to begin making a clay pipe that rears itself up from the floor to reach that dress? Does the dress material itself give off an odour that passes through intervening matter to reach the insects and to which they respond? This seems as reasonable as the belief that something outside the termites tells them that an edible dress exists just above them and slightly to the right.

Yet some termites seem quite unable to appreciate certain situations as dangerous to themselves. For example, when they are building a fresh air chimney at the top of their termitary they are preyed upon by a certain pied jumping spider. These little spiders wait at the edge of the chimney. When a worker termite comes up with its load of building material and is about to "lay its brick" it is seized by one of the spiders, sucked dry of its body fluids and thrown down into the black depths from whence it came. Only a few workers complete their job, patiently turning round to descend for another load. This creates a stalemate situation. The chimney cannot get any taller and the spiders keep things in a constant stalled position. The individual workers seem to have no way of communicating their spider problem to their leader, although sometimes soldier termites are sent to protect the workers. The soldiers are ineffectual, and the spiders simply hump over them to grab a worker. However, not all termite mounds have their ventilation shafts infested with spiders.

A Blue Swallow Family

This is a very special member of the swallow clan, an extremely beautiful bird with long tail shafts in the adult male. Being uncommon they excite immediate interest when seen for the first time by anyone keenly interested in our birds. They spend part of their lives in Natal, the Eastern Transvaal and the eastern borders of Zimbabwe along the Chimanimani Mountain range, when they breed between October and March. In the non-breeding season Blue Swallows migrate northwards to Uganda seeking and finding their favourite habitat: open grasslands on mountain slopes and in their valleys. One may see them settle on grass stems, an unusual habit for swallows.

When we lived in a farmhouse in the foothills of the Chimanimani Mountains, a family of these birds had their nest on the veranda just above our front door. They nested there for five years in succession and we marvelled at their unerring sense of direction as they returned to us each year from Uganda. On one occasion a nearly fully grown youngster flew out of the nest one black stormy night – perhaps on account of a flash of lightning. We heard the two remaining chicks making a "chitter-chittering" noise at 3 am after the lightning bolt. Investigating with a torch we saw the two chicks looking at us over the side of their mud nest. We presumed the wayward chick must have perished in the storm as there was no sign of it in the morning.

The parent birds meanwhile continued to feed the remaining chicks but on the third day after that storm we saw the parents feeding their lost chick who was now perched on a long grass stem, looking strong and purposeful and demanding attention of his busy parents. They divided their time between him on the mountainside and the two chicks still in the nest. A week later all five birds were seen flying together over a nearby dam where the three chicks gained strength, beauty and experience by the day as the whole family, ably led by the long-tailed male, swooped and banked over the water chasing the tiny flying insects that make up their diet.

The male Blue Swallow sometimes indulges in a display flight which consists of hovering in one place with his long tail shafts pointing downwards. We sometimes saw him flying along normally when he would suddenly change his flight movements and hover like a butterfly, probably for the entertainment of his mate.

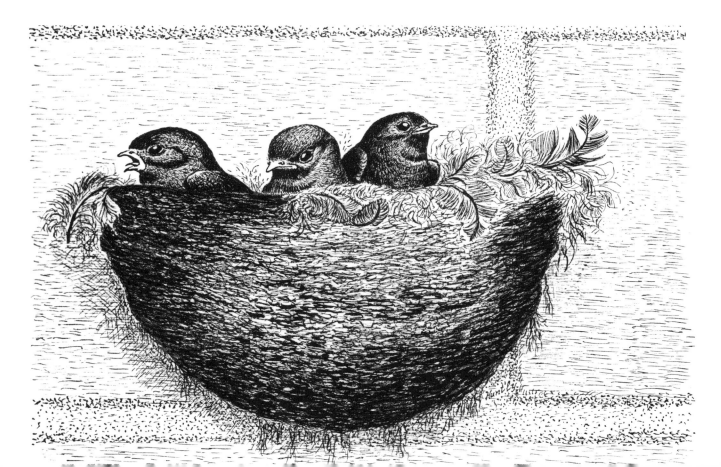

African Black Duck

There are some boulders and rocks protruding from the water - they are blackish-brown, and some of them have white markings on them.

The white splashes are made by Reed Cormorants, which sometimes rest on these rocks and inevitably deposit their dung there! One of the rocks begins moving slowly upstream, to be joined shortly by another! Seen through binoculars, they turn out to be a pair of African Black Ducks wonderfully camouflaged by a trick of the sunlight to resemble

who obey her instantly. I watched a mother duck with her flotilla of ducklings passing parallel to a reedy bank. When she noticed me she must have very quietly spoken to her charges in duck language, for they swam quickly into the cover of the water weeds and stayed hidden in the shadows. The mother herself remained in full view for some time; then when I walked away for some distance she summoned them again, and they came out of hiding. Her instructions were inaudible to me, but obviously the little ones

the stones. They too are blackish-brown with flecks of white to break up their outline.

The Black Duck is fairly scarce, and is an inconspicuous bird, retiring into shady parts of the river when it feels the presence of man. The species is a true river duck, and it often escapes notice by its skilful use of cover and by its stealthy movements. It will remain on the water as long as it thinks it has escaped notice. But if approached or watched with too close an interest it becomes uneasy and takes off, often flying low over the water up or downstream until it disappears round a bend in the river.

The mother Black Duck is a clever parent adept at leading her ducklings out of danger. She has some means of conveying her instructions to her brood,

got the message clearly enough.

If a hawk or falcon should dive down to take a duckling, the mother bird will splash water at the attacker with her wings. Besides man, her natural enemies include the otter and the water-mongoose. The male and female Black Duck are inseparable companions and may be seen day after day swimming together on a certain stretch of river that they consider to be their territory.

An interesting point about the colour and shape of these ducks is that they resemble the rocks in shallow rapids where they often feed. They gather larvae from the ooze at the bases of the rocks.

Their scientific name *Anas sparsa* alludes to their sparse numbers throughout their vast range in Africa.

A Silver Bird

The White-chested Cuckoo-shrike is a most attractive inhabitant of the msasa highveld, and when seen for the first time evokes interest because of its elusive ways and singular appearance. The chest and under-parts are pure white and the rest of the body and wings are a clean, unsullied grey, giving the effect of immaculate grace and perfection of form.

Cuckoo-shrikes hunt for their insect food high up in Brachystegia trees and are most often observed as single birds.

Occasionally a pair may be together in a grove of msasa trees in company with a bird-party comprising Red-headed Weavers, Hyliotas, Spotted Creepers, Helmet Shrikes, Tits and other species, which band together apparently for mutual protection.

For the most part the Cuckoo-shrikes are inconspicuous; quiet and not aggressive towards other birds. Their call is in keeping with their retiring ways – a soft squeak like "foo-wee", which the bird can vary in intensity as circumstances demand.

Roberts' *Birds of Southern Africa* describes the call as a whistling warble of "duid-duid" from the male, and "tch-e-e-e" from his mate. There is nothing loud about this sound, but it is far-carrying under certain circumstances.

But by far its most interesting characteristic is its nest. This must be seen to be believed. The whole structure is like a miniature grindstone with gently sloping sides – about the size of a cupped hand.

It has softly rounded edges made to look like the rounded bumps and lumps seen along msasa branches.

Without seeing the bird rise off the exact spot on the branch one could never discover the nest, so well does it blend with its background. The nest is made of dry springy leaf stems all from the same kind of leaf and bound with cobweb.

This is then carefully covered with soft green strands like seaweed from old msasa branches, sometimes referred to as "Old Man's Beard". This stuff, incidentally, is also used for the same purpose by the Orioles.

The nest is so shallow that one might think the eggs would roll out if the branch swayed in the wind. However, the Cuckoo-shrikes build in well-sheltered woodland and on stout branches that don't sway.

A nest that I found was situated in well-protected msasa woodland, insulated from the wind and at a joint in a thick branch, the nest being invisible from below.

The eggs, usually two in number, are fittingly beautiful for such a special bird: pastel green with flecks of yellowish-brown and vague undertones of grey. Size 27 x 19mm.

The reed-bordered stream reflects countless stars upon its surface, so that when I walk along its banks I have stars above my head and beneath my feet. But the effect is intensified because all round me there are phosphorescent pin-points of light from hundreds of fireflies. Some of these creatures are in flight above the water, and their lights and reflections mingle with those of the stars. Sometimes what I take to be a star, fixed in its place in the universe, darts away or performs a loop - a firefly has detached itself from its invisible perch among the reeds. I could not have seen anything more enthralling; and the sense of magic is intensified by the utter silence of the place.

In contrast to the stream of stars and fireflies wrapped in silence, I recall a different stream in a vlei where companies of little reed frogs tinkled. I had walked quietly along this stream and come upon *The Place of the Reed Frogs*. The nearer I got the louder the sound became. Perhaps a hundred of them clung to the reed stalks just above the water and uttered their piercing tinkles. It was quite deafening, the sheer multitude of separate notes chiming simultaneously caused the mind to reel. Such a big noise from such tiny amphibians.

This stream also reflected the stars, and by standing on a flat rock in the middle of it I could look straight down into the water beneath my feet and see the Milky Way. But the sound of the froglings became too much and I retreated across the damp vlei grass.

I had visited this spot during the day and had seen two nests of the Large Golden Weaver attached to the reed stems. They were both occupied, and I had seen the beak of one of the brooding birds protruding from the entrance hole to her large rough nest. I wondered how these birds ever got any sleep at night among all the din. The row went on for hours with varying waves of intensity. One can only suppose that birds must be less sensitive to noise than people. Other birds trying and possibly succeeding in getting some sleep were also present in the reeds: coots, rails, ducks and reed warblers.

Having put some distance between myself and the frog orchestra I began to enjoy the sound. Like the bagpipes their combined sounds have more enchantment with distance.

Longtailed Widow

This singular widow bird frequents certain open grassy places where it practises a vague or ill-defined aloofness from the other widow species. At least that is the impression I have gained watching them over a period of five years. Although one or two other widow species may share the same general area, there seems to be only occasional mixing. Sometimes when I arrive at their place I find the Long-tailed Widows the only species remaining in that chosen locality all year round.

In their off-season, when they are not breeding, they form a smallish flock and stick to themselves. The males lose their spectacular breeding regalia and most of their black feathers, although they still retain some black on the wings. Interestingly they are remarkably tame in the off-season; they will allow the close approach by a man and his dog. The female in particular seems to lose her wild timidity during the winter months. One may see a group of these brown stripy birds perched together on dry weeds.

The larger dark-winged individuals are the males and the more striped, slightly smaller and more numerous others are the females. They utter a "chuck" note at these times.

When a female has her back towards the observer she appears more striped than the male, and her tail feathers show a forked outline. Not pronounced as in the Fork-tailed Drongo, but nevertheless a short stubby fork. The flight of both males and females is fast and powerful, perhaps in response to aerial predators such as the Lanner Falcon, a pair of which I have seen hunting together over this very place, which is next to an airfield. The swerving jinking flight of these widows would automatically help them to elude falcons.

Males are distinguished in flight by their dark, almost black wings, and when at rest by the red and white shoulder-patch. I believe the wide wings are a special adaptation to carry the weight of the huge curving tail of the male in the breeding season.

Breeding coincides with the rains, abundance of insect food for their chicks and long dense grass-clumps in which to conceal the well-built nests. These nests are very hard to find, so well are they hidden by dense green grass-blades, some of which are deliberately pulled down over the nest to cover it from view.

In some areas the breeding males become vulnerable during and just after a heavy downpour, when their long tail-feathers are wet. The water-logged feathers weigh them down, so that they flop exhausted into the grass, where they are hunted down and caught for food by native children. This cruel activity must greatly affect the numbers of these birds, since it is done at the precise time when it should not be done.

Long-tailed Widows do a good job of nest-making and create a strong thick nest in which three or four eggs are laid, off-white, creamy or sometimes greenish with camouflage splotches of darker colours. Enemies: boys in season, various hawks such as the African Marsh Harrier and other harriers that quarter up and down over vlei ground, the Lanner Falcon, one or two mongoose species, human "developers".

Oxpeckers and Kudu

Back Cover

The Afrikaans naturalist Eugene Marais, in his *Soul of the White Ant*, admits to a sense of disillusion and despair when searching for God in nature. To him the deep wonders of nature should have provided the reassurances and comfort of a just and loving God, the creator of the universe and of the infinite complexities of earth's life forms in which there is "the breath of life".

We can sense this longing for reconciliation between a loving creator and ruthless nature in all his writings. He asked questions that remain unanswered. His study of life in a termite mound raised questions seemingly impossible to answer. For most of mankind shares a conviction that a God exists, however much His laws are treated with contempt.

Perhaps no men were more in tune with nature than the American Indians, who saw its beauty with a fresh vision and who could call a blue lake "the smile of the Great Spirit". Marais shared this poetic vision of nature reflecting a benign deity. Yet his joy in the natural world evaporated when he began to understand the soulless cruelty of the termite systems.

A soldier termite, defending his community by blocking an entrance with his armoured head, is eaten from behind by the workers of that same community when his usefulness is over and the danger from outside is removed. When the queen termite is accidentally killed, all activities throughout the mound cease. The teeming hordes abandon their normal work and wander about aimlessly as though cut off from their source of intelligence.

But the source of intelligence is not the queen herself, for when her usefulness is at an end this fact is anticipated by the workers, who have prepared a successor. So whatever mental force is controlling the community it is neither in the queen nor in the workers. And this intelligence is savage, cunning and frighteningly efficient. The human observer therefore asks: "If God made all that is and has the breath of life, why is it so unlike the divine nature that we imagine? Why is it so pitiless and cruel?"

Observe the proud kudu with a majestic tilt to his head pitting his wits for centuries against his implacable enemy, man. And observe the little birds that clamber about his body keeping it free from ticks. The kudu, the oxpecker and the ticks together offer anyone looking for evidence of God in nature a bundle of complex contradictions.

Ticks will climb up grass stems lining a game trail. They don't waste their time climbing stems elsewhere. Look for yourself along a footpath in the tick season. The ticks know where to cling to stems, with two forelegs spread out and hooked ready to catch the fur of mammals using the path. By what intelligence do they know when and where to be at the right moment? Is God in league with parasites?

The oxpeckers don't bear too close a look either. They are as repulsive and greedy as the ticks, even though they warn the animals of the approach of a hunter. For if the kudu should develop a sore or suffer a wound the birds enlarge the hole until it becomes a sort of free blood-bar for these daylight vampires.

Could Eugene Marais have been puzzled over the words of Jesus: "Are not two sparrows sold for a farthing? And one of them shall not fall on the ground without your Father." (Matt 10:29.)

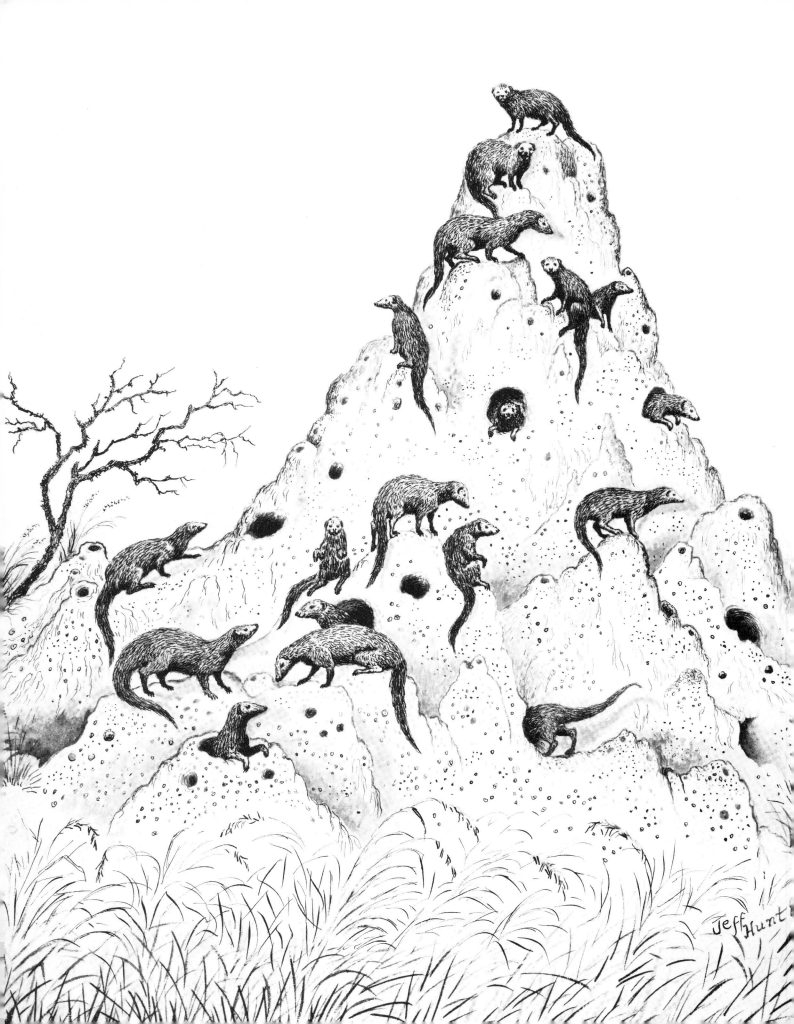